Four Icons in the Menil Collection

Four Icons in the Menil Collection

edited by

Bertrand Davezac

THE MENIL COLLECTION MONOGRAPHS 1

This publication was made possible in part by
the generous support of Mrs. James H. Pappas,
Mrs. Thomas W. Pew, Mr. James D. Prappas,
and Clare Sprunt.

Library of Congress Cataloging-in-Publication Data

Four icons in the Menil Collection /
edited by Bertrand Davezac.
 p. cm.—(The Menil Collection monographs ; v. 1)
 ISBN 0-939594-21-8
 1. Icons, Byzantine—Themes, motives. 2. Christian
saints in art. 3. Uspenie (Icon) 4. Mary, Blessed Virgin
Saint—Art. 5. Icons, Russian—Themes, motives. 6.
Orthodox Eastern Church and art. 7. Menil Collection
(Houston, Tex.)
I. Davezac, Bertrand, 1930– . II. Series.
N8186.U6M474 1992 90–19433
704.9'482–dc20 CIP

Published by Menil Foundation, Inc.

Distributed by University of Texas Press
Post Office Box 7819, Austin, Texas 78713-7819

Printed in the United States of America

Cover: Saint Marina icon, The Menil Collection, Houston

CONTENTS

Contributors 9

Bertrand Davezac Foreword 11

Color Plates 15

Christine Havice The Dormition of the Virgin Icon 24

Ellen C. Schwartz The Saint Stephen Icon 46

Nancy P. Ševčenko Vita Icons and "Decorated" Icons 56
of the Komnenian Period

Leslie Brubaker The Vita Icon of Saint Basil: 70
Iconography

Annemarie Weyl Carr The Vita Icon of Saint Basil: 94
Notes on a Byzantine Object

Jaroslav Folda The Saint Marina Icon: *Maniera Cypria,* 106
Lingua Franca, or Crusader Art?

Credits 135

CONTRIBUTORS

Leslie Brubaker
Professor of Art History,
Wheaton College

Annemarie Weyl Carr
Professor of Art History,
Southern Methodist University

Jaroslav Folda
Professor of Art History,
University of North Carolina, Chapel Hill

Christine Havice
Professor of Art History,
University of Kentucky

Ellen C. Schwartz
Professor of Art History,
Eastern Michigan University

Nancy Patterson Ševčenko
Cambridge, Massachusetts

Foreword

This is the first of a number of anticipated publications on The Menil Collection's Byzantine holdings and Russian icons. The presentation of the studies included here, though forming a first installment of a larger project, is of a singular nature in that it ensues from special circumstances: 1) a request from the organizers of the 14th Annual Byzantine Studies Conference for a special session on the icons in The Menil Collection, which led to the Conference being held in Houston, sponsored by The Menil Collection; 2) an offer by the Menil Foundation to publish the articles corresponding to the expanded versions of the more significant among these papers.

Four icons became subjects in this way. Three of them are Greek icons of stellar importance: two of these, besides their artistic merit, by reason of the problems they raise and the answers they allow (St. Basil and St. Marina); the third by reason of its inherent, albeit intimate, splendor (the magnificent small icon of St. Stephen). The fourth is Russian, possibly Muskovite, a majestically aristocratic Dormition from the second half of the sixteenth century.

The Russian icon shares with its companion piece, the Timken Ascension icon of San Diego, which was perhaps separated from it for the first time upon the dispersal of the Hann collection in 1981, a common origin in the same workshop, as well as the same vicissitudes over three centuries (circular down-trimming, subsequent restoration of the original format, and, of late, defamation), all of which has added to the Menil Dormition an aura, making it difficult to perceive the exact nature of the original style. It took Christine Havice a good deal of ingenuity to analytically restore the original character of its great style underneath accretions and in spite of its transformations and the intellectual weight of discrediting judgments passed upon it. It is a style which Havice was able to, if not pinpoint, at least circumscribe within the framework of influences from Novgorod, from the pluralistic milieu of Moscow and possibly Tver, thus debunking the arguments challenging this icon's authenticity.

In contrast to the Russian Dormition, the Greek St. Stephen icon, here analyzed by Ellen Schwartz, is limpid and unproblematic. No trace of heterogeneity of style here, of provincial amalgamation or bastardization. The finest expression of Constantinopolitan art shines with all its finesse and skill and in the style that one expects from a good metropolitan atelier of the Palaiologan period. In placing it in the first quarter of the fourteenth century, Schwartz is at variance with previous datings which place it two or three decades earlier. The transparent delicateness of plastic expression, albeit acutely delineated, pictorially translates the words in Acts 6:15 describing Stephen's features, "His face was like the face of an angel."

The final two icons presented here are, like the St. Stephen, not only foremost in the collection but also in the history of Byzantine painting. The St. Basil icon is the earliest and apparently only "vita icon" (the image of a saint surrounded by scenes from his life) or historiated icon of this major holy figure in Byzantine art, hagiography, and liturgy. It is datable within only decades after this type of icon seems

to have originated, in the last years of the twelfth century.

The St. Marina icon recommends itself not only for the discrete character of its comparatively rare style in Byzantine icon painting, but also, and perhaps more importantly, for the novel perspective that—according to Jaroslav Folda, a scholar of vast experience in the art of the Crusader States—it opens on the complex question that has been brought increasingly into focus within Byzantine studies in recent years: the interface between Crusader art and Byzantine art under specific, cross-influencing and volatile historical conditions.

The St. Basil icon is approached from the triple aspect of the archaeology of the vita icon by Nancy Ševčenko, its iconography by Leslie Brubaker, and its style morphology and art historical context and function by Annemarie Weyl Carr.

Ševčenko, the leading authority on the historiated icons of that most popular of all saints in the Byzantine and slavic worlds, Saint Nicholas, traces the origins of the format—rectangular center field with an emblematic subject surrounded by related narrative scenes on all sides—to Antiquity in a variety of mediums ranging from mosaics to book painting, stone relief and ivory carving. But more immediate sources are tentatively suggested to be in eleventh-century epistyle cycles (so-called festival icons of a choir screen, or icons that are placed atop the choir screen of an Orthodox church), and there is both archaeological as well as textual evidence to support this hypothesis. Eleventh-century silver and silver-gilt icons, with peripheral historiated or hieratic vignettes—examples of which are found in Georgia dating in the eleventh century—are instances also adduced by Ševčenko as icons designated in texts as "decorated" icons which she renders as "enhanced" icons.

Brubaker's contribution is twofold: the elucidation of the primary iconographic level of meaning (Panofsky) of what remains of the badly worn peripheral scenes of Basil's life, and the ascertainment of the textual basis. She is as successful as can be possible on the former approach, given the partially ruined condition of this relic of an icon. The textual basis of Basil's life scenes is the funeral oration of Gregory of Nazianzus, Basil's lifelong friend, written two years after Basil's death in 379—many illustra-

tion versions of which have survived from the ninth century onward. Brubaker is a long-standing scholar of the famous Paris Gregory, Paris, B.N. gr. 510, the illustrious monument of middle-Byzantine miniature painting which was the object of her doctoral dissertation. A secondary source is found in the *Sacra parallela* of John of Damascus, which is entirely derivative from Gregory's funeral oration. Definitely ingenious is Brubaker's identification of the partially preserved bottom scene as Basil's meeting with Holy Ephrem, the source of which is not found in the gregorial filiation but in a text attributed to the so-called pseudo-Amphilochios, an identification which supersedes Christopher Walter's previous identification of the scene as a thanksgiving for the death of Julian the Apostate.

Thus, Brubaker and Ševčenko have defined on two concentric circles of investigation, as it were, extrinsically the sources of the historiated icon as a devotional genre and intrinsically the sources for the border illustrations.

It is Annemarie Weyl Carr's share to approach the essential question of style. Having first inventoried the constitutive features of the form, analyzed the calculated economy of line and color, and perceptively assessed the expressive effect with respect to balance of color and mutual response of formal elements within the composition, Carr then moves on to delineate the geography of the style. Her investigation is here aided to best advantage by her familiarity with book painting, which reinforces this conclusion, itself drawn from the consideration of four aspects essential to Cypriot painting: the provenance of the St. Basil icon is definitely Cyprus, where it may have been venerated in an icon stand, a so-called proskynetarion. The existence of such icons is attested, writes Carr, by inventories (typica). If such is the case with our icon, writes Carr, it is "both public and personal. As such it gives a good impression of the dual power of the Byzantine icon, public and immediately recognizable in form, yet personally compelling in address."

The areas of Byzantine civilization from the twelfth to the fifteenth century that were outside the limits of Byzantine political dominion have been given considerable notice beginning with Buchthal's

landmark publication, *Miniature Painting in the Latin Kingdom of Jerusalem* (Oxford, 1957), and in the attention showered upon the enormous hitherto untapped collection of icons of St. Catherine at Mount Sinai by the Soterious and Weitzmann. But with the publication of Weitzmann's seminal article in 1963 (see *infra*, Folda, Bibliography), followed by subsequent studies by him on the same central issue, a new star has appeared before the telescope of Byzantine students: Crusader art, concretized in the Crusader icons. This led to revitalizing the old notion of *maniera greca* with specific and refined connotations in the face of this peculiar, newly discovered phenomenon: a Byzantine pictorial idiom practised by non-Byzantine artists, which in turn gave a new twist to the old concept of *lingua franca* (Belting, 1978, "Zwischen Gothik und Byzanz," *Zeitschrift fur Kunstgeschichte*, 41, 1978, 246-247; Cormack, 1984; *infra*, Folda, Bibliography). The question of assigning a place of production to the Crusader icons led to the promotion and demise of centers such as Acre in favor of new places, the latest to date being Cyprus, recently vindicated by Doula Mouriki in her fundamental study (1986, *infra*, Folda, Bibliography), already a classic. The reports by Winfield, and the studies by Megaw, Mango and Hawkins on specific monuments of the island during the twelfth century, the comprehensive survey of Cypriot monumental painting by Hadermann-Misguich and of Cypriot icons in the same period by Papageorghiou have apparently had the effect of confirming a latent prejudice against Cypriot art of the following period during the early phase of the Lusignan rule of the island, a period long regarded as one of stagnation. Yet Cypriot painting during this particular phase is a crucible in which the earlier qualities of Byzantine Komnenian art amalgamate with western characteristic and ornamental features which Weitzmann has associated with Crusader icons and Mount Sinai. This amalgamation gave rise to a new coinage in Byzantine studies: *maniera cypria*. It designates an insular style contemporaneous with the Crusader icons and results from the interfacing of various cultures, "living together in a place which had become, more than in any other previous period, a crossroads between East and West" (D. Mouriki, *op. cit.*, 76).

This sketchy background of Byzantine art beyond the orbit of Constantinopolitan influence during the period when the Franks held ground in the Eastern Mediterranean sets the stage for Jaroslav Folda's study of the St. Marina icon. Although not mentioned in Mouriki's comprehensive survey, the initial presumption of a Cypriot origin is, as a result of her study, inescapable, and Folda's analysis of the stylistic traits associated with Cyprus posits the concept of *maniera cypria*. However, neither the latter together with such idiosyncratic features as the pastiglia technique nor other feaures generally associated with Jerusalem, Palestine, or Sinai are determinant enough to warrant an attribution of the icon to one of these centers. Folda's invaluable contribution is the discovery of a new province of Crusader art: a province in which the cult of Saint Marina is more fervent than anywhere else, a province which took the position of Jerusalem as a place of pilgrimage after the fall in 1244, the county of Tripoli, a region rich in monumental painting. The St. Marina icon is assigned to that Crusader state on its remarkable stylistic affinity to a group of grotto frescoes in the Quadisha Valley, and specifically to the frescoes of the grotto of "Our Lady of the Abundant Milk" at Saidet ed Darr, south of Tripoli (Lebanon). A new significance is thus added to Mouriki's *maniera cypria*. While the latter implies the amalgamation of not only the Frankish but also, to the East, the Syro-Palestinian influx, Folda's discovery contributes a phenomenon in reverse: the Menil St. Marina icon is the work of a Syrian artist with an oriental vocabulary and familiarity with Cypriot painting. One cannot say more in summation than Folda does: "[The St. Marina icon] is not the work of a Syrian artist painting under the Byzantine influence of his newly settled Cypriot milieu in the thirteenth century, but rather much more likely the work of a Syrian artist painting in his homeland south of Tripoli in the service of the cult of St. Marina."

Bertrand Davezac
The Menil Collection

Four Icons in the Menil Collection

Color Plates

Plate 1.
Dormition of the Virgin icon, 16th century
Tempera and gold over gesso and cloth
 on carved wood panel
$32^{1}/_{4}$ x $26^{3}/_{4}$ inches
The Menil Collection, Houston
85–57.57 DJ

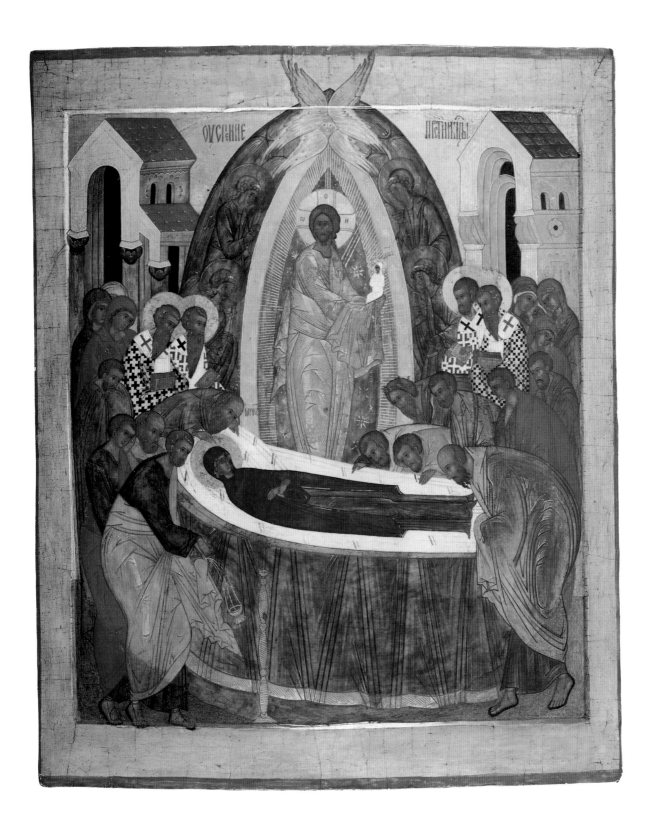

Plate 2.
Saint Stephen Protomartyr icon, ca. 13th century
Tempera and gold paint over gesso and cloth
 on carved wood panel
$10^{1}/_{2}$ x $8^{7}/_{8}$ inches
The Menil Collection, Houston
85–57.03 DJ

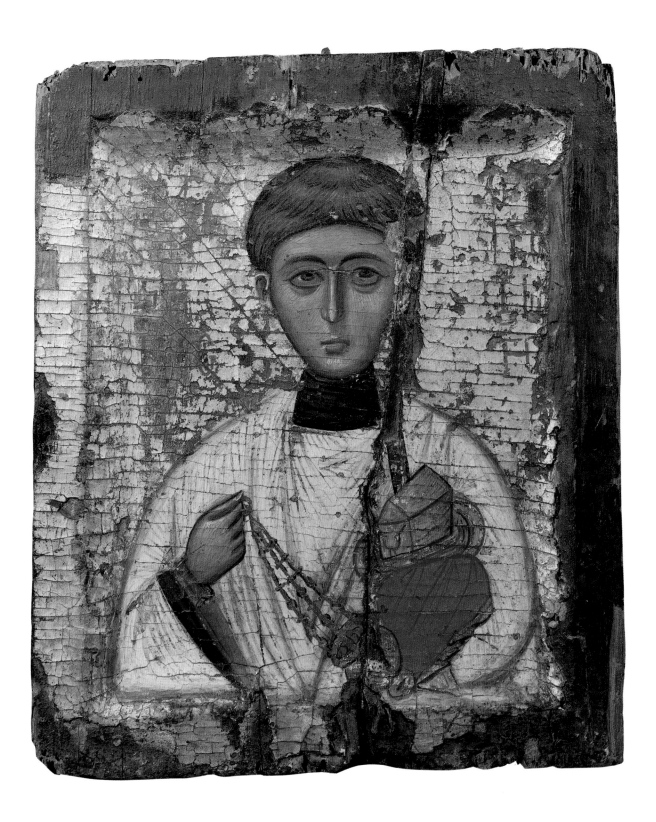

Plate 3.
Saint Basil icon, 13th century
Tempera and gold over gesso and cloth
 on carved pinewood panel
26 $^3/_4$ x 14$^3/_{16}$ inches
The Menil Collection, Houston
85–57.02 DJ

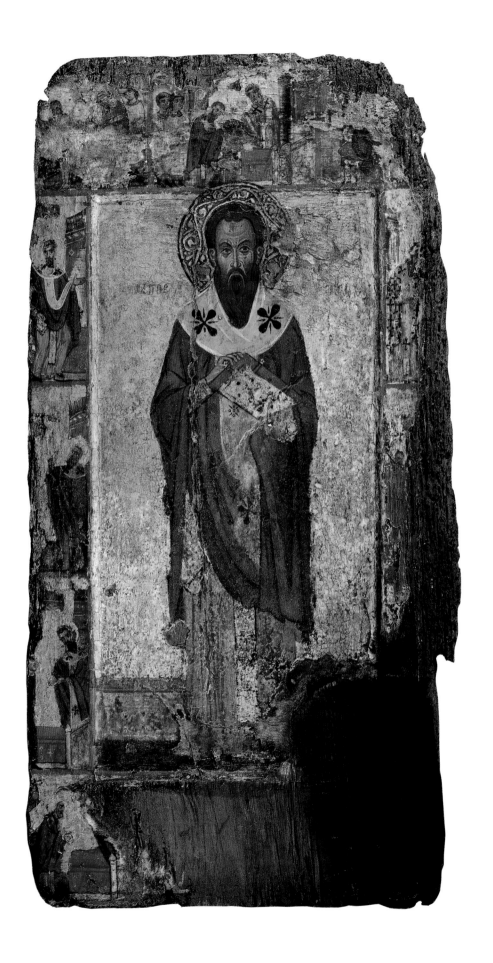

Plate 4.
Saint Marina icon, 13th century
Tempera over gesso on carved wood panel
$8^1/_2$ x $6\,^3/_8$ inches
The Menil Collection, Houston
85–57.04 DJ

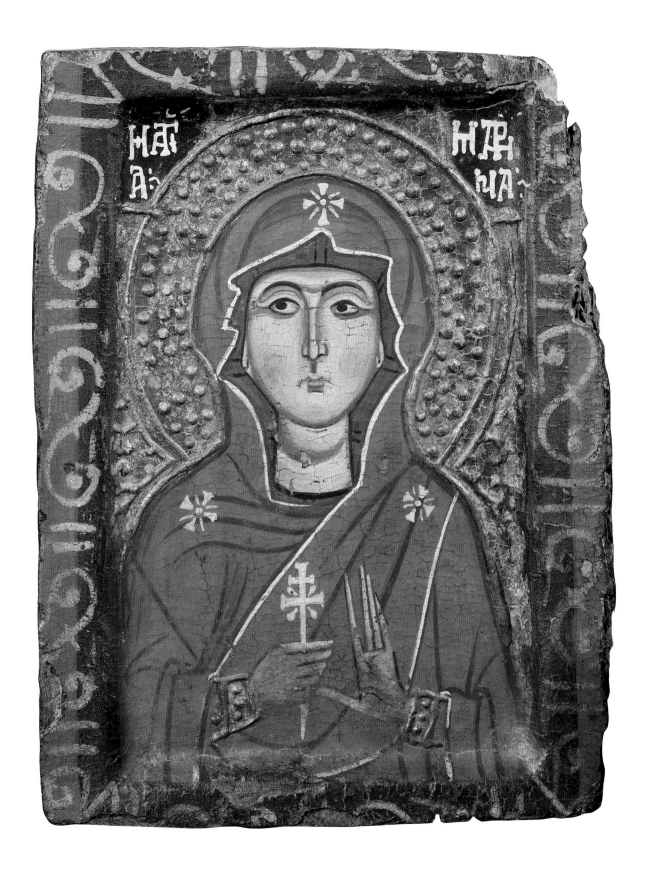

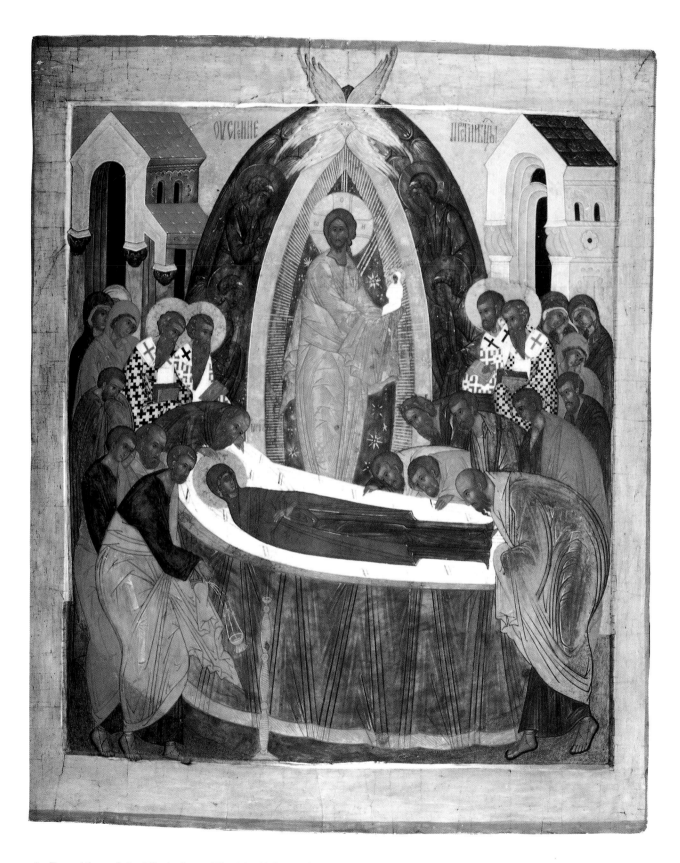

1. Dormition of the Virgin icon. The Menil Collection,
Houston (85-57.57 DJ).

The Dormition of the Virgin Icon

CHRISTINE HAVICE

Upon the dispersal of the Eric Bradley Collection in 1985, the Menil Foundation acquired a large Russian icon representing the Dormition of the Virgin (acc. #85-57.57 DJ; pl. 1, fig. 1). The work is apparently excellently preserved, dominated by golds and greens with bright red, white, and rose accents, all of which create a striking painting of considerable size (81.6 x 68.7 x 3.2 cm).

The elongated, golden figure of Christ occupies the center of a triple green mandorla. He faces forward in hieratic dignity, although his lower body turns slightly to our right, its direction emphasized by the strong gesture of his arms as he holds the infant-soul of the Virgin *(dousha)* silhouetted in white to the right. The radiant, star-bestrewn core of the mandorla is flanked by taper-bearing archangels and surmounted by a seraph. The crimson inscription, in a compressed and decorative hand, balances on either side of the mandorla, which, with the seraph, extends into the raised border *(polye)* of the icon. This border is wider above and below than on the sides and is enframed on the outside by a pale red strip.

Disposed about the bier are the apostles, five on the left, seven to the right, and behind them the four nimbate hierarchs, clad as bishops and bearing codices: James of Jerusalem, Timothy, Hierotheus, and Dionysos the Aeropagite.[1] Two trios of mourning women stand before gabled buildings in each upper corner, balancing the strongly symmetrical composition. The body of the Virgin creates an emphatic horizontal across the front of the composition, its deep hues of crimson and dark green contrasting sharply with the white mattress of the bier. At the left, Peter swings a censer at the head of the bier next to a tall candlestick, while, at the foot, Paul bends low to approach with veiled hands. Three other apostles bow over the bier and touch it with their hands, while the remaining figures incline forward in respect or raise hands to cheeks to indicate great feeling.

The icon, which first came to Western attention after it entered the George R. Hann collection in the late 1930s,[2] presents a number of problems. Perhaps the most notorious of these is the allegation made in 1981 by Vladimir Teteriatnikov that this icon, along with most of the others purchased by Hann, is a modern forgery.[3] Such a claim may be evaluated when the Dormition icon is examined with regard to its physical condition and state of preservation and then compared to better-known examples of Dormition iconography and of Russian icon-painting of the sixteenth through eighteenth centuries.

Physical Condition and State of Preservation

While the Menil Dormition appears to be in excellent state of preservation, the careful observer notes on the obverse a curving seam at each corner as well as areas of substantial overpainting. These seams cut across the legs, bier, and ground in the lower portions of the icon, and buildings, inscription, and seraph above, describing a rough circle (fig. 2). Andrei Avinoff, editor of the catalogue

Diagram A

(frontal view of present rectangular assembly)

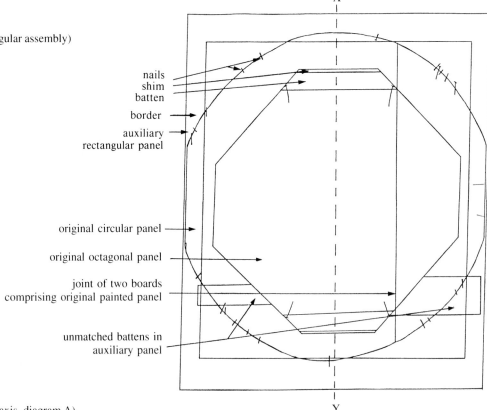

nails
shim
batten

border →

auxiliary
rectangular panel →

original circular panel →

original octagonal panel →

joint of two boards
comprising original painted panel →

unmatched battens in
auxiliary panel →

X

Y

Diagram B

(1, 3, 5: cross-section on XY axis, diagram A)

1. Original circular panel

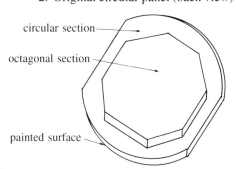

painted surface
circular section
octagonal section
cut away section
original batten

2. Original circular panel (back view)

circular section
octagonal section
painted surface

3. Auxiliary rectangular framing panel

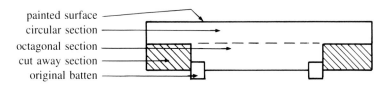

carved-out circular section
carved-out octagonal section
auxiliary rectangular panel

4. Auxiliary rectangular framing panel (front view)

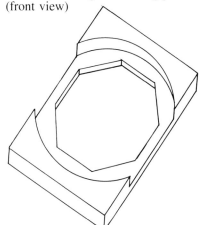

5. Present rectangular assembly

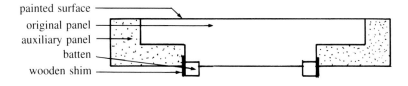

painted surface
original panel
auxiliary panel
batten
wooden shim

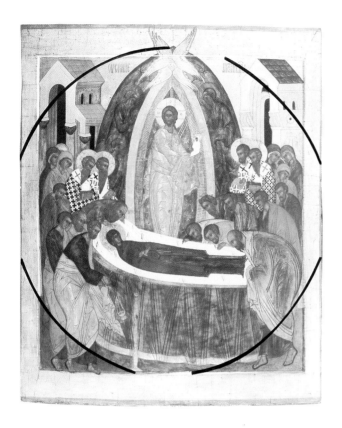

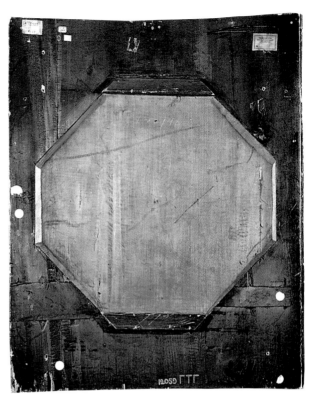

2. Menil Dormition icon: diagram indicating seams of cut and restored corners.

3. Menil Dormition icon, reverse.

in which the icon was first published in 1944, explained this peculiarity as the result of trimming the original, rectangular icon in order to fit it into an unspecified Baroque iconostasis.[4]

The present corners of the icon would be the result of a further intervention which restored the icon to its original format. And, in fact, we can note that these restored areas, particularly on the left, have been distinguished by slightly darker shades of paint. The reverse of the icon offers an even more dramatic and complex configuration (fig. 3): An irregular central octagon, carved in relief on the back of the two vertical boards joined to make the original panel (and including the remains of battens above and below), now sits within an auxiliary rectangular framing panel of darker wood. This framing panel originally incorporated a pair of unmatched battens visible on either side of the lower half of the octagon.

Careful study of the physical condition of the Menil Dormition icon was undertaken in the course of the summer of 1988 and included X-radiographs, ultraviolet, and microscopic examinations. Using these techniques, then Adjunct Conservator Andrea di Bagno identified the several interventions still evident in the icon's construction (diagram A) and reconstructed a hypothetical physical history of the object to account for the several campaigns to which it seems to attest (diagram B).[5] A cross-section from top to bottom (on XY axis in diagram A) of the original panel (B1) shows the original battens or *shponki* and painted obverse, which is composed of two vertical boards. Di Bagno finds plausible the Avinoff suggestion that the rectangular icon was trimmed to fit a later, circular iconostasis frame as illustrated in B1 and isometric B2. This would account for the difference in format between the roughly circular obverse and the octagonal reverse, the latter presumably preferred to reduce the chance of the icon shifting in the new circular frame. Then, at some later date, the iconostasis would have been

4. Menil Dormition icon: detail, upper left corner, indicating seams.

5. Menil Dormition icon: detail, center right group of figures.

6. Menil Dormition icon: detail, center left, overpainting in apostles' heads.

dismantled and the now circular icon removed. To restore it to its original format, an auxiliary panel (B3, stippled area, and isometric B4) would have been carved out to receive the icon, which, with the remnants of its original battens, was inserted (B5) into the auxiliary panel and wedged into place by shims above and below. The original and new portions of the icon were further secured on the reverse by four large nails, visible in X-radiographs and indicated in diagram A, and on the obverse by numerous smaller nails. Di Bagno notes the aged appearance of the wood of the auxiliary panel and suggests that an old panel was deliberately used, not "to confuse, camouflage, or mislead, but rather to achieve a sensitive restoration," [6] because an older panel would have already undergone its most drastic drying and would thus accommodate another old, curved panel without developing significant differential tensions.

On the obverse, then, the corners beyond the curved seams belong to the second intervention, the restoration, and, in fact, the raised border or *polye* is revealed by material analysis to be made of gesso. While the entire surface of the icon bears an even coat or coats of varnish, evident under ultraviolet light, di Bagno has noted that the center of the icon displays a "fine even web of aging craquelure," while the corners exhibit not an authentic surface craquelure but painted patterns. [7] Instead of interpreting this discrepancy as evidence of an attempt at falsification, she terms this a traditional technique familiar to experienced restorers and so understands it as benignly intended, evidence again of the care with which this restoration seems to have been carried out. [8]

In relation to upper corners, the inscription *Ouspenie presviatiia Bogoroditsi* ("Dormition of the most holy Mother of God") overlaps into the right restored portion and presented several problems of orthography and incorrect or meaningless letterforms, as well as using a form of "presviatiia" uncommon before the eighteenth century. [9] Technical investigation reveals that no earlier inscription underlies the present one, which thus must be the only inscription in this part of the icon and must date from the time of the restoration (this is true as well of the inscription on the Timken Ascension icon, to

be discussed below, where the inscription lies wholly in the restored corners of the panel). The apparent absence of any trace of earlier inscription on the icon is troubling, although a significant number of surviving icons, including some of the Dormition, lack original inscriptions, a problem not yet comprehensively treated in the literature. [10]

Even without the aid of technical processes, the careful observer can readily see substantial overpainting on the front of the Dormition icon. Along the corner seams (fig. 4), the restorer has painted into the center of the panel in order to blend, and probably from the same time, lines of redefinition were applied to many of the figures to simplify contours, particularly those of faces. Some areas were extensively overpainted: the head, neck, and hand of the profiled apostle in the red mantle to the right (fig. 5), for example, have been repainted, as have the pattern and folds of the polystaurion of the heirarch just above him. Perhaps most significantly, many of faces have been repainted (fig. 6), a fact not hitherto recorded but visible to the naked eye. Fine black lines define profiles, noses, eyebrows, and lips, and the repainted, closely spaced tiny black eyes effectively lengthen facial proportions. This linear handling contrasts with the subtle and more plastic modelling of the rest of the face, which had larger eyes and broader, less pinched proportions, discernible in the underlying layer of paint in several passages. Any discussion of style in the Dormition icon thus must take these alterations into account.

Timken Ascension and Menil Dormition Icons

A large icon representing the Ascension of Christ (fig. 7), purchased by Hann at the same time as the Menil Dormition and now owned by the Putnam Foundation at the Timken Museum of Art in San Diego, shares a number of physical traits with the Menil icon. A comparison of dimensions and of the several labels and inscribed inventory numbers on the reverse of the two icons reveals that they must have been produced together, presumably as part of a larger set of icons for a church screen, and that they were paired, ostensibly at the Tretyakov Gallery, early in this century.

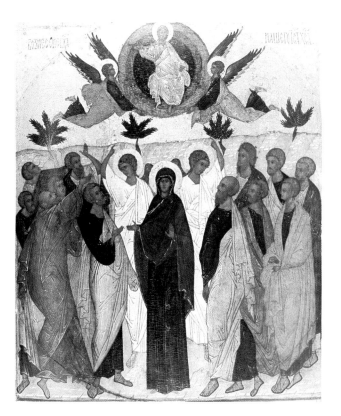

7. Ascension icon. The Putnam Foundation, Timken Museum of Art, San Diego, California.

TABLE 1

Menil and Timken Icons

DORMITION ICON 81.6 x 68.7 x 3.2 cm	ASCENSION ICON 81.4 x 67.8 x 3 cm.
(label) "Gosudarstvennaya Tretyakovskaya Gallereya no. 225" (white paint) 12059 GTG (label) C/18903 (label) $\frac{Cl}{240}$	(label) "Gosudarstvennaya Tretyakovskaya Gallereya no. 226" (red paint) 12060 GTG (label) C/18909 and 24 (label) $\frac{C}{254}$

Beyond these details, scrutiny of the Ascension icon reveals, on the obverse, the same curving seams at the corners which imply trimming to circular format and then subsequent restoration to the original rectangular shape. Similarly, the reverse of the Ascension icon offers a construction analogous to, if slightly more complex than, the Menil Dormition: an unequal octagon (the back of the original) with portions of its two *shponki* has been fitted into a rectangle constructed of eight or

8. Entry into Jerusalem. Einar Krane Collection, Stockholm.

9. Passion icon. Tretyakov Gallery, Moscow. (no. 22285).

nine pieces of wood. The original icon, like that in the Menil Collection, is composed of two vertical boards.

Independent conservatorial investigations of the Timken Ascension icon in 1982 and 1984 arrived at conclusions similar to those proposed to explain the physical condition of the Menil Dormition. Vera Beaver-Bricken Espinola, who conducted an exhaustive examination of the Ascension icon in 1984, found, moreover, that the materials and techniques employed in its construction are "compatible with those used in Russia during the sixteenth and seventeenth centuries" and that the present restoration, which she dates to the late nineteenth or early twentieth century, attempts to join structurally and unify aesthetically the disparate parts of the piece. [11]

Thus, evidence of the final restoration of each icon suggests that they were worked upon in tandem. While it is not possible, on the basis of the remaining physical evidence, to conclude that the two were originally created together as part of a single iconostasis, patterns which emerge upon iconographic study of each do increase that possibility, as we shall see. However, it is worth continuing to explore the hypothesized history of these "twin" icons—the proposal that the original rectangular icons were modified in shape to fit into an iconostasis with circular frames—in order to assess the plausibility of this explanation.

Icons in Non-Rectangular Format

Other instances in which rectangular icons have been cut down to fit into polygonal or circular frames are relatively few, but two works in the Einar Krane Collection in Stockholm, of which one is reproduced here (fig. 8), offer a parallel to the Dormition and Ascension icons. [12] Kjellin dates this pair to about 1600 on the basis of style and notes the rarity of this circular format without attempting to account for it. However, other sources attest to this practice: Vladimir Soloukhin, in *Searching for Icons in Russia,* [13] describes the trimming of a rectangular icon's upper border to fit into the arched frame of an iconostasis which dates to the end of the eighteenth century.

Icons in non-rectangular format could also be created as such from the outset. Although somewhat strange to the more austere Byzantine taste and less familiar to our contemporary Western eye, numerous elaborate Baroque iconostases were constructed in Russia in the later seventeenth and eighteenth centuries. Such a "modern" style flourished in Moscow, as attested by the best-known example, the iconostasis in the Church of the Discovery of the True Cross in the *Teremnoi dvorets*. [14] However, the taste for the more fulsome style and thus for polygonal, oval or circular icons was not limited to the capital [15]: provincial iconostases, from the Sveni and Ferapontov monasteries to note just two, [16] offer other instances in which icons, in the upper tiers especially, were fitted into frames with cusped upper profiles or other non-rectangular shapes.

Moreover, the numbers of surviving icons now detached from their frames underscore the frequency with which, in the later seventeenth and eighteenth centuries, such non-rectangular formats were chosen. In contrast to the Dormition and Ascension icons, which were adapted to their new frame, these oval, circular, and octagonal icons were designed for the new format by shifting or omitting traditional compositional elements of narrative scenes. Examples are a series of ten circular Passion scenes painted on elongated octagonal boards, now in the Tretyakov Gallery (fig. 9), [17] another set of Passion icons from an eighteenth-century iconostasis, [18] and a round icon of the Trinity by Nikita Pavlovetz of 1671, now in the Russian Museum. [19] In addition to these narrative compositions, various other medallion-shaped icons survive which bear portraits of the Evangelists or the Virgin. [20]

In sum, icons of circular, oval, and polygonal shape were created, either by cutting down extant rectangular paintings or by creating original icons in such shapes, to fit late seventeenth- or early eighteenth-century iconostases. Both practices are attested by surviving icons and icon screens, even though these are less well-known to the West. This lack of familiarity may in part account for the restoration of such reformatted icons to their original rectangular shape, as hypothesized for the Menil and Timken panels.

10. Dormition icon, early 13th century. Tretyakov Gallery, Moscow (no. 30461).

Style

Discussion of style in the Menil Dormition must be conducted within the constraints posed by the icon's physical condition and state of preservation, as noted above. Effectively, this means that only the central circular portion of the icon is available for stylistic analysis, and that with great caution, given the significant areas of overpainting and redefinition. The impact of these painterly interventions, to review briefly, has been to change facial proportions in the direction of greater elongation and more closely spaced eyes, to simplify and strengthen the linear quality of contours, and to sharpen the otherwise softly modelled facial features.

While facial proportions have been altered through the later redefinition, the figures themselves are elongated, swelling through the torsoes and tapering above to tiny heads. From crown to chin, the head of Christ is approximately one tenth the height of the figure were it completed. The artist increases this sense of the vertical through the thin dimensions of the lighter inner mandorla, through the slender proportions of the flanking buildings, and

through the raising of the central figure above the heads of the others, who have been located at or below vertical center in the icon.

The icon may be characterized by certain incomplete impulses: First, a sense of undulant rhythm, as in the graceful curves of the backs of the inclined lateral figures, the heads and shoulders of the figures above them, and the gestures, all of which fold into the center of the composition and enframe the figure of the reclining Virgin, itself partially curved within the gentle outlines of the striped mattress. Yet the lower body of the Virgin is stiff and sharply horizontal, as though drawn with a straightedge, and the central figure of Christ rises as a strong vertical, emphasized by the other rising vertical forms that flank him, none much modified by tapering contours. Compositionally, the icon is heavier on the right, where three figures break across the mandorla, the line of their shoulders resolved in the sweeping contour of Paul's back and then the group piling through the intermediate, almost upright figures to the pair of hierarchs, bracketed by the mourning women at the edge. This is counterbalanced by the tighter, lower arrangement of the remaining five apostles, two hierarchs, and second mourning trio at the left, where shoulders, backs, and inclined heads set up three tight curves that repeat the (concealed) curve of the head of the bier, with no glances distracting from the focus of attention.

All of this is pushed far forward in the picture plane, emphasizing its two-dimensionality despite the suggestion of three- dimensional space in the doorways and details of the architecture, most notably the right building, with its distinctive doubled arch and scrolled consoles. In fact, the artist has so organized the figures that the dominant figure of Christ and the subtle contours of the bier suggest a slightly bowed or convex composition, its ends wrapping backward to accommodate the tightly packed clusters of figures but its center propelled outward by the giant form of Christ, given greater monumentality by the relatively neutral space around it.

Most of these stylistic features reflect the influence of the art of Dionysii (c. 1440–1508), whose lyrical, gently sinuous figures and compositions and tender color schemes established the standard against which icons of Muscovy were measured through the sixteenth century. [21] The rhythmic groupings and measured arabesques of the contours which are typical of Dionysii's work may be seen in a Crucifixion attributed to him and dated by inscription to 1500, now in the Tretyakov Gallery. [22] Yet it should also be noted that the Menil Dormition seems to have hardened those arabesques, through slight exaggeration and then through the redefinition; the softness that avoids the formulaic in Dionysii's art finds no place in the Menil icon. Compositionally, we may confront Dionysii's fresco at the Ferapontov Monastery, the *Pokrov*, with its multifigural and multi-planar organization, [23] with the Menil Dormition: The architectural coulisses function less spatially in the former, but the emphasis on a grand central figure, dominating the crowded lateral figures by size and by the neutral space around it, offers some parallels (although the *Pokrov* works on a concave compositional schema, due in part to the lunette into which it has been inserted).

The palette of the Menil Dormition is richer, more brilliant, less subtle, although it repeats Byzantine conventions, as in the *changeant* highlights on the himation of Paul, which Dionysii, and before him Rublev, found worth exploring in their best icons. The emphasis on gold and the way in which that noble element dominates the other hues suggests that this icon was created for some ostentation, no longer so spiritual and immaterial in intent as the works created by Dionysii and his two sons.

All of this suggests some chronological distance from the immediate impact of Dionysii and the early sixteenth century. Without being able to specify this more precisely, we should also note that, in the faces, the delicate linearity of contour and feature contrast with the soft, almost sfumato modelling of the various planes, a stylistic detail which further argues for a later, rather than earlier, sixteenth century manufacture. This may be corroborated by the approximately square format of the panel (when allowing for the variance in width of the *polye,* the interior, recessed *kovcheg* seems emphatically square), which becomes more typical of later sixteenth and seventeenth century icons. The style of the inscription, with its condensed letter-forms not yet florid or convolutedly cursive, seems also to suggest the later sixteenth or early

11. Dormition (reverse of the Virgin of the Don),
by Theophanes the Greek, 1392. Tretyakov Gallery,
Moscow (no. 14244).

seventeenth century, but apparently this portion of the work has been wholly repainted in more recent times.

The stylistic evidence, then, would argue for a late sixteenth- or early seventeenth-century date for the icon. The restoration of the icon seems to have taken this dating into account and to have emphasized features which more clearly point to such a time period, obscuring the broader, softer facial features—which we may still note on the surface—which recall less Dionysii and his school than some provincial copy. We must leave these questions open until final technical investigation of the icon provides additional evidence upon which to allow or disallow these and other stylistic observations.

Composition and Iconography

The iconography of the Menil Dormition postdates the reduced, symmetrical representations of this subject which the icons of early Rus' inherited from Byzantium, as in the giant, early thirteenth-century Dormition from the Church of the Desiyatinnaya Monastery near Novgorod, today in the Tretyakov Gallery (fig. 10). [24] This early Russian version is a shallow, emphatically horizontal composition, with the central, vertical figure of Christ contrasted with the strong lines of the Virgin's body and bier and the ranks of apostles pushed far to the ends of the bier in two flat rows. The rigid symmetry takes its dominant impulse from the candlesticks enframing Christ and from the paired angels and clouds of apostles borne to Jerusalem in the sky above. The monumental composition becomes stiff and formal, particularly when compared to a fourteenth-century Byzantine version of same, the celebrated mosaic in the Kariye Djami of 1315-1320. [25] While the Byzantine work is more dynamic in its massing of the figures and more complex in the inclusion of the double mandorla surrounding Christ and of the sprawling background architecture, it evidences the same strongly vertical and symmetrical composition. If we can characterize this direction of early Russian Dormition composition and iconography as monumental, it finds its clearest expression in

the celebrated double-sided icon by Theophanes the Greek, datable to 1392. On the reverse of the image of the Virgin of the Don, a huge figure of Christ towers over his mother's bier (fig. 11), which in turn pushes the two groups of mourning apostles to the icon's edge, as though products of the painter's afterthoughts. [26]

On the other hand, in the course of the fifteenth century, certain Russian Dormition icons developed into far more complex compositions, with figures multiplied both in heaven and on earth. The famous "Blue Dormition" in the Tretyakov (fig. 12), provides an example: in addition to the apostles, trios of mourning women, elaborate architectural coulisses, and a broad, angel-filled mandorla about Christ fill the lower portions of the icon, while the skies above teem with angels escorting the cloud-borne apostles and, on the central axis, the Virgin enthroned in heaven gestures toward the swaddled *dousha* below. [27] Alpatov has related these compositional changes to a transformed iconography, in which the sorrow of the individual is overpowered by a sense of joy at the reunion of Mother and Child. He was the first to note the choral dimension of such Dormition iconography, in which the assembled figures can be seen to sing praises of the *Bogomater.* [28] The subsequent development of this type of choral composition can be seen in a mid sixteenth-century icon from Novgorod, now in the Russian Museum in Leningrad (fig. 13). [29] The multiplication of tertiary figures [30] and the elaboration of traditional elements, such as the gates of heaven behind the enthroned Virgin, the angelic host in the mandorla, and the fantastic excrescences piled up on the architecture, create an encyclopedic image analogous to the liturgical iconographies, such as the image of the *Pokrov*, developing out of Rus' hymnody from the sixteenth century. [31]

Also in this particular icon, the inclusion of the incident of the blasphemer Jephonias (or Athonias), who attempted to upset the Virgin's bier only to have his hands cut off by an avenging Archangel Michael as they touched the couch, amplifies this sense of anecdotal profusion. This narrative tangent, derived from the apocryphal Discourse of St. John Concerning the *Koimesis,* [32] appears more regularly in Dormition icons of the sixteenth century and thereafter, but E. S. Smirnova has also suggested

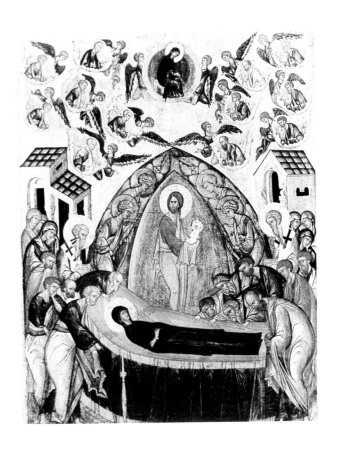

12. "Blue" Dormition, mid-15th century. Tretyakov Gallery, Moscow (no. 22303).

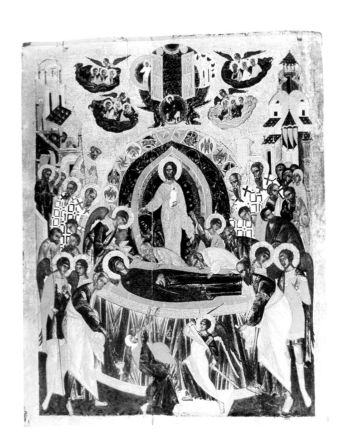

13. Dormition from Novgorod. Russian Museum, Leningrad (inv. no. 3122).

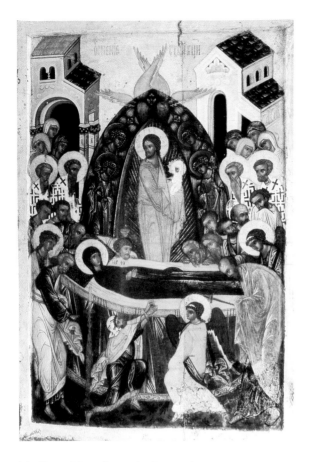

14. Dormition, from the Feast Tier, Church of
the Dormition in Volotova-Field. Museum Zone,
Leningrad (no. 3770). "V" in the text.

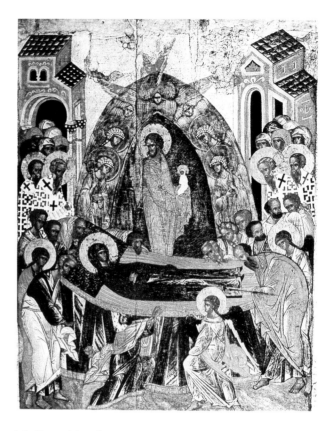

15. Dormition from Gostinopolye Monastery,
ca. 1500. Tretyakov Gallery, Moscow (no. 22296).
"G" in the text.

that this scene tends to be represented less often in icons from the feast tier of the iconostasis and more frequently in those intended as the "local" icon next to the Royal Doors (thus in churches dedicated to the Dormition). [33] This observation suggests that the Menil Dormition would originally have been intended for the festal tier, a possibility favored by the existence of its "twin," the Ascension in San Diego.

Iconographically and compositionally, the Menil Dormition allies itself strikingly with a group of icons created in and around Novgorod between about 1450 and 1550. In approximate chronological order, the Novgorod group includes: a Dormition icon from the feast tier of the iconostasis of a church at Volotovo, dated to the fourth quarter of the fifteenth century and now in Leningrad (hereafter "V", fig. 14) [34]; a Dormition icon from the Gostinopolye monastery iconostasis from the last

years of the fifteenth or first of the sixteenth century, now in the Tretyakov (hereafter "G", fig. 15) [35]; a Dormition from the Church of St. Sophia in Novgorod, ca. 1500, one of the series of double-sided *tabletki* which Lazarev noticed in the Tretyakov and associated with the rest of the set in 1977 (hereafter "SS", fig. 16) [36]; and a mid sixteenth-century, provincial version of the same subject, now in the Russian Museum in Leningrad (hereafter "N", fig. 17). [37]

The shared features of these four paintings emerge clearly upon simple juxtaposition: a composition dominated by the triple mandorla surrounding Christ, who turns sharply to gaze at the face of the outstretched Virgin while holding the *dousha* in profile to the right; a pair of simple buildings with extensively indicated interior spaces and exterior details in the corners; rhythmically disposed figures of the apostles wrapping around the ends of the bier, behind which stack up the paired figures of

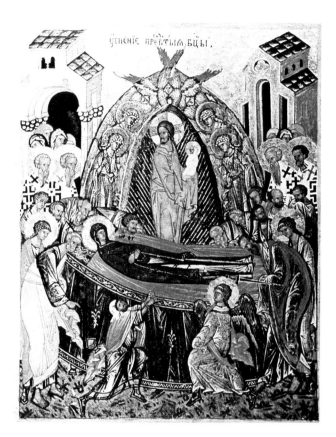

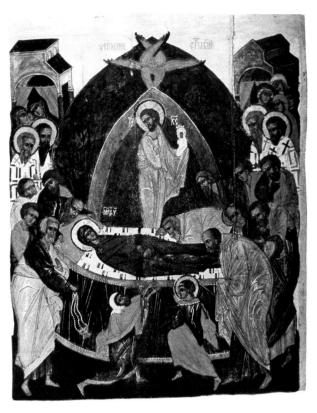

16. Dormition icon (tabletka), ca. 1500, from S. Sophia in Novgorod. Tretyakov Gallery, Moscow (no. 22033). "SS" in the text.

17. Dormition from Novgorod. Russian Museum, Leningrad (no. 3071). "N" in the text.

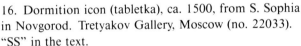

the hierarchs and doubled trio of mourning women; inclusion of the episode of Jephonias in the foreground; omission of the cloud-borne apostles or enthroned Virgin above; and roughly square format (with the exception of V). In fact, so strong are the similarities within this group that one begins to suspect a common model, as attested by a secondary detail such as the flat-roofed house with the broad arch and doubled columns in the upper left corner in V, G, and SS, or by the two apostles awkwardly leaning over the back of the Virgin's bier—perhaps Simon Zelotes at the left, his chin hooked over the edge of the couch, and Matthew (?) at the right—again consistent in V, G, and SS, with the left figure lacking in N.

In several respects the Menil Dormition inserts itself into the Novgorod group. Its pronounced symmetry prompts the inclusion of two pairs of hierarchs rather than the more strictly authorized

three found in Byzantine iconography such as the Kariye mosaic and then resumed in early Rus' versions such as the early thirteenth-century great Dormition in the Tretyakov, discussed above, as well as the Dormition tentatively attributed to Andrei Rublev and his assistants. [38] While the Menil Dormition lacks the Jephonias vignette, the spatial nature of the two buildings, the triple articulation of the mandorla and its dominance of the composition, and the wrapping of the groups of the apostles around the extremities of the bier suggest a relation to the icons of the Novgorod group. The upper reaches of the composition in all these icons are void, unused except for the outstretched wings of the seraphim at the top of the mandorla and the inscription (where it survives). Further, all these icons, by contrast to the great Dormition in the Tretyakov, the "Blue" Dormition (fig. 12), and that attributed to Rublev and his associates, evidence

37

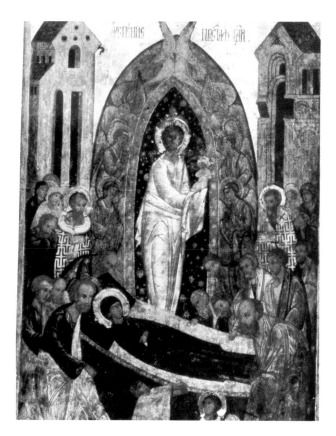

18. Dormition from the Church of Sts. Peter and Paul, Novgorod.

a certain delight in exploring various complex patterns of crosses, rendered in crisp black and white, in the cloaks of the hierarchs under their *polystauria.*

On the other hand, certain features of composition and iconography in the Menil icon suggest that the artist was not entirely bound to the traditions salient in the Novgorod group. Most striking is the greater monumentality that results from the more frontal Christ, who resumes the distant, detached iconography noted in the great Dormition of the early thirteenth century. The outsized, elongated figure establishes more direct communication with the beholder of the icon and avoids the emotional nuance suggested when the figure of Christ directs his gaze toward his mother, a theme noted in the icons of the Novgorod group and amplified in certain sixteenth-century icons by a parallel gesture of the right hand, as may be seen in the Russian Museum Dormition adduced previously (fig. 13).

Beyond this, the identities and grouping of the

apostles seem to follow earlier models: John, leaning in at the head of the bier over the Virgin's pillow, is more prominent for the omission of the Simon Zelotes figure who usually appears at the Virgin's left shoulder in the Novgorod group. At the right, two apostles of middle age bend sharply over the bier and touch it tentatively, while St. Andrew—most easily identifiable of the group by means of his unruly locks—leans into the space in front of the inner radiance of the mandorla, above the strongly horizontal backs of his two colleagues.

There are other surviving icons to which the Menil Dormition bears isolated similarities and which, cumulatively, suggest that its artist worked at a time and place in which resumption of motifs from earlier works of varying date and origin was feasible. A mid sixteenth-century Dormition from the Church of Saints Peter and Paul in Novgorod (fig. 18), published by Kondakov, offers a similarly frontal, monumental Christ looming over a composition which is more pronouncedly vertical than any in the Novgorod group. [39] While the artist here has reduced the number of hierarchs and has crowded vertically the apostles and mourning women due to the narrow format of the icon, two features shared with the Menil Dormition should be noted: above and to the right of the bier, the two apostles plus Andrew configuration is used and, behind these at the right, a singular profiled apostle raises a stump-like right hand to his chin or throat in contemplation of the event. Second, although more steeply proportioned, the right building in the Sts. Peter and Paul Dormition displays the unusual doubled arch for a doorway, scrolled consoles, and lateral decoration that we find in the Menil icon.

That same house—though with only a single arch—appears in this position in the "Blue" Dormition in the Tretyakov Gallery (fig. 12), a work of the second quarter to mid-fifteenth century which is usually assigned with question marks to the School of Tver. [40] This large (113 x 88 cm) Dormition also employs the two apostles plus Andrew configuration of the Menil and Sts. Peter and Paul icons, as well as the apostle with hand raised to chin (although not shown in profile), and, at the far left, an apostle hunched forward and completely wrapped in his mantle, who raises a covered hand to his chin in mourning (a feature also shared with the Menil and

Sts. Peter and Paul icons). Such elements distinguish these three icons from the Novgorod group and may also be noted in yet a fourth icon, sold from the Tretyakov Gallery in the 1920s and now in the National Museum in Stockholm (fig. 19).[41] Neither date nor localization for this work is firm— Abel prefers a date of ca. 1500 and either Novgorod or Pskov, while Smirnova proposes a broader, first half of the sixteenth century date and a localization to either Novgorod or Moscow, or perhaps a good monastery workshop with models from either of those cities[42]—but its association with the group of icons under consideration is evident, even allowing for the elaborate silver *basma* still in place.

A final piece in this puzzle of iconographic and compositional interrelationships is problematically offered by an icon published in 1906 by N. P. Likhachev in his *Materiali dlya istorii russkogo Ikono pisanie.*[43] The work (fig. 20) is reproduced in the still emergent technology of that date—thus of regrettable quality—and is provided with only the most summary of captions; moreover, its fortunes since 1906 and current location are still unknown to this writer. However, even poorly reproduced and full of enigma, the icon clearly belongs in some relationship to the Menil icon and its group by reason of such elements as its main massing, the frontal Christ, and, particularly, the near identity of the pair of buildings in each corner. A single pair of hierarchs flank Christ in the triple mandorla, but the remaining groups of figures match those in the Menil Dormition on an almost one-for-one basis. Further, the brittle folds and patchy highlights of St. Peter's himation at the left offer near perfect

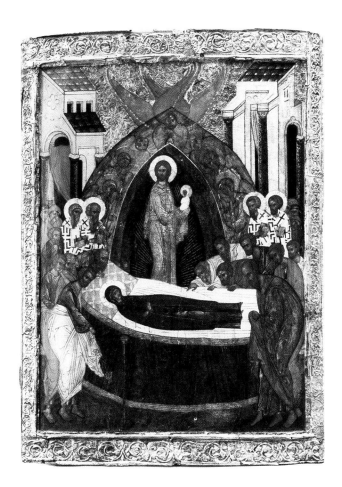

19. Dormition icon. National Museum, Stockholm (NMI 248).

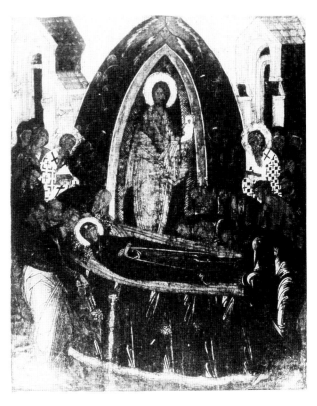

20. Dormition icon, present location unknown. From Likhachev, *Materiali dlya istorii russkogo Ikono pisanie,* vol. I, tabl. CXXI, fig. 232.

correspondances between the two works.

While significant questions remain as regards the nature of certain of these icons and the dates and localization of the two groups which seem to emerge from this survey, it should by now be clear that, solely on the basis of iconography and composition, there is a distinctive cluster of Dormition icons from the Novgorod region and a second group of icons related to these but less strictly. This second group appears to have originated somewhat later—the Stockholm and Sts. Peter and Paul icons seem to span the first half of the sixteenth century—a conclusion we can tentatively draw upon the basis of iconographic comparison and then corroborate by the general stylistic features of the works, as well as by the limited stylistic analysis possible for the Menil Dormition.

The Menil Dormition in Context

With the preceding comparisons in mind, we can turn to particular arguments raised by Vladimir Teteriatnikov in alleging that the Menil Dormition is a twentieth-century forgery. In fact, he has asserted that the Menil icon is a copy of the Sts. Peter and Paul Dormition adduced above, although this claim is not developed. [44] We have already seen that the two icons do share certain compositional and iconographic features, but also that these are more widely shared with other works, whose interrelationships we have broadly sketched in and which were not cited by Teteriatnikov.

In fact, the initial charges of forgery laid against the Menil Dormition and all but one of the other icons in the Hann Collection by Teteriatnikov were prompted in the first instance by strong similarities between these and other, better known icons still in Soviet collections, particularly the Tretyakov Gallery. [45] To complicate matters, the pedigrees of many of the Hann icons, including the Dormition, are admittedly problematic.

According to tradition, George Hann purchased the Dormition icon from the Tretyakov through Mosgostorg, the Moscow branch of one of several trade syndicates in the Soviet Union of the 1930s which arranged sales of works of art to foreigners. [46] Unfortunately, the details of the sale cannot be verified, although Michael Glenny claims that an invoice still exists which lists "extremely low" prices for most of the icons involved. Hann purchased these on the basis of hand-tinted photographs brought to him in the States by an agent of Mosgostorg in 1935. [47] Two labels on the back of the Menil Dormition appear to confirm that the icon was once held by the Tretyakov Gallery, [48] and it has already been noted that these two labels on the Menil icon correspond closely in form, as well as in numerical sequence, to two on the Timken Ascension: GTG nos. 225 and 226, respectively, and 12059 GTG and 12060 GTG (see Table 1 above). Following a suggestion by Vera Beaver-Bricken Espinola, [49] we find that icons bearing the numbers in the series 12000 to 12100 came into the Tretyakov from the Ostroukhov Collection in 1929; some sixty of these remain in Moscow, while gaps in the numbering sequence published in the Antonova/Mneva catalogue of 1963 would accommodate several icons that were once part of the Hann Collection, including both the Dormition and Ascension. File documentation for the icon now at the Menil Collection repeats the provenance from Ostroukhov, although the Christie's catalogue of the Hann sale [50] noted only that icons in the Hann Collection came from the Tretyakov, as well as the Morosov and Likhachev collections. Prior to entry into Hann's possession, neither the Menil Dormition nor its "twin," the Timken Ascension, had been published or otherwise noted. However, while this *ex silentio* argument urges some caution, it alone cannot be taken as proof that the icons are forgeries, particularly in view of other evidence which plausibly allows for them.

In an effort to discredit the Dormition icon, Teteriatnikov makes a number of allegations which he does not trouble to support. Among those most easily checked is the assertion that the thickness and method of working of the icon were "impossible before the eighteenth century" [51]; presumably he means that the Menil Dormition icon is too thick, but the ambiguity is typical. A quick juxtaposition of the dimensions of the icons in the Novgorod group discussed above (see Table 2) reveals that, although their sizes vary widely from the rather large older icons (those from Volotovo and Gostinopolye) to the diminutive

tabletka from St. Sophia, their dimensions easily encompass that of the Menil Dormition, with results neither substantially thicker or thinner than others of comparable height and width, such as V and N. This group includes works from the fifteenth and sixteenth centuries; other works from the sixteenth and seventeenth centuries offer a similar range of dimensions. The result of these comparisons is that this particular index offers no greater precision in dating than any other and that, taken alone, it is inconclusive.

TABLE 2
Comparative Dimensions
Five Dormition Icons

	(in centimeters)		
	h	w	th
(V) Volotovo iconostasis (ca. 1475-1500)	90.5	58.5	3.2
(G) Tretyakov 22296, Gostinopolye Monastery (ca. 1500)	116	91.2	3.8
(SS) Tretyakov, St. Sophia tabletka	24	19.5	not given
(N) Leningrad Russian Museum from Novgorod	84.2	65.2	3.3
Menil Dormition [85-57.57 DJ]	81.6	68.7	3.2

However, Teteriatnikov's fundamental objection to the Menil Dormition and to other icons formerly in the Hann Collection lay in the fact that they appear to copy celebrated icons in public collections in the Soviet Union and that certain museums, such as the Tretyakov Gallery, owned several works which are allegedly identical. [52] In the case of the Menil Dormition, he proposes that its main features derive from the icon formerly in the Church of Sts. Peter and Paul in Novgorod, whose resemblance to and differences from the Menil Dormition have been explored above. [53] He does not develop this assertion by further comparison of the two works, and, as has been demonstrated here, the iconographic, compositional, and stylistic position of the Menil Dormition is far more complex than that of a mere copy of any single extant work.

He does, however, claim that the twin Ascension icon now at the Timken Museum is an identical copy, adducing four other icons from the circle around Andrei Rublev which it closely resembles. [54] For Teteriatnikov, the sort of close copying to which

this group of icons attests is "unknown in the history of Russian art." [55] However, the analysis of the stylistic and compositional relationships among this group of works and the implication for the Timken Ascension remain somewhat unconvincing as Teteriatnikov sets them forth: the icons are not identical. Further, his stylistic assessment of the Timken Ascension rests in part on what he describes as a "style of false piety" which he does not adequately define in such a way as to distinguish this work from others in the group. [56] By way of conclusion to this set of arguments, he notes that two of this group of four icons, an Ascension from the Cathedral of the Dormition in Vladimir by Andrei Rublev and Daniil Chorney (fig. 21) and an Ascension of unknown origin formerly in the Ryabushinski Collection (fig. 22), are owned by the Tretyakov Gallery. [57] Since the Timken Ascension was apparently deaccessioned by the Tretyakov, that gallery would have owned three "identical" icons, a situation which Teteriatnikov finds "fantastic." [58]

Yet the above situation parallels quite closely what we have discovered in exploring the iconography and compositional elements of the group of Dormition icons from Novgorod, which appear identical in some respects and yet can be differentiated, and against none of which can any doubt of authenticity be raised. Further, two of those works now hang in the Tretyakov Gallery. When the Menil Dormition icon was added to this group, we noted that it occupied a position between the Novgorod icons and a number of later Dormition panels which are not so easily localized. This position in particular, although less clearly defined by him, troubled Teteriatnikov, [59] who still classifies the later icons in either the Novgorod or Muscovite school, despite the forced transposition of Novgorodian artists to the capital in the mid-sixteenth century and the resulting blend of traditions and styles in works from this period onward. [60] With the addition of the Menil Dormition to our consideration, we again have a situation in which the Tretyakov Gallery would have possessed three quite similar, although not identical, icons and then deaccessioned the latest and sold it to a Western collector. With a better understanding of the iconographic and compositional context for our icon, such a coincidence seems more plausible, less "fantastic" and certainly not "unknown in

the history of Russian art." Questions remain, but they cannot be resolved solely on the basis of rejecting the process of close copying, which is attested by these two groups and others, particularly of the later sixteenth century.

Conclusions

The Dormition icon in The Menil Collection presents a number of problems that cannot be fully answered without reconsidering the history of icon painting in fifteenth- and sixteenth-century Rus' both more broadly and in greater detail. Above all, however, the work's physical condition and state of preservation seem to reveal significant interventions in at least two phases: the trimming of the original icon to a round format, and then its subsequent restoration to a form and size approximating its original condition. The hypothesis that the first intervention was undertaken to fit the icon to a newer Baroque iconostasis is plausible by comparison to other examples of such formats, if unproven. The restoration to original condition seems to have been of the highest quality: sensitive, practical, and probably not intended to mislead, as its distinctive traits are readily discernible. It also seems that, in touching up the icon, the restorers did take certain liberties with the figure style: the faces, in particular, in the overpainting take on the proportions and features of works closer to the time of Dionysii and his school rather than of later decades. Such an "adjustment" has altered the apparent significance of the icon, although, again, close observation with the unaided eye readily reveals the nature of this intervention. We can only speculate as to its motive.

Parallels between the Menil Dormition and the Timken Ascension in physical construction and in iconographic and compositional contexts offer an example of either very clever forgery or complex, though plausible, art history. With a better picture of the iconographic and compositional position of the Menil Dormition—its basis in Novgorodian traditions amply attested by a group of fifteenth- and sixteenth-century works, and its affinities with a group, though presently less well defined, of later Dormition icons—we find no glaring anomalies.

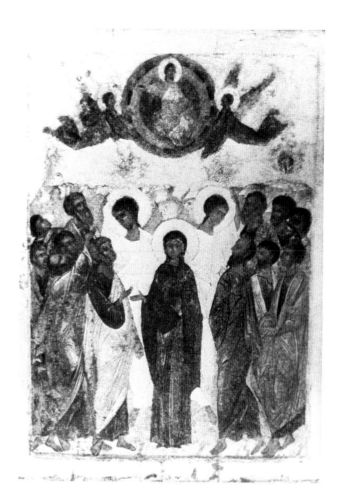

21. Ascension icon, Andrei Rublev and Daniil Chorney, 1408, from the Cathedral of the Dormition, Vladimir. Tretyakov Gallery, Moscow.

It is unneccessary to dismiss the painting due to this mixture of traditions; rather, that fact helps to situate the icon chronologically to no earlier than the second half of the sixteenth century. It is more difficult, based upon both stylistic and iconographic analysis, to offer a *terminus ante*. Certainly we can dismiss most of the technical objections raised by Teteriatnikov against such a date of manufacture, allowing, again, for the problematic history of the physical object. Thus, the probability of the work being a forgery is somewhat reduced: one could view it instead as a piece of fascinating art history, complex and revealing of practices and forces long postdating its original manufacture.

Many questions remain. Some of these may be resolved with further technical investigation of the

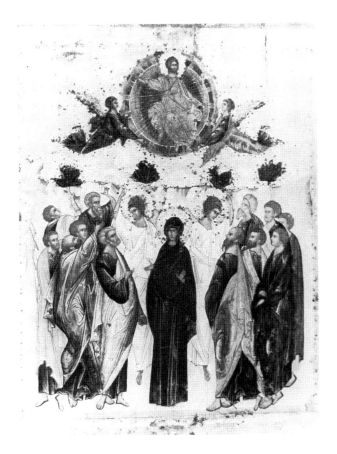

22. Ascension, formerly in the Ryabushinski Collection, ca. 1500. Tretyakov Gallery, Moscow.

Menil icon, such as pigment tests of portions of the center and the corners of the panel to determine whether and at what layers the pigments differ. Other, perhaps more critical, questions require better understanding of the history of restoration and making of copies of icons in the former Soviet Union in the early years of this century. Igor Grabar's introduction to the 1931 exhibition of icons and copies of icons at the Metropolitan Museum[61] offers some tantalizing glimpses of the work of restoration and copying in the large, government-sponsored workshops associated with the major Soviet galleries and museums and, to our contemporary Western perspective, raises many more questions than we currently have the resources to begin to answer. Teteriatnikov, and others in

recent years,[62] clearly are aware of the complexities of this phenomenon and are to be credited for making the public aware of them, even as some of the objections raised against specific works may not withstand scrutiny.

At this point we find ourselves at the intersection of art, money, politics, and scholarship. Because of politics, and also because of economic conditions following upon them, art in the former Soviet Union has played a number of highly significant roles in this century, particularly vis-a-vis the West: no one can have failed to notice that exchange exhibitions of blockbuster proportions have increased in the past two decades. Yet these are only the most recent efforts of a process intermittently carried out since the 1920s, in which icons, and copies of icons, also played a major role as exotic emissaries of an ancient and once again powerful culture. The details of Soviet initiatives to make this art form known to the West and then to sell examples—of various origin—to collectors outside of the Soviet Union remain to be discovered. No mere curiosity, these initiatives have direct bearing on questions of contemporary scholarship regarding works such as the icons we have been considering. They are a part of the contemporary historiography of the art of Rus' and will offer invaluable information and perspectives by which to conduct further scholarly inquiry, which hitherto has been limited by difficulty of access and by political sensitivity.

It is to be hoped that the already promising fruits of *glasnost,* evident in more frequent travel opportunities and scholarly exchanges, will continue to ripen, encouraging greater openness among scholars, freer communication of ideas and information less impeded by bureaucratic and structural obstacles, and greater access by the general public to the rich heritage of art carefully preserved but little known to non-specialists. Under such conditions, the fuller history of the Menil Dormition, and of other icons which travelled to the West in the course of this century, may be written with greater certainty.

For all their assistance at various stages in the writing of this paper I wish to thank most warmly Professor Bertrand Davezac, Mr. Harris Rosenstein, and Ms. Susan Davidson of The Menil Collection and Ms. Andrea di Bagno, formerly of The Menil Collection.

1. L. Ouspensky and V. Lossky, *The Meaning of Icons* 2 (Crestwood, 1952; 1982): 213–214; the authority for the inclusion of the hierarchs is the Pseudo-Dionysos, "De Divinis Nominibus" (PG 3 [Paris, 1889], col. 681 ff.)

2. A. Avinoff, *Russian Icons and Objects of Ecclesiastical and Decorative Arts from the Collection of George R. Hann* (Pittsburgh, 1944), no. 69, was the first publication of this icon.

3. *Icons and Fakes: Notes on the George R. Hann Collection* (privately published, 1981), no. 8, 122–129.

4. Avinoff, no. 69.

5. Letter, 22 September, 1988; author's and Menil Collection files.

6. Letter of 22 September, 1988, 3.

7. Ibid., 5.

8. Ibid., 5.

9. Catherine Bortoli: Communication to the editor in June, 1991.

10. Dormition icons lacking inscriptions include, among others, the giant panel from the Desiyatinnaya Monastery, the "Blue" Dormition, and the Dormition attributed to Rublev, all in the Tretyakov; the Volotovo Dormition now in Leningrad; and the missing icon published by Likhachev in 1906. For all of these, see the section on composition and iconography below.

11. "Examination of a Russian Icon, the Ascension," private report to the Putnam Foundation, April 16, 1984.

12. Kjellin, Helge. *Russiske Ikoner i Norsk og Svensk eie* (Oslo, 1956), cat. nos. 84 and 85, 199.

13. 1972, translated from the Russian by P. S. Falla, 92.

14. Faensen, Hubert, and Vladimir Ivanov. *Early Russian Architecture* (London, 1975), 422, date this iconostasis to 1680–1; it is reproduced, though erroneously labelled, in S. Massie, *Land of the Firebird: the Beauty of Old Russia* (New York, 1980), unnumbered plate in first section of the text.

15. Other Muscovite Baroque iconostases are recorded for the Dormition Cathedral in the Novodevich Monastery (D. K. Treneff, *Ikonostas smolenskovo sobor a moskovskovo novodevichyavo monastirya, XVI–XVII vekov* (Moscow, 1902), 34 fig. no. 30) and V. I. Antonova and N. E. Mneva, *Katalog drevnerusskoi zhivopisi, XI nachala XVII veka* (Gosudarstvennaia Gallereia Tretyakova) (Moscow, 1963), II. no. 973, 454–455, document a Baroque iconostasis with round icons in the Church of the Presentation in Barashakh in Moscow (figs. 162, 163).

16. N. J. Mneva, N. N. Pomeranzev, and M. M. Postnikova-Losseva, "Schnitzerei und Plastik des 17. Jahrhunderts," in Akademiia nauk SSSR, *Geschichte der russischen Kunst,* vol. IV (Dresden, 1965), 234, Abb. 169, for Sveni with its row of octagonally-framed feast icons; other iconostases with round or polygonal frames may be identified in several reproductions within this anthology, such as the feast row in the icon screen of the Roshdestvo-Bogorodizy Church in the Ferapont Monastery, (vol. III, 359, fig. 269), with oval frames.

17. Antonova-Mneva, II, no. 973 again.

18. Treneff, op. cit., n. 13 above, 125 and figs. 93–106.

19. J. J. Danilowa and N. J. Mneva, in Akademiia nauk SSSR, *Geschichte der russischen Kunst,* vol. IV, fig. 219.

20. S. I. Maslenitsyn, *Jaroslavian Icon-Painting* (Moscow, 1973), pl. 61 for a portrait of the Evangelist Mark by Semyon Spiridonov for the Royal Doores of a Jaroslav iconostasis of the 1680s; and N. P. Kondakov, *The Russian Icon,* II (Prague, 1929), pl. 24, from another set of Royal Doors, a medallion of the Virgin with Archangels, assigned, probably erroneously, to the fifteenth century.

21. For a full discussion of the stylistic and compositional contributions of Dionysii, and then his sons, to the art of the sixteenth century, see G. H. Hamilton, *The Art and Architecture of Russia* 3 (Harmondsworth, 1983), 157ff.

22. M. V. Alpatov, *Art Treasures of Russia* (New York, nd.), pl. 61

23. Alpatov, op. cit., pl. 65.

24. No. 30461; Antonova-Mneva, I, no. 11, 73–75 and pl. 73; see also the discussion in M. V. Alpatov, *Early Russian Icon Painting* (Moscow, 1984), 11.

25. Paul A. Underwood, *The Kariye Djami,* I (Princeton, 1968), 164–167 and vol. II, pl. 185.

26. Acc. no. 14244; Antonova-Mneva, no. 216, 255; Alpatov, *Early Russian Icon Painting,* 11, notes the greater passion in the postures of the apostles, the contrast of their sizes to that of the enormous Christ, and the strong color resonance in the glowing cherub set against the deep blue mandorla.

27. 25. Acc. no. 22303; Antonova-Mneva, no. 201.

28. *Early Russian Icon Painting,* 11.

29. Acc. no. 3122; D. Likachev, *Novgorod Icons, XII–XVIIth Centuries* (Leningrad, 1980), 316 and pls. 165–167.

30. Based upon the apocryphal text of St. John, cited below.

31. W. Felicetti-Liebenfels, *Geschichte der russischen Ikonenmalerei* (Graz, 1972), 156ff.

32. Tischendorf, *Apocalypses Apocryphae* (Leipzig, 1866), 95ff; see also Underwood, loc. cit., 164.

33. *Zhivopis velikovo Novgoroda, XV vek* (Novgorod, 1982), 251.

34. Acc. no. 3770, from E. S. Smirnova, *Zhivopis Velikovo Novgoroda XV vek* (Leningrad, 1982), cat. no. 30; D. Likhachov, *Novgorod Icons*, 302–303, with full bibliography, and pls. 115–117; V. Lazarev, *Pages from the History of Novgorodian Painting: the Double-Faced Tablets from the St. Sophia Cathedral in Novgorod* (Moscow, 1977), 25.

35. Acc. no. 22296; D. Likachev, *Novgorod Icons*, 314, with full bibliography, and pl. 159.

36. Acc. no. 22033; *Pages from the History of Novgorodian Painting*, 43–44 and passim.

37. Inv. no. 3071; Likachev, *Novgorod Icons*, 328, with full bibliography, and pl. 208.

38. Tretyakov Gallery, acc. no. 28626; Antonova-Mneva, no. 228, 280–281.

39. *The Russian Icon* (Prague 1929), II. pl. XLIII. 2. The present location of this work is unknown to me.

40. Antonova-Mneva, I, no. 201, pp. 235–236, and pl. 141; see also M. Alpatov, *Early Russian Icon Painting* (Moscow, 1984), 292. The icon was formerly in the Ostroukhov Collection.

41. Inv. no. NM1248; U. Abel, *Ikonen aus dem Nationalmuseum Stockholm* (Berlin, 1978; 2nd ed. 1983, no.1 (colorplate); U. Abel, "The Collection of Icons in the Stockholm Nationalmuseum," in Acta Universitatis Upsaliensis, Figura, n.s. 19: *Les pays du nord et Byzance* (Uppsala, 1981), 255; and U. Abel, *The World of Icons*, exhibition catalogue (Helsinki, 1970), no. 17 (ill.).

42. Private communication from Ulf Abel, 10 October, 1990.

43. St. Petersburg, 2 vol. album; the icon appears in I, tbl. CXXI, fig. 232, with label on p. 8.

44. Loc. cit., p. 127.

45. *Icons and Fakes,* iv et passim.

46. Michael Glenny, "Icons, Fakers, and Fools," *Arts and Antiques* (April, 1984), 52.

47. Ibid., 53.

48. See the comparative table of markings on the reverse of both the Menil Dormition and the Timken Ascension, Table 1 above.

49. "Examination of a Russian Icon, The Ascension," op. cit., 8.

50. Christie's, *The George R. Hann Collection, Part I. Icons and Russian Works of Art,* April 17–18, 1980; see, too, Bronislaw Dvorsky, "The Hann Collection of Icons," *Christie's Review of the Season 1980,* 338.

51. Op. cit., 123.

52. Op. cit.,"Introduction", iv, and 135.

53. Op. cit., 127

54. Op. cit., 130ff, especially 133–135.

55. Op. cit., 135.

56. Op. cit., 134.

57. The Rublev-Chorney icon dates to 1408; Antonova-Mneva, pl. 183; Felicetti-Liebenfels, 78, gives its dimensions as 124 x 93 cm. —For the Ryabushinski Ascension, see Antonova-Mneva, no. 175, where it is given a date of ca. 1500.

58. Op. cit., 135.

59. Op. cit., 125–127.

60. G. H. Hamilton, *The Art and Architecture of Russia 3* (Harmondsworth, 1983), 158–159.

61. "Ancient Russian Painting: Icons from the Twelfth to the Eighteenth Century," in *A Catalogue of Russian Icons received from the American Russian Institute for Exhibition* (New York, 1931), ix–xviii.

62. Others who have addressed the problems of the export of originals and copies of works of the Russian artistic patrimony include Michael Glenny, op. cit., n. 44 above, and Robert C. Williams, *Russian Art and American Money, 1900–1940* (1980); a slightly different perspective on this dynamic is offered in Armand Hammer, *The Quest of the Romanoff Treasure* (1932).

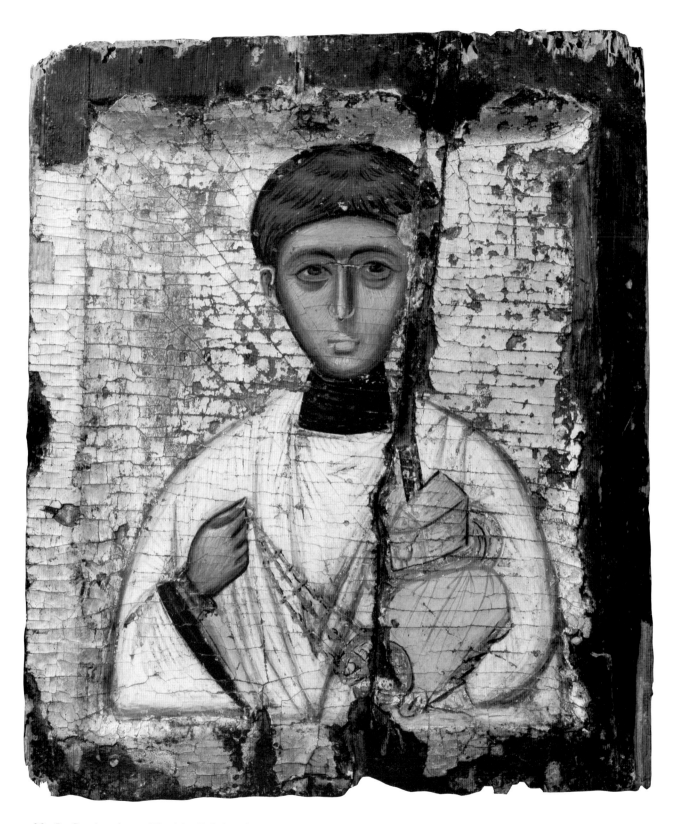

23. St. Stephen icon. The Menil Collection, Houston.

The Saint Stephen Icon

ELLEN C. SCHWARTZ

In 1985, the Menil Collection acquired this superb icon of St. Stephen (pl. 2, fig. 23). The panel was part of the collection of Eric Bradley, bought originally from the Temple Gallery in London. The icon, accession #85–57.03 DJ, is 26.5 cm high, 23 cm wide, and 2.3 cm thick. [1] The icon is painted on a one-piece plank of solid wood bevelled to a depth of .6 cm. While it has not warped, it has cracked and been mended with iron dowels driven through both parts, sometime in the eighteenth or nineteenth century (visible in X-ray photograph, fig. 24). [2] The condition of the icon is fairly good. The ground painted on the reverse and the preparation for color on the top of the panel remain, along with the shaft for the original hanging ring. The figure is entirely preserved, although the inscription to either side is badly effaced. The icon is painted in a rather unusual technique, for the entire panel was covered in mordant, an earth pigment preparation, rather than the usual combination of mordant as a base for the figure, and bole, a preparation made from animal glue, which served as a binder for the gilded background. [3] On the preparation over the second layer of gesso, the figure was laid out with incised lines, those for the halo made with a compass. The examination report prepared by the Courtauld Institute hints at another irregularity in the painting, stating that the infra-red photo shows wide, loose brush work in the robe which seems to indicate a suppler medium than tempera (fig. 25). Unfortunately the report does not elaborate on this, other than to call it "a very resinous medium." [26] The buildup of color in the face, however, is

discussed in detail; it consists of many distinct areas of different colors abutted, not layered (fig. 26). Greenish brown shadows in glaze are laid on toward the end of painting the face, hands, and ears. Pure vermilion was used for the red touches—the inscription, the tip of the nose, and parts of the gold objects the saint holds. [5]

The St. Stephen panel is not unknown. It was exhibited at Cardiff University in 1973, and at the Temple Gallery in 1974. It formed part of the show "Splendeur de Byzance," in Brussels (1982), and it was on display at Dumbarton Oaks in 1983. Despite its notoriety and publication in several catalogues, [6] many issues about the icon remain unresolved, and it is this set of intriguing questions which this article will address.

The icon shows the single bust portrait of Saint Stephen dressed as a deacon, presented frontally against a gold background. The bust length figure with attributes is the usual format for such a small-scale icon, which may have been placed in a chapel dedicated to the saint, or brought out on his feast day, 27 December. The St. Panteleimon icon at Chilandar provides a good comparison (fig. 27). The identification is assured by the inscription (fig. 28), which—while in poor condition—is still readable as the standard Ὁ αγιος στεφανοσ ὁ πρωτομαρτυρος *(O agios Stephanos o protomartyros).*

Depictions of St. Stephen as a deacon are numerous in icon and monumental painting, such as the well-known eleventh century example in the Hermitage. [7] Often found at the eastern end of a church, mosaics and frescoes of Stephen in the

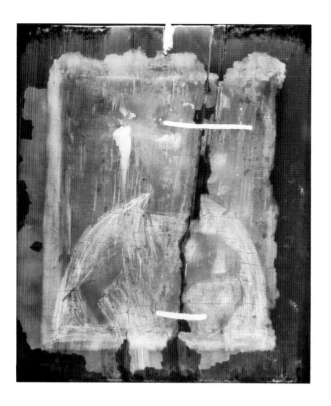 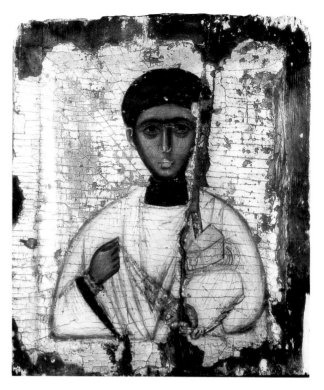

24. St. Stephen icon (x-ray photograph). The Menil
Collection, Houston.

25. St. Stephen icon (infra-red photograph). The Menil
Collection, Houston.

26. St. Stephen icon, diagram of layers of pigment
(cross section taken through carnation—at side of face).
Based on examination report, Courtauld Institute, London.

company of other deacons show him dressed as in the Menil icon in a dark undergarment, a white surplice, and a thin stole or orarion falling over the left shoulder. Early writers comment on the orarian which symbolizes the wings of an angel;[8] angel-deacons, in fact, are often found alongside historical deacons, performing the same functions, such as wielding rhipidia during communion as in the apse of the church of Saint Clement, Ohrid, from 1295.[9] St. Stephen is traditionally shown with a pyxis and a censer.

Within this canon, however, several elements of the Menil icon stand out as unusual. The liturgical implements held by the saint are noteworthy. St. Stephen holds a gold casket in his left hand; it rests on a golden plate supported by the saint's hand shrouded in a red cloth. With his right hand, he swings a censer. The censer shown in its entirety is primarily reserved for full-length depictions; bust portraits include only the upper parts of the chains, as in a mid thirteenth-century medallion from Peć (fig. 29). In our panel, however, it is shown

completely and with a surprising attention to detail. The three-part bulbous body and the three chains made of long and cross-shaped links are seen in many fourteenth-century frescoes, such as in the Koimesis scene from Staro Nagoricano (1316–18).[10] Bulbous bodied censers exist in many collections, and similar chains can also be seen in preserved objects like the fifth/sixth-century censer in the Malcove Collection, Toronto (fig. 30).[11] The bottom flange, and the embers glowing within complete the detailed description on the Menil panel.

The attention paid to the censer makes the other object carried by St. Stephen all the more puzzling, if we are to accept its veracity. For this piece is truly unusual. Typically the pyxis a deacon holds has a cylindrical shape and domed lid like the one held by St. Euplos in a thirteenth-century fresco from Studenica.[12] In the Menil panel, the golden box is house-shaped with a pitched roof. This surprising shape must have inspired Lafontaine-Dosogne to call it a "box for alms" in the Brussels catalogue.[13] But the gold patenlike plate on which the object is

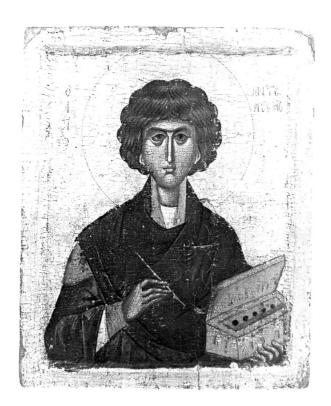

27. St. Panteleimon icon. Chilandar Monastery, Mt. Athos.

28. St. Stephen icon, inscription detail (diagram by author). The Menil Collection, Houston.

29. Roundel showing Deacon Isaurios, ca. 1240–60. Holy Apostles Church, Peć.

30. Censer, ca. 6th century. The Malcove Collection, Toronto.

31. Gold reliquary, 6th century, Yugoslavia. The Menil Collection, Houston.

carried—along with the covered hand—underscores the importance and sanctity of the box, and the respect the saint shows for it. This argues against its identification as anything other than a pyxis, a container for the consecrated host. But there remains the problem of its shape. Small metal boxes do exist, but most are the inner containers of sarcophagus-shaped reliquaries, like the sixth-century one in the Menil Collection published by Davezac (fig. 31), and the contemporary silver one from Leningrad. [14] Duffy and Vikan argue for the interchangeability of shapes and functions of small metal boxes in early Byzantine times, [15] and indeed, later, house- and box-shaped pyxides do appear in depictions of deacons in fourteenth-century frescoes from Serbia and Macedonia. Most of these are found in paintings of the so-called Milutin group—such as the two examples from the King's church at Studenica from 1313/14 (fig. 32), and another pair from the church of Bogorodica Ljeviska in Prizren (1307-13). [16] Possible implications of these comparisons as to the dating and origin of the icon will be discussed below. For now, note that the emphasis on the three liturgical objects in the Menil icon seems to stress the multiple functions of the deacon who plays a major role during the liturgy and at communion time, and who also carries communion to other churches as well as to the homebound.

The Menil St. Stephen is a truly beautiful piece of Byzantine painting. The strong shape of the figure stands out from its gold background, filling and dominating the panel. The curving lines of the shoulders and drapery, indicated by thin gold lines, give the figure breadth, although the dependence on line to define the figure and garment folds lends an ethereal air to the icon. The severe geometry of the face provides a strong contrast to the delicate rendering of the body, and the shading of the face with green, particularly around the perimeter, produces a three-dimensional effect lacking in the draped bust below. This contrast is echoed by the use of both modelling and an outline in the painting of the head. The most dominant visual feature of the icon is the use of radiating white highlights; in addition to the usual lights on the nose, in the eyes, and around the mouth, a fine network of radiating white lines covers the surface

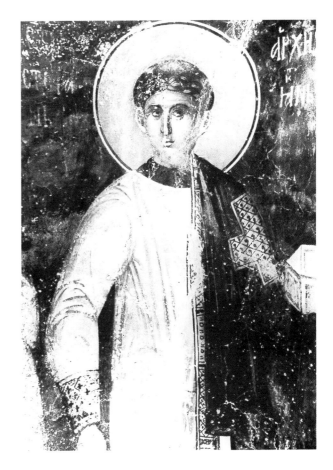

32. Deacon from King's Church, 1313/14. Manastir Studenica, Serbia.

of the cheeks. Another unusual highlight form is the use of vertical strokes—not horizontal—to define the chin.

Liveliness is lent to the face by the numerous touches of vermilion. These are found under and along the nose and on the lips, as well as in the eyes and on the cheeks. This use of red, in fact, ties the surface of the icon together: the red in the face echoes the red letters of the inscription, the red in the folds in the collar of the undergarment, and the red lining of the sleeves. The liturgical implements Stephen holds in his left hand are supported on a red cloth; red is used to outline the pyxis, paten, and censer chains as well as to indicate the glowing coals inside the swinging vessel.

The St. Stephen icon has been attributed to the thirteenth or fourteenth century.[17] The inscription is in such fragmentary condition that paleographic dating is of limited use. A similar form of alpha with a long tail and serif pointing to the left is used sometimes in the mosaics of St. Mary Pammakaristos (Fetiye Camii), as seen in the apse inscription (fig. 33).[18] Parallels may also be suggested with inscriptions in old Serbian; the alpha is found at Mušutištu (1315), along with the ligature omicron/upsilon rendered as a vertical unit with a tall stem (fig. 34).[19] Similar ligatures are found in Stefan Decanski's inscription at Banja (1329),[20] while comparable alpha forms can be found in a grave inscription from 1330.[21]

The majority of the evidence adduced for dating the St. Stephen icon, however, must be stylistic and iconographic. The proportions of the figure and its relationship to the panel recall the Chilandar Panteleimon icon attributed to the end of the thirteenth or beginning of the fourteenth century

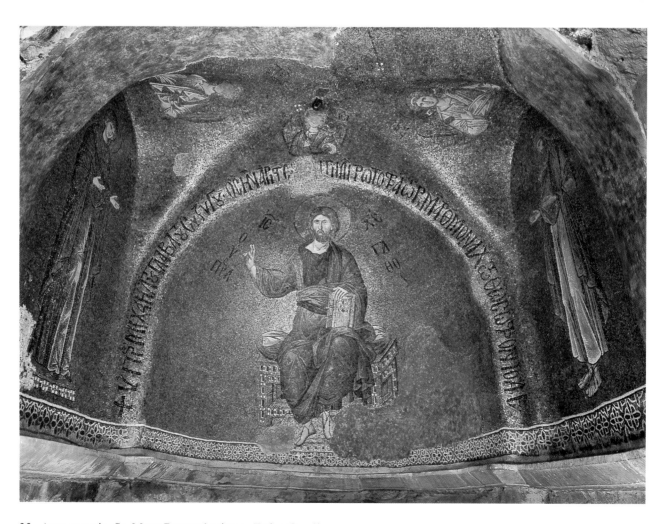

33. Apse mosaic, St. Mary Pammakaristos. Fetiye Camii.

+ПОУЕСЕ:НСЬЗДАСЕ: БЖСТВЬНН · ІКОУГН·ХРАФУ ГНЕВАУЦЕНШЕ·БЦЕ
ФІНЈГЕ:ІСТЕМЕЛНАВАГРЬНСОКФБКРАНЬ:ХРОША СТРКДОМЬ ІЕПОСПЕШЕНЕНЬІ СЬВЕЛНКОКА
ЗІЦА ДРАОСЛАВАСЕ ЛЕНОМЬ СПОДУЖЕНЬ СВОНЬ ІСТАНШОМЬ СНОЮЬСН НЕНОМЬ ФРОСІ ВЛЕ: Ь S Ф) КГ ЕНАК

34. Inscription from church at Mušutištu, 1315.

(fig. 27). Certain stylistic elements appear earlier. The youthful type, with the features clustered in the center of the geometric face and capped by short or curly hair, had been popular for young physician and warrior saints since the twelfth century—a well-known example is the framed Panteleimon at Nerezi. [22] Other stylistic norms can be identified in the second half of the thirteenth century: the bulbous, curving contours of the body are paralleled at Sopocani (ca. 1265), along with some details— the shape of the eyes with curving shadows indicated by one stroke beneath, and the fine network of lines fanning out over the surface of the face. [23] Most of the icon's stylistic features are only found later, however. The exaggerated triangular shape of the head is found in works such as the frescoes in the main church at Chilandar, ca. 1319. [24] The clustering of the features in the center of the face, along with the exaggerated almond-shaped eyes, the long, thin nose, and the almost sullen pursed shape of the mouth are seen in some frescoes of the Kariye parecclesion (fig. 35). [25] The tiered hairdo is a fourteenth-century style, as seen in several examples from Staro Nagoricano (1316– 18). [26] And the fine network of radiating highlights is closely paralleled in a Virgin Hodegetria icon housed at Rhodes, which travelled with the show, "Holy Image, Holy Space" (fig. 36). Surprisingly, this icon also displays the vertical highlights on the Virgin's chin, as well as the vermilion outline of the tip of the Child's nose. The icon has been attributed to a Constantinopolitan workshop in the second quarter of the fourteenth century, a dating close to the time of our piece. [27] An early fourteenth-century date for the St. Stephen icon is further supported by the iconographic detail of the pyxis; as we have seen, comparisons can be made with pyxides held by deacons in frescoes from Bogorodica Ljeviska

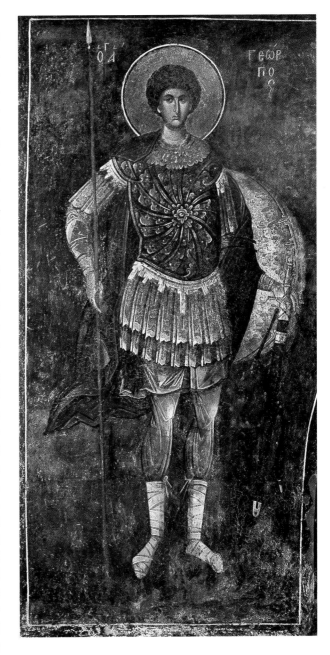

35. St. George from the Kariye Djami parecclesion, ca. 1320.

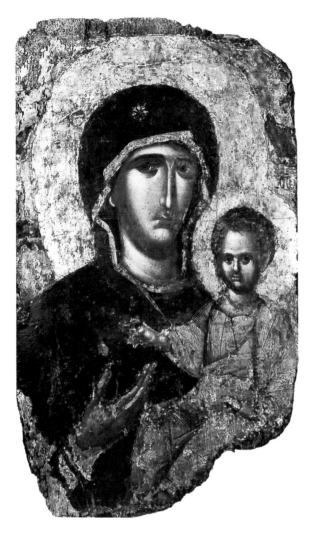

36. Virgin Hodegetria, from a double icon, ca. 2nd quarter of fourteenth century. Castello, Rhodes.

(1307–13) and Studenica (1313/14). [28] Thus, both iconographic and stylistic evidence point to a date in the first quarter of the fourteenth century as most reasonable for the St. Stephen icon.

Some of these comparisons may hint at a provenance, as well. While the inscription in Greek indicates to a Greek origin, patron, and artist, a connection with the workshops decorating contemporary churches in Serbia seems clear. This might indicate Thessalonica as a likely place of manufacture, for the Thessalonican origin of many of the artists working for King Milutin has been established without doubt, and a similar provenance has been posited for the painters of other contemporary ensembles. [29] No stylistic parallels from Thessalonica have emerged, so far, however; frescoes and icons from Northern Greece exhibit a more vigorous and robust style. [30] Closer stylistic forms, like the Hodegetria icon mentioned above, have been attributed to the capital, but usually on basis of quality alone. The refinement of our figure, reminiscent of both the Virgin icon and the Kariye decoration may point to a metropolitan origin for the Stephen panel; at this point, this is as specific as one can hope to be.

With many of secrets revealed, the Menil St. Stephen can rightly take its place among the highest quality paintings of the Byzantine Palaiologan period. We are fortunate to have this piece in an American collection, available to scholars and amateur lovers of Byzantine art alike.

1. Data from the accession report, The Menil Collection.

2. The X-ray photograph shows two dowels, while a drawing in the examination report prepared by the Courtauld Institute (1972–73) shows only one. My thanks to The Menil Collection for making this report and many photographs available to me.

3. Thanks to conservator Andrea di Bagno for her opinion on the preservation and repair of this piece.

4. Courtauld examination report.

5. Ibid. The examiner's suggestion that, "The strange incisions extending from the left hand ear may have been part of an unfulfilled plan to decorate the halo," however, is contraindicated by the pure Byzantine style of the piece.

6. Entry by Dick Temple on the St. Stephen icon (#102) in the catalogue of the show at University College, Cardiff, *Image, Picture, God, Likeness* (Cardiff, 1973), n.p.; entry on Icon #2 by Dick Temple in the Temple Gallery exhibition catalogue, *Masterpieces of Byzantine and Russian Icon Painting 12th–16th Century* (London, 1974), p. 15; entry by Jacqueline Lafontaine-Dosogne in the catalogue, *Splendeur de Byzance* (Brussels, 1982), icon #5, p. 40.

7. See Alice Bank, *L'Art byzantin dans les musées de l'Union Soviétique* (Leningrad, 1977), p. 315 and fig. 233.

8. S. Salaville and G. Nowack, *Le Role du Diacre dans la Liturgie Orientale* (Paris-Athens, 1962), pp. 4–8.

9. Petar Miljković-Pepek, *Deloto na zografite Mihailo i Eutihij* (Skopje, 1967), figs. 38–41. An angel-deacon fills the intrados of the door between the prothesis and apse in the Holy Apostles church at Peć, while a bust medallion of the deacon Isaurius decorates the south wall of the choir.

10. Richard Hamann-MacLean and Horst Hallensleben, *Die Monumentalmalerei in Serbien und Makedonien* (Giessen, 1963), fig. 290; a similar one from Sv. Nikita is seen in fig. 230.

11. Sheila D. Campbell (ed.), *The Malcove Collection* (Toronto and Buffalo, 1985), object #116, p. 90.

12. Sima Ćirković, Vojislav Korać, Gordana Babić, *Studenica Monastery* (Belgrade, 1986), fig. 55.

13. *Splendeur de Byzance*, p. 40. The Courtauld examination report calls it a "tabernacle."

14. For the Menil piece, see Bertrand Davezac, "A Gold Byzantine Reliquary," *The Menil Collection* (New York, 1987), pp. 74–78 and fig. 63; the silver reliquary is discussed in Kurt Weitzmann (ed.), *Age of Spirituality* (New York, 1979), p. 633.

15. John Duffy and Gary Vikan, "A Small Box in John Moschus," *Greek, Roman and Byzantine Studies* 24, 1 (Spring, 1983), 93–99.

16. Gordana Babić, *Kraljeva crkva u Studenici* (Belgrade, 1987), figs. 85, 86, and also in the portrait of an unidentified deacon forming part of pendant pair on the eastern wall (sketch V); and Draga Panić and Gordana Babić, *Bogorodica Ljeviška* (Belgrade, 1975), fig. 10, p. 53 and sketch 1, p. 116. Rectangular pyxides with flat tops are also to be found throughout this region, as early as the eleventh-century decoration of Sv. Sofia, Ohrid; see Hamann-MacLean and Hallensleben, *op. cit.*, pl. 8.

17. The Menil Collection accession report cites a thirteenth-century date, as do the entries by Temple; Lafontaine-Dosogne suggests one in the fourteenth century (*Splendeur de Byzance*, p. 40).

18. Hans Belting, Cyril Mango and Doula Mouriki, *The Mosaics and Frescoes of St. Mary Pammakaristos (Fetiye Camii at Istanbul)*, Dumbarton Oaks Studies XV (Washington, D.C. 1978), pl. II and figs. 24b and 25a.

19. Gordana Tomović, *Morfologija ćiriličkih natpisa na balkanu* (Belgrade, 1974), inscr. #25, p. 48.

20. Ibid., inscr. #29, pp. 50–51.

21. Ibid., inscr. #30, pp. 51-52.

22. Vojislav J. Djurić, *Vizantijske freske u Jugoslaviji* (Belgrade, 1974), pl. V; antecedents to this type may be seen in the sixth-century Sinai encaustic icon of the Virgin and saints, pictured in Kurt Weitzmann, *The Icon* (New York, 1978), pl. 2.

23. See Vojislav J. Djurić, *Sopoćani* (Belgrade, 1963), pl. XLVII.

24. Dimitrije Bogdanović, Vojislav J. Djurić, and Dejan Medaković, *Chilandar* (Belgrade, 1978), fig. 60.

25. Detail of St. George from Paul A. Underwood, *The Kariye Djami* (New York, 1966), vol. 3, pl. 250.

26. *Deloto* (as in note 9), pls. 177, 178; the same form can be found at Chilandar (*Chilandar* [as in note 24], pl. 64), among many other examples.

27. Myrtali Acheimastou-Potamianou (ed.), *Holy Image, Holy Space* (Athens, 1988), catalogue no. 18, pp. 182–183.

28. Similar pyxides may be identified in the poorly preserved deacon frescoes in the sanctuary at Matejić, 1356-60; see Tania Velmans, *La peinture du moyen âge en Yougoslavie* (Paris, 1969), fasc. IV, pls. 65 and 69.

29. The Milutin school is discussed in Slobodan Ćurčić, *Gračanica, King Milutin's Church and Its Place in Late Byzantine Architecture* (University Park, PA and London, 1979), pp. 70–141. Arilje, painted in 1296, has been linked by inscription to a workshop from Thessaloniki; see Sreten Petković, *Arilje* (Belgrade, 1965), pp. IX–X.

30. Examples of painting from Thessaloniki and its cultural orbit are presented in Doula Mouriki, "Stylistic Trends in Monumental Painting of Greece at the Beginning of the Fourteenth Century," *Vizantijska Umetnost Početkom XIV Veka—Naučni skup u Gračanici, 1973* (Belgrade, 1978), pp. 55–70 and figs. 1–29.

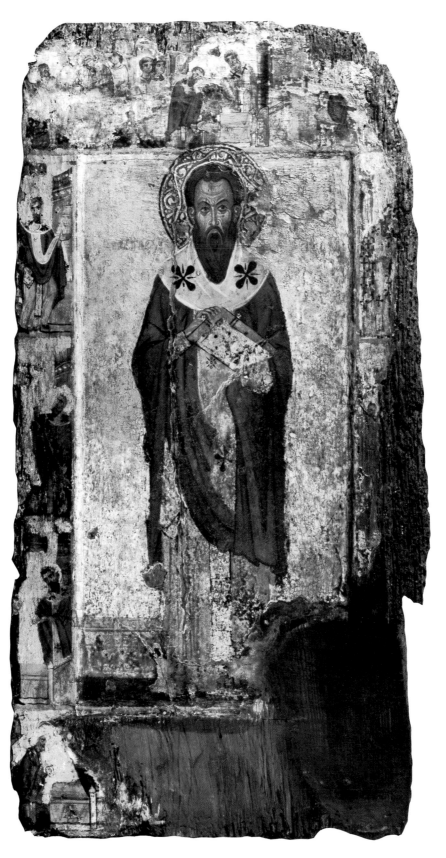

37. Icon of St. Basil. The Menil Collection, Houston.

Vita Icons and "Decorated" Icons
of the Komnenian Period

NANCY PATTERSON ŠEVČENKO

The icon of Saint Basil in The Menil Collection (pl. 3, fig. 37) belongs to a type of icon known as "hagiographical," "historiated," or, most commonly, a "vita" icon. This genre first appears in the East around the late twelfth or early thirteenth century (fig. 38), and has a long and happy life in post-Byzantine Greece (fig. 39), in the Balkans, and in Russia (fig. 40)[1]; it was transmitted to the West (fig. 41),[2] and even made a startling appearance in 1988 in the *Boston Globe* (fig. 42).[3] In the middle of such icons is the image of a saint—sometimes the figure is full-length, sometimes a bust—and around him, usually on all four sides, are little compartments containing scenes from his life.

The form is so familiar that it is somewhat surprising to realize that there are scarcely two dozen surviving Byzantine examples, and that no one really knows how and where the form originated.[4] In Byzantine texts vita icons do not apparently constitute a distinct category. Formal parallels in late antiquity can be found—such as Heracles or Mithras surrounded by their various labors—and there are comparable forms among Early Christian monuments such as the ivory five-part diptychs (fig. 43) or the portrait of St. Luke flanked by Gospel scenes in the so-called St. Augustine Gospels in Corpus Christi College, Cambridge (Cod. 286, fol. 129v) (fig. 44). But if we try to take the story forward in time, we run into difficulties. A little Carolingian ivory book cover of Christ in the Bodleian Library in Oxford does appear to imitate the form of the earlier ivories (fig. 45), but then the trail vanishes; the reappearance of the form on thirteenth-century

Byzantine icons is unlikely to have depended directly on such models, and we should look for an origin closer in time.[5]

What, then, are the possibilities? One is that the scenes around the sides were thought of as wings, and have their source in ivory triptychs—a large central image, with smaller ones at the sides.[6] There is, in fact, a St. Nicholas icon on Sinai of the late eleventh century which could well reflect the influence of this triptych form (fig. 46).[7] But on our vita icons the scenes almost always go around all four sides, for which I know of no parallel among Byzantine ivories.

Another hypothesis is that the vita icons imitate epistyle cycles: the *rows* of scenes on a single wooden beam designed to be placed above the templon columns. Epistyles usually contain the Twelve Feasts, but we do know of epistyles with scenes from the life of a saint. There is one very fragmentary early thirteenth-century example on Sinai which has Nicholas scenes, and a well-preserved one illustrating the posthumous miracles of St. Eustratios, miracles for which, incidentally, we have no surviving text whatsoever (fig. 47).[8] In both cases the scenes occupy small arches, and are interrupted by a central Deesis. There is textual evidence for the existence of such epistyles from an even earlier period: a list drawn up by Michael Attaleiates, the Constantinopolitan historian, of icons that he is handing over to his foundation, the monastery of Christ Panoiktirmon, includes this item: Τὸ τέμβλον ἔχον καὶ αὐτὸ μέσον τ(ὴν) Δέ(ησιν) καὶ τοῦ τιμίου καὶ ἁγίου Προ(δρόμου) τὴν

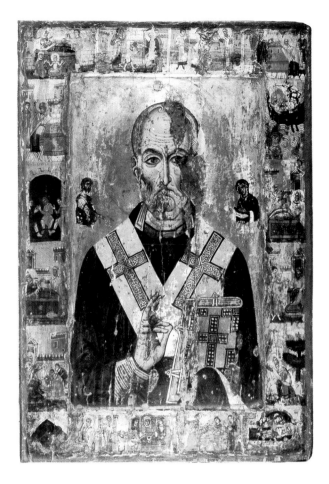

38. Vita icon of St. Nicholas. Monastery of St. Catherine, Mt. Sinai.

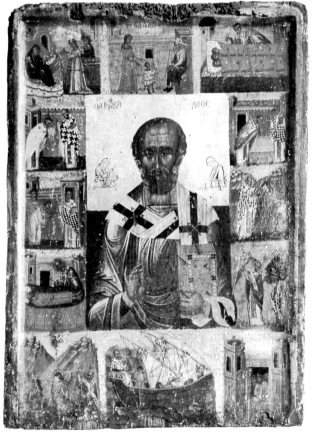

39. Vita icon of St. Nicholas. Monastery of St. John, Patmos.

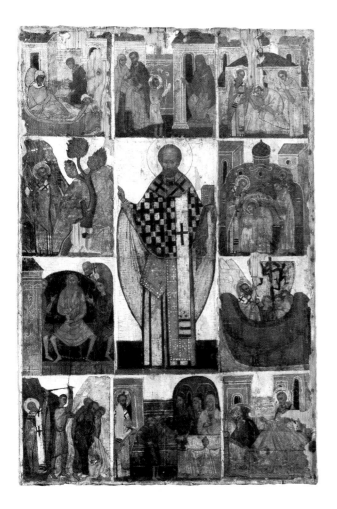

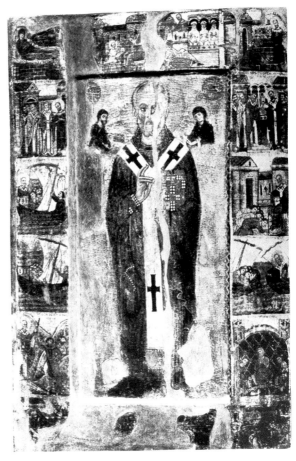

40. *(top, left)* Russian vita icon of St. Nicholas. The Menil Collection, Houston.

41. *(top, right)* Vita icon of St. Nicholas. Pinacoteca, Bari.

42. *(right)* Dukakis "vita icon," *Boston Globe* (June 28, 1988). Illustration by Eric Orner.

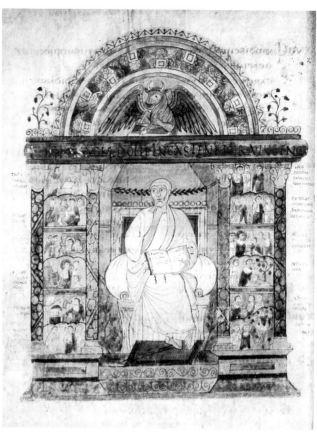

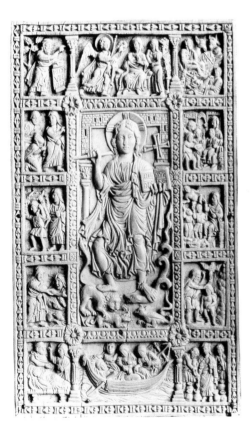

43. *(top, left)* Ivory diptych. Cathedral Treasury, Milan.

44. *(top, right)* St. Luke flanked by scenes from his Gospel. Corpus Christi College, Cambridge (mss. 286).

45. *(left)* Christ Treading the Beast. Ivory panel. Bodleian Library, Oxford.

διήγησιν ("the templon, having the Deesis in the middle, and the story of the venerable saint, the Prodromos"). [9] Attaleiates' *diataxis* dates from 1077—his templon is thus a good century earlier than the surviving Sinai examples, and, being a metropolitan work (the monastery was right in the middle of Constantinople), it shows that the Sinai evidence is no provincial aberration.

Our vita icons surely reflect the same current of interest in hagiographical narrative. [10] But just how did such a strictly horizontal row of scenes end up wrapped around a central portrait? Iconostasis beams of this kind may have influenced the *content* of our vita icons, but they can scarcely have been the immediate source that we are seeking.

Another possibility is that the whole business came from the West. Vita icons do crop up in the East and West at just about the same time, the early thirteenth century, and in the East the surviving Byzantine icons derive almost exclusively from areas subject to considerable Western influence: Sinai, Cyprus, and Kastoria. Could the movement possibly have gone the other way entirely, from West to East?

Before yielding to such a radical solution, let us return to Attaleiates, and read his descriptions of other icons. They are remarkably precise, and we can nearly always come up with extant icons which correspond to his descriptions—even if these are not always absolutely contemporary works.

He begins his inventory with the main proskynesis icon of his monastery, that of Christ Panoiktirmon. Then, after describing some silver-gilt crosses and a fancy silver-gilt box, he turns to the *metal* icons. There is a silver-gilt icon with the bust of Christ and around it nine icons, i.e., nine images, and the Hetoimasia. [11] All-metal icons like this have not survived in Byzantium from this

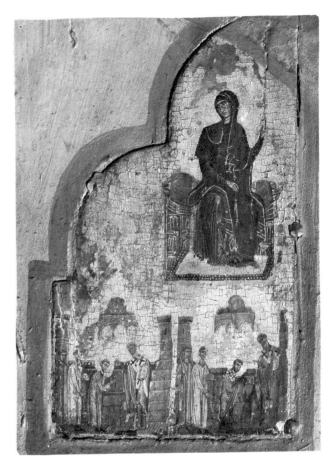

46. St. Nicholas scenes, wing of icon triptych. Monastery of St. Catherine, Mt. Sinai.

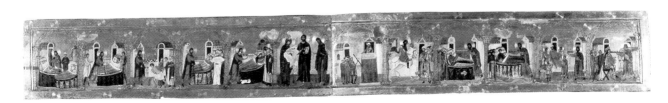

47. Iconostasis beam with St. Eustratios scenes. Monastery of St. Catherine, Mt. Sinai.

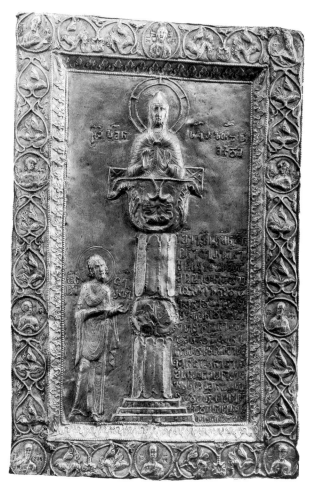

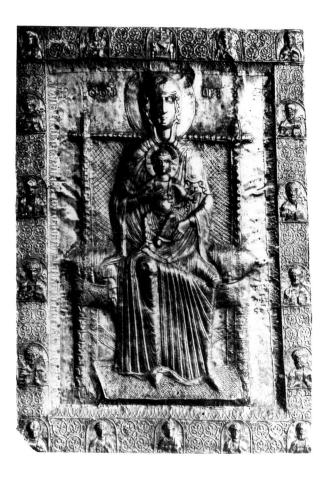

48. Silver icon of St. Symeon Stylites. State Art Museum, Tbilisi.

49. Silver icon of the Virgin of Čukuli. State Art Museum, Tbilisi.

period, but comparable works can be found still in Georgia. An eleventh-century silver-gilt icon in Tbilisi of St. Symeon Stylites, for example, has a Deesis on the top and seven other busts inside the rinceaux of the border (fig. 48) [12]; another Georgian silver-gilt icon, the Čukuli Virgin, has the Hetoimasia, as did Attaleiates' icon, but has seventeen images, not nine, on the frame (fig. 49). [13] The surviving Byzantine examples are not made entirely of metal, but the design is the same: a little mosaic icon of St. Nicholas on Patmos, for example, has a silver frame with the Hetoimasia at the very top (fig. 50). [14] It is usually dated to the later eleventh century, and is thus virtually contemporary with the *diataxis* of Michael Attaleiates. Another somewhat later example is a thirteenth-century mosaic icon of St. John the Evangelist from the Lavra Monastery

on Mt. Athos: its frame has exactly nine images— this time in enamel—plus the Hetoimasia (fig. 51). [15] In short, comparison with extant icons at once proves the credibility of Attaleiates' descriptions, and indicates that icons with images surrounding a central figure existed already in eleventh-century Byzantium.

Atteleiates then proceeds to another category of icon: the *painted* icons (the word he uses is "hylographia," ὑλογραφία) that have metal borders or "peripheria" (περιφέρια). He speaks of one which has eighteen busts—εἰκόνας λαιμία ιη'— on its silver-gilt frame, and of a painted icon of St. Catherine whose frame has eight eikones: six busts and two standing figures (six λαιμία and two στασίδια). [16] The latter can be compared to the silver-gilt frame of an eleventh-century painted icon

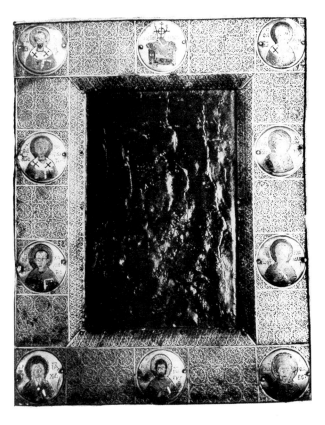

50. Mosaic icon of St. Nicholas. Monastery of St. John, Patmos.

51. Mosaic icon of St. John the Evangelist. Lavra Monastery, Mt. Athos.

of St. Michael from Upper Svanetia in Georgia, to a twelfth-century Georgian all-metal icon of St. George in Tbilisi, or to a fourteenth-century mosaic icon of St. Anne at Vatopedi. [17] Finally, Attaleiates records an icon of St. Panteleimon, whose border has twenty-five ὑέλια—the word means glass, probably here glass cabuchons—plus sixteen icons. [18]

Icons such as Attaleiates describes recur frequently in monastic documents of the eleventh and twelfth centuries, and came to be known as κεκοσμημέναι εἰκόνες, "decorated" icons, to distinguish them from the plain painted icons. [19]

Written sources indicate that by the mid twelfth century the metal revetment had begun to invade the painted surface. In the inventory of 1142 of the monastery of Xylourgou on Mt. Athos, we find

reference not only to the kinds of icons owned by Attaleiates, but to *painted* icons where the figures have silver haloes (φεγγεῖα) and cuffs (ἐπιμανίκια, ἐπιμάνικα): for example, φεγγεῖα ἀργυρὰ ἐγκαῦστα; φεγγὴν ἀργυρὸν διάχρυσον καὶ εἰς τὰ ἐπιμανίκια ἀργυρὰ διάχρυσα. [20] Such revetment must have resembled that on a fourteenth-century icon of the Virgin from Vatopedi. [21]

The Patmos inventory of the year 1200 describes a collection which happily still exists, or at least in part. The main proskynesis icon of St. John the Evangelist, to whom the monastery is dedicated, is described in this inventory as follows: εἰκὼν ἁγία μεγάλη ὁ Θεολόγος μετὰ περιφερείων ἀργυροδιαχρύσων καὶ στεφάνου καὶ εὐαγγελίου, τῶν ἀμφοτέρων χρυσοχειμεύτων ἀργυρῶν ("a large holy icon of the Theologos, with a silver-gilt frame and

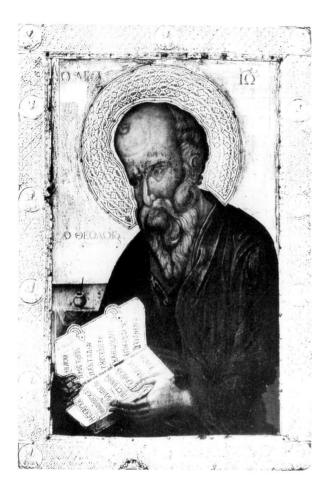

52. *(above)* Proskynesis icon of St. John the Evangelist. Monastery of St. John, Patmos.

53. *(top, right)* Annunciation icon. Umetnicka Galerija, Skopje.

54. *(bottom, right)* Icon of the Virgin. Freising Cathedral.

halo and Gospel, both of which are enameled and silver-gilt[?]").[22] It is very probable that this description refers to an icon which is actually in the monastery today (fig. 52); though the icon was repainted in the fifteenth and nineteenth centuries (the saint's head doesn't fit properly into the halo), the description is otherwise very accurate.[23]

The Patmos inventory lists other icons which it says are "holokosmetos" (ὁλοκόσμητος)—meaning decorated all over—or "holotzapotos" (ὁλοτζάπωτος)—meaning probably chased or hammered all over—clear references to icons like those of the Annunciation in Skopje which have a silver-gilt ground as well as a border (fig. 53).[24]

Thanks then to the accuracy of the sources, we get a good idea of what Komnenian "kekosmemenai eikones" looked like. To the evidence provided by the inventories should be added one other source which tells us a little more about how such icons were viewed in their time: I refer to the long epigrams written by poets such as Nikephoros Kallikles to celebrate specific icons, especially those icons given a silver-gilt revetment by some member of the Komnenian family or their circle of friends.[25] The number of the recorded donations is really astonishing, and it explains why when Isaac II Angelos needed money on the eve of the Fourth Crusade, he started off by melting down the "kosmous" of icons (many of the ones cited in this article are over a meter tall).[26] Only a small number of these poems have been published in their entirety, and for many others all we have access to at present is the title, which usually runs like this: "On the icon of Christ adorned in gold (κοσμηθεῖσαν χρυσῷ) by Maria, the wife of Manuel Komnenos."[27] The *kosmema* or decoration frequently involves precious stones and pearls, as well as silver and gold.[28] Even these poems, which at first seem like flights of literary fancy, can be seen to have had a base in reality when we compare them with an icon such as that in Freising which has altogether fourteen lines of comparably flowery twelve-syllable verse actually written in niello on the silver frame of the icon (fig. 54).[29] An analysis of these epigrams will certainly tell us a lot about how these icons were viewed and used.

Many of the characteristics of the so-called "decorated" icons—a holy figure surrounded by various

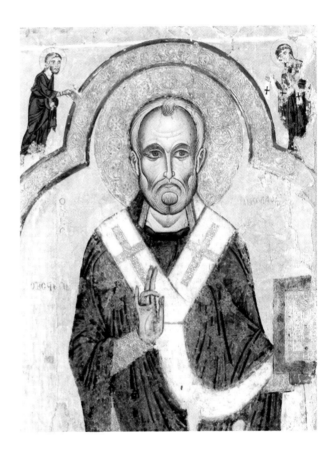

55. Icon of St. Nicholas (detail of central section) from Kakopetria. Museum of Byzantine Icons, Nicosia.

56. Icon of the Mandylion. San Bartolomeo degli Armeni, Genoa.

57. Silver icon of the Virgin from Zarzma. State Art Museum, Tbilisi.

smaller images; the use of silver haloes and cuffs on the painted surface, and the chased backgrounds— begin to be imitated on contemporary painted icons, as substitute for the costly metalwork. [30] The haloes and cuffs are quite literally reproduced on painted icons, especially on Cypriot icons beginning in the thirteenth century, through the use of gilded gesso. We should compare the description of an icon of St. John Chrysostom in the Patmos inventory of 1200 with the icon of St. Nicholas made for the church of St. Nicholas at Kakopetria on Cyprus (fig. 55): "Another icon, Chrysostomos, with the halo, Gospel book, cuffs and three crosses, all silvergilt." On the Kakopetria icon, each of these very elements is covered in gesso instead of silver. [31]

In short, the painted icons of the thirteenth century quite clearly draw on a decorative repertory already established for the silver-gilt icon treasures of the eleventh and twelfth centuries. Is it possible that the development of the vita icon could have been part of this process, and *also* had its source in metal icon frames?

Icons which have scenes, not just busts or standing figures, on their silver-gilt frames, do exist. There is the famous Mandylion icon in Genoa (fig. 56), with its fine set of scenes recounting the Abgar legend on the frame, and an icon in Moscow that has Virgin scenes. [32] But these monuments are fourteenth century, and the scenes are not contiguous boxes, but are separated by panels of ornament. Georgian metal crosses have contiguous panels enclosing hagiographical narrative scenes, [33] but the only metal icon which seems to provide exactly the model we seek is that of the Virgin from Zarzma, a Georgian work which has been dated by some to the eleventh, by others to the late twelfth century (fig. 57). [34] If either date is accurate, this icon might serve to strengthen the hypothesis that this form originated in the all-metal or the so-called "decorated" icons so popular in the eleventh and twelfth centuries. Could Attaleiates' icon of St. Panteleimon, with its "girothen eikones 16," have been the metal equivalent to a painted vita icon of this saint found on Sinai (fig. 58), which also has sixteen "eikones" around the central figure? [35]

Whatever the formal source may have been, it does seem likely that the vita icon was considered in its time a kind of κεκοσμημένη εἰκών, and should

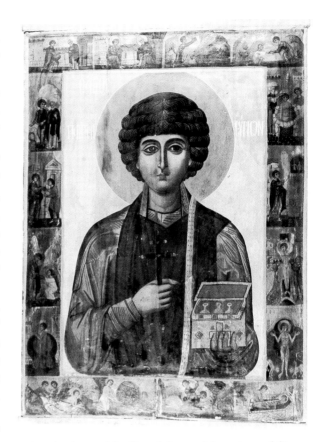

58. Vita icon of St. Panteleimon. Monastery of St. Catherine, Mt. Sinai.

be studied as such. These κεκοσμημέναι εἰκόνες constituted a special, expensive, private type of pious donation which increased in popularity over the course of the twelfth century. These "enhanced" icons, as we might call them, were apparently primarily destined for private foundations, family tombs and the like, and images of the donors, as is the case with our vita icons, were often included. Further study of the epigrams celebrating these icons, and of the dedicatory inscriptions on the icons themselves, will help us understand the real function not only of these vita icons, but of all those icons having special frames, whether they are metal or painted; it will also reveal much about the motivation of their Constantinopolitan donors, and, by extension, about that of their counterparts in other regions of the Mediterranean having the same pious inclinations but rather less cash in hand.

1. N. P. Ševčenko, *The Life of St. Nicholas in Byzantine Art* (Turin 1983), esp. pp. 162–65; K. Weitzmann, "Icon Programs of the 12th and 13th centuries at Sinai," *Δελτίον τῆς χριστιανικῆς ἀρχαιολογικῆς ἑταιρείας*, Ser. 4:12 (1984), esp. pp. 94–102. J. Myslivec, *Dvě studie z dějin Byzantského umění* (Prague 1948), 55ff; A. Boguslawski, "The Vitae of St. Nicholas and his hagiographical icons in Russia," Ph.D. dissertation, University of Kansas, 1982.

2. V. Pace, "Icone di Puglia, della Terra Santa e di Ciprio," *Il Medio oriente e l'occidente nell'arte del XIII Secolo* (Atti del XXIV Congresso internationale di storia dell'arte, Bologna 1979), pt. 2, pp. 181–91; K. Weitzmann, "Crusader Icons and Maniera Greca," *Byzanz und der Westen,* ed. I. Hutter (Vienna 1984), pp. 154–56, figs. 13–20; J. Stubblebine, "Byzantine influence in Thirteenth-Century Italian Panel Painting," *Dumbarton Oaks Papers* 20 (1966), pp. 87–101; H. Hager, *Die Anfänge des italienischen Altarbildes* (Munich 1962), esp. pp. 91–100; E. Garrison, *Italian Romanesque Panel Painting* (Florence 1949), esp. pp. 150–56.

3. *Boston Globe,* June 28, 1988, p. 27. Artist: Eric Orner.

4. There are Byzantine vita icons of Sts. Nicholas, Catherine, George, Panteleimon, John the Baptist, and Moses on Mt. Sinai, of Sts. Nicholas and Marina on Cyprus, and icons of St. Nicholas and of the Anargyroi (Sts. Kosmas and Damian) in Kastoria. There are a few vita icons of Sts. George and Nicholas elsewhere, and there is the Menil St. Basil icon. Cf. Weitzmann (as in notes 1 and 2) and *The Icon. Holy Images—Sixth to Fourteenth Centuries* (New York 1978), pls. 34 and 35; Ševčenko, *Nicholas,* nos. 1, 3, 5, 14, 37, 41–44; G. and M. Soteriou, *Εἰκόνες τῆς Μονῆς Σινᾶ,* 2 vols. (Athens, 1956, 1958), nos. 165-70; A. Papageorgiou, *Byzantine Icons from Cyprus* (exhibition catalogue, Athens 1976), nos. 11, 35. Cf. also T. Mark Weiner, "Narrative Cycles of the Life of St. George in Byzantine Art," Ph.D. dissertation, New York University, 1977; J. Myslivec, "Svatý Jiří ve východokřesťanském umění," *Byzantinoslavica* 5 (1933–34), pp. 304–75.

5. On the late-antique and Early Christian parallels, see Ševčenko, *Nicholas,* pp. 164–5; A. Grabar, *Les revêtments en or et en argent des icônes byzantines du moyen-âge* (Venice 1975) p. 10. Cf also W. Ehrlich, *Bilderrahmen von der Antike bis zur Romanik* (Dresden 1979).

6. A. Goldschmidt and K. Weitzmann, *Die byzantinische Elfenbeinskulpturen des X–XIII Jahrhunderts,* vol. 2 (Berlin 1934), passim.

7. Ševčenko, *Nicholas,* no. 1; K. Weitzmann, "Fragments of an early St. Nicholas triptych on Mount Sinai," *Δελτίον τῆς χριστιανικῆς ἀρχαιολογικῆς ἑταιρείας,* Ser. 4:4 (1966), pp. 1–23, rpt. in his *Studies in the Arts of Sinai* (Princeton 1982), no. VIII.

8. Nicholas epistyle: Ševčenko, *Nicholas,* no. 5. Eustratios epistyle: K. Weitzmann, "Illustrations to the Lives of the Five Martyrs of Sebaste," *Dumbarton Oaks Papers* 33 (1979), pp. 108–10. For epistyles with the Twelve Feasts, cf. Weitzmann, "Icon Programs" (as in note 1), 64–86; Soteriou, *Εἰκόνες,* pls. 87–102, 112–16; Weitzmann, "Crusader Icons" (as in note 2), figs. 27a–b.

9. P. Gautier, "La Diataxis de Michel Attaliate,"*Revue des Etudes byzantines,* 39 (1981), p. 89:1195–96. A useful study making use of many of the sources cited here for the information that they provide on Byzantine enamels has recently been completed by Paul Hetherington, "Enamels in the Byzantine World: ownership and distribution," *Byzantinische Zeitschrift* 81 (1988), pp. 29–38.

10. Readings from the lives of the saints, especially those by Symeon Metaphrastes, had become a standard part of monastic orthros (matins) from the eleventh century, A. Ehrhard, *Überlieferung und Bestand der hagiographischen und homiletischen Literatur der griechischen Kirche* (Leipzig 1937–40), vol. 2: pp. 314–17

11. Attaleiates, p. 89:1174–84.

12. W. Seibt, T. Sanikidze, *Schatzkammer Georgien. Mittelalterliche Kunst aus dem Staatlichen Kunstmuseum Tbilisi* (Exhibition catalogue, Vienna 1981), no. 26, fig. 19; V. Beridze, G. Alibegašvili, A. Volskaja, L. Xuskivadze, *The Treasures of Georgia* (London 1984) pl. p. 201; G. Čubinašvili, *Gruzinskoe čekannoe iskusstvo* (Tbilisi 1959) pp. 302–08, pl. 305A (details only).

13. Grabar, *Revêtments,* fig. 17; K. Weitzmann et al., *The Icon* (New York 1982) pl. p. 102. Čubinašvili, *Iskusstvo,* pp. 225–34, pl. 136.

14. *Patmos, Treasures of the Monastery,* ed. A. Kominis (Athens 1988), pp. 106–7, pl. pp. 129–30; M. Chatzidakis, *Εἰκόνες τῆς Πάτμου,* (Athens 1977), no. 2.

15. Grabar, *Revêtments* no. 33, fig. 71; M. Chatzidakis, "Une icône en mosaïque de Lavra," *Jahrbuch des Österreichischen Byzantinistik* 21 (1972), pp. 74–81.

16. Attaleiates, p. 89:1189–91.

17. St. Michael: Beridze, *Treasures,* pl. p. 149; St. George: Seibt and Sanikidze *Schatzkammer,* no. 39, fig. 30 (cf. also the more fragmentary eleventh-century metal icon frame for the seated Virgin, *ibid.,* no. 32, fig. 25); St. Anne: Grabar, *Revêtments,* no. 23, fig. 60.

18. Attaleiates, p. 91:1197–99: Ἑτέρα εἰκ(ὼν) ὑλογρα(φία) ὁ ἅγιος Παντελεήμων μετὰ περιφερίων ἀργυρ(ῶν) διαχρ(ύσων) καὶ ὑελίων κε΄, ἔχοντ(α) τὰ περιφέρια γυρόθ(εν) εἰκόν(ας) ις΄.

19. Gautier, "Le typikon du sébaste Grégoire Pakourianos," *Revue des études byzantines* 42 (1984), p. 121; *idem.,* "Le typikon de la Théotokos Kécharitôménè," *Revue des études byzantines* 43 (1985) p. 153:53, 55 (founded ca. 1110); L. Petit, "Typikon du monastère de la Kosmosoteira près d'Aenos," *Izvestija russkogo arheologičeskogo instituta v' Konstantinopole* 13 (1908) p. 64:6 (founded in 1152). Though all speak of icons

with metal borders, and Isaac Komnenos in the latter text refers to the border of his mosaic icon as its "kosmos" (cf. also the poems cited here, p. 65), the specific phrase "kekosmemene eikon" appears only somewhat later, in inventories of the 14th century, cf. H. Delehaye, *Deux typica byzantins de l'époque des Paléologues* (Brussels 1921), p. 92:7, 31–33; 94:10; 102:16 (Monastery of the Virgin Bebaia Elpis, ca. 1345); *Actes de Lavra* III, ed. P. Lemerle et al. (Paris 1979) pp. 106-07 (inventory of the monastery of the Gabaliotissa at Vodena, dated 1375); L. Petit, "Le monastère de Notre-Dame de Pitié en Macédoine," *Izvestija russkogo arheologičeskogo instituta v' Konstantinopole* 6 (1900), p. 118:16–119:6 (Monastery of the Virgin Eleousa at Strumica, inventory dated 1449). A famous icon might receive a succession of frames over the years: the Virgin of Vladimir was given a silver revetment first in the twelfth, then in the 15th and again in the 17th centuries (Grabar, *Revêtments,* no. 41, figs. 88–97). Cf. also the different frames presented to one icon by both Cantacuzene and Palaiologan rulers: M. Theocharis, "Παναγία ἡ Ἀρτωκοστᾶ. La Beata Vergine della grazie," *Ἀρχαιολογικὴ Ἐφημερὶς,* 1953–4:3 (1961) pp. 232–52. The "kekosmemena euangelia" or "decorated" Gospelbooks mentioned in some of these same sources are surely books given metal covers, not books with miniatures: cf. Manuel Philes (as in note 25 below), vol. I, p. 68, 70, and the Gabaliotissa inventory, etc.

20. *Actes de Saint-Pantéléèmon,* ed. P. Lemerle, G. Dagron, S. Ćirković (Paris 1982), pp. 74–76.

21. Grabar, *Revêtments,* no. 32, figs. 69–70.

22. Ch. Astruc, "L'inventaire dressé en Septembre 1200 du trésor et de la bibliothèque de Patmos. Edition diplomatique," *Travaux et Mémoires* 8 (1981), p. 20:4-5.

23. *Patmos,* pp. 107–08, pl. p. 131; Chatzidakis, *Εἰκόνες,* no. 2.

24. Astruc, "L'inventaire," pp. 20–21. Skopje icons: Grabar, *Revêtments* no. 10, figs. 26–29.

25. S. P. Lambros, "Ὁ Μαρκιανὸς κῶδιξ 524," *Νέος Ἑλληνομνήμων* 8 (1911) pp. 3–59, 123–192; *Nicolà Callicle, Carmi,* ed. R. Romano (Naples 1980), pp. 82, 89. The practice continued into the 14th century: cf. the poems of Philes, *Manuelis Philæ Carmina,* ed. E. Miller (Paris 1855) vol. I, p. 35, no. 79 and p. 65. Cf. also the many 14th-century icons illustrated in Grabar, *Revêtments.*

26. Niketas Choniates, *Historia,* ed. J. L. van Dieten (Berlin–New York, 1975), p. 347:52–56.

27. Lambros, "Μαρκιανός", p. 126, no. 109.

28. The Caesar John Dalassenos adorned an icon of the Virgin with jewels which had belonged to his wife, Lambros, "Μαρκιανός", p. 21, no. 52. Cf. Grabar, *Revêtments,* nos. 17, 19.

29. Grabar, *Revêtments,* no. 16, figs. 39-41. The icon, commissioned by a certain Michael Disypatos, is surprisingly small (27.8 x 21.5 cm).

30. As observed by M. S. Frinta, "Raised Gilded Adornment of the Cypriot Icons, and the Occurrence of the Technique in the West," *Gesta* 20 (1981), pp. 333–47; D. Talbot Rice, "Cypriot Icons with Plaster Relief Backgrounds," *Jahrbuch der Österreichischen Byzantinischen Gesellschaft* 21 (1972) 269–78; S. Kalopissi-Verte, "Διακοσμημένοι φωτοστέφανοι σὲ εἰκόνες καὶ τοιχογραφίες τῆς Κύπρου καὶ τοῦ Ἑλλαδικοῦ χώρου," *Πρακτικὰ Β' Διεθνοῦς Κυπριολογικοῦ Συνεδρίου Τόμος Β'* (Nicosia 1986), pp. 555–60; D. Mouriki, "Thirteenth Century Icon Painting in Cyprus," *The Griffon,* N.S. 1–2 (1985-6), pp. 55-56.

31. Patmos inventory: Astruc, "L'inventaire," p. 20: 6–7. Kakopetria icon: Ševčenko, *Nicholas,* no. 14; Mouriki, "Thirteenth Century," pp. 38-42, figs. 48, 53.

32. Mandylion: Grabar, *Revêtments,* no. 35, color pl. C and figs. 74–78; C. D. Bozzo, *La cornice del ΑΓΙΟΝ ΜΑΝΔΗΛΙΟΝ di Genova* (Genoa 1967). Virgin: Moscow, Oružejnaya Palata, Grabar, *Revêtments,* no. 19, fig. 45. Cf. also no. 21 (Virgin Hodegetria at Vatopedi).

33. Čubinašvili, *Iskusstvo,* pl. 270. The Mestia cross has scenes from the passion of St. George.

34. Weitzmann, *The Icon* (as in note 13), pl. p. 103; Beridze, *Treasures,* pls. pp. 97–98; Seibt and Sanikidze, *Schatzkammer,* no. 31, fig. 24; *Au pays de la toison d'or* (Exhibition catalogue, Paris, Galeries Nationales du Grand Palais, 1982) no. 62; Čubinašvili, *Iskusstvo,* pp. 194–212, pls. 203–205; N. Thierry, "La Vierge de tendresse à l'époque macédonienne," *Zograf* 10 (1979), p. 70, fig. 17; T. Velmans, "Icônes médiévales de Géorgie," *Archaeologia* 168 (1982), 31–32. The inscription on the icon names members of the Laklakidze family as donors; the date of their donation is unknown, although a liturgical fan was given by another member of the same family (in the early eleventh century?), Seibt and Sanikidze, *loc. cit.,* no. 81.

35. Weitzmann, "Icon Programs" (as in note 1), p. 101, fig. 29. Cf. note 18 above.

59. Baptism of Basil (top register, left scene). St. Basil, vita icon. The Menil Collection, Houston.

60. Consecration of Basil (top register, center). St. Basil, vita icon. The Menil Collection, Houston.

61. Basil writing (top register, right scene). St. Basil, vita icon. The Menil Collection, Houston.

62. Meeting of Basil and Ephrem (bottom register, left scene). St. Basil, vita icon. The Menil Collection, Houston.

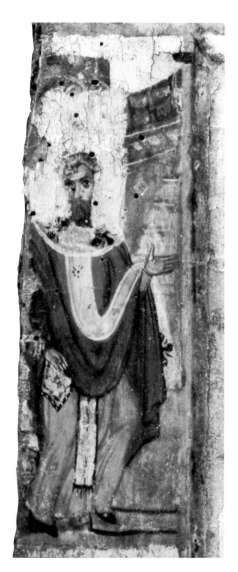

63. Basil (left frame, top scene). St. Basil, vita icon.
The Menil Collection, Houston.

64. Basil performing liturgy (right frame, top scene). St.
Basil, vita icon. The Menil Collection, Houston.

65. Basil praying (left frame, second scene from top).
St. Basil, vita icon. The Menil Collection, Houston.

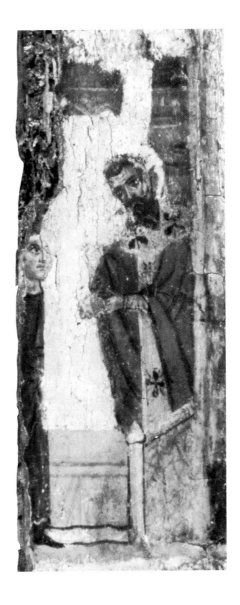

66. Basil (right frame, second scene from top). St. Basil, vita icon. The Menil Collection, Houston.

67. Basil and youth (left frame, third scene from top). St. Basil, vita icon. The Menil Collection, Houston.

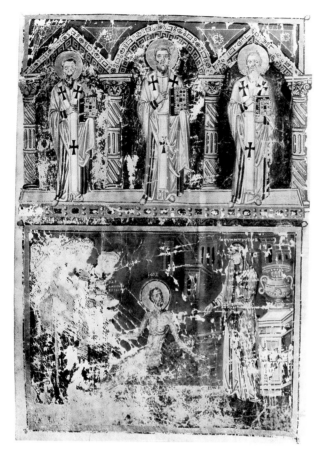

68. Sts. Basil, Gregory of Nyssa, Gregory of
Nazianzus; Job. Homilies of Gregory of Nazianzus,
Bibliothèque Nationale, Paris (gr.510, f.71v).

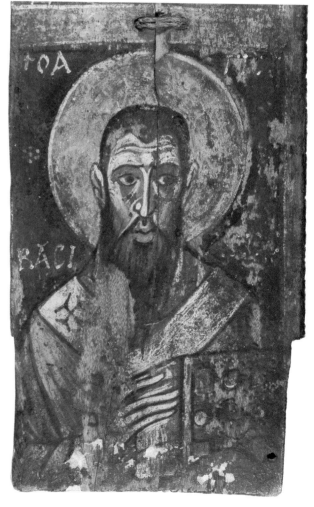

69. St. Basil icon. Monastery of
St. Catherine, Mt. Sinai (B.24).

The Vita Icon of Saint Basil:

Iconography

LESLIE BRUBAKER

The Menil icon of Saint Basil is, apparently, the only preserved Byzantine icon of the saint that surrounds him with scenes from his life (pl. 3, figs. 59–67). [1] Once, the large central portrait of the standing saint was encased by up to twelve images; now, three separately framed episodes run across the top and three more fall along the left side of the icon, part of one scene remains in the bottom register, and fragments of two more descend on the right. Even with the aid of textual and pictorial witnesses to Basil's life, not all of the scenes that remain can be identified. In part, this is due to the fact that none of the scenes survives intact, and most have lost their explanatory inscriptions. But it is also the case that the sequence followed on the Menil icon has no parallels, textual or pictorial, that might help us decipher some of the fragments. This latter point seems to me significant, and I shall return to it later.

St. Basil (d. 1 January 379), bishop of Caesarea in Cappadocia, wrote one of the two liturgies most frequently used in the Orthodox church and founded basilian monasticism. Not surprisingly, the Byzantines revered Basil—along with his brother, Gregory of Nyssa, and his good friend, Gregory of Nazianzus—as one of the great Cappadocian church fathers. The three are sometimes painted as a trio, as in a miniature from a ninth-century copy of the sermons of Gregory of Nazianzus (fig. 68). Indeed, medieval painters frequently depicted Basil; and the central image of the Menil icon, a standing portrait that dominates the panel, conforms in most respects with other Byzantine representations. Basil's features follow a formula

established by the seventh century, as seen on icon B.24 from Sinai (fig. 69): both icons, and the ninth-century miniature (fig. 68) that chronologically lies between them, show the typical long, thin face, the furrowed, thoughtful forehead, the short brown hair that waves forward over the central forehead and recedes slightly above the temples, and the long triangular beard. [2]

On the Menil icon, Basil stands on a narrow green strip of ground, before a low horizontal band of ochre and red, and against a gold background. He wears, as nearly always on this icon, an ochre omophorion and a dark greenish-brown phelonion over a rust-colored sticharion. The omophorion, a band of cloth looped around the neck like a modern scarf, with one end hanging over Basil's shoulders and the other falling down the center of his phelonion, identified its wearer as a bishop. [3] As is normal in Byzantine images of bishops, Basil's omophorion is marked with three crosses. The rounded ends of these crosses, however, provide a variant on the more normal angular cross. Similar round-headed crosses appear elsewhere, but they are usually associated with omophoria looped asymmetrically in the more ancient style with the front band falling over the bishop's left breast. [4] When Basil appears in a symmetrically hung omophorion as he does on the Menil icon, the decorative crosses are habitually angular, with rectangular or triangular arms (see fig. 68); [5] the mid-twelfth-century mosaic portrait of Basil at Cefalù in Sicily and a miniature in an eleventh-century manuscript from Mount Athos (fig. 73) are among the few parallel examples

70. St. Basil. Menologian of Basil II, Vatican Library, Rome (gr.1613, p.288).

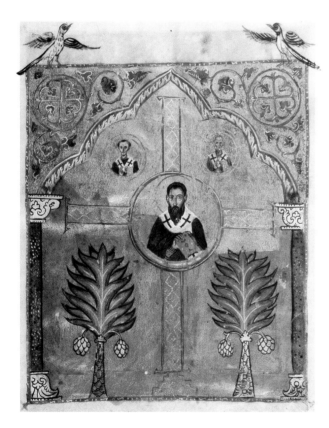

71. Sts. John Chrysostom, Basil (center), Nicholas. Homilies of Gregory of Nazianzus, Bibliothèque Nationale, Paris (gr.550, f.4r).

that show Basil in a symmetrical omophorion embellished with round-headed crosses. [6] Basil's ample phelonion replicates mantles worn by many saints, and is not a signal of ecclesiastical rank, while his undergarment—the long tunic known as a sticharion—was a conventional attribute of the clergy. [7] On the other hand, the gold epitrachelion, the end of which visually bisects Basil's sticharion below the omophorion, and the gold encheirion or epigonation (a cloth originally used for hand-wiping) that hangs from his girdle and is visible where the phelonion has been raised by Basil's right arm, were, like the omophorion, normally reserved for bishops. [8]

Basil's halo is another conventional attribute of sanctity, as is the book he grasps in both hands. Usually, however, holy figures support their books with their (covered or uncovered) right hands, leaving their left hands free to gesture in blessing. This is true of many portraits of Basil, but there is also a cluster of images that repeat the two-handed grasp of the Menil icon. Among these, the miniatures in the Menologion of Basil II of ca. 1000 (fig. 70), an eleventh-century lectionary, and a twelfth-century copy of the Homilies of Gregory of Nazianzus (fig. 71) may be singled out as closely anticipating the Menil icon. In the latter two instances, Basil has been clearly distinguished from other bishops and holy men by his two-handed grasp on the book. This gesture, which suggests special authority over (or even ownership of) the written word, perhaps indicated to its audience Basil's command of the Gospels, or, less likely, his prolific writings. [9]

Even from this brief introduction, it is clear that Byzantine painters and carvers portrayed Basil with a regularity that befits his status as one of the great Fathers of the Orthodox church. Usually, however, as in every one of the examples cited above, a simple portrait sufficed: only rarely did Byzantine painters attempt a narrative of Basil's life. Before returning to the pictorial vita framing Basil's portrait on the Menil icon, let us first briefly consider the texts and other picture cycles that narrate Basil's life.

Two major textual traditions exist, and both received illustration. The earliest vita is not a proper Life at all, but the funeral oration delivered two years after Basil's death by his good friend

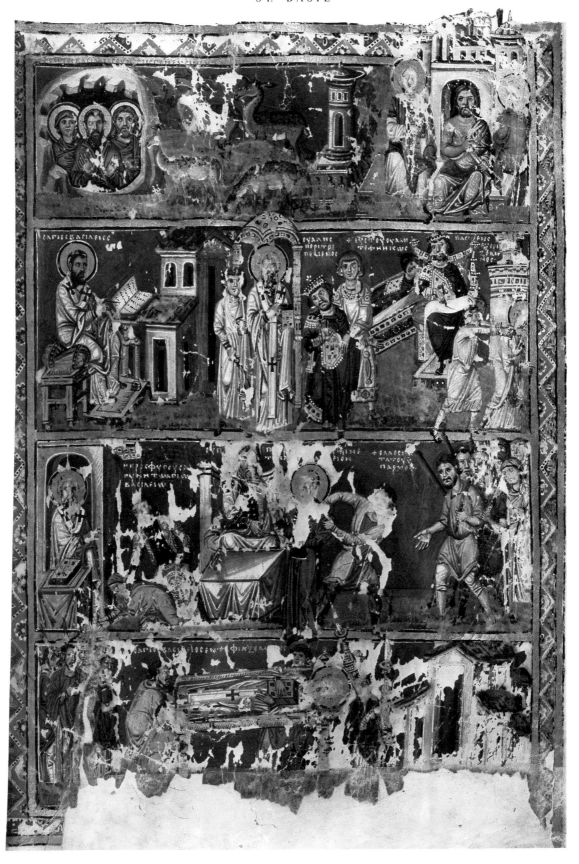

72. Life of Basil. Homilies of Gregory of Nazianzus,
Bibliothèque Nationale, Paris (gr.510, f.104r).

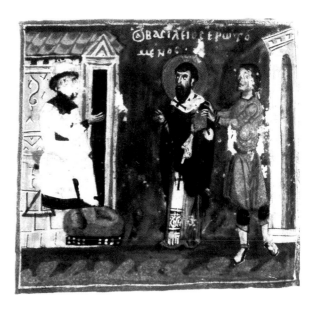

74. St. Basil before the prefect Modestus. Homilies of Gregory of Nazianzus. Panteleimon Monastery, Mt. Athos (cod.6, f.134v).

73. Sts. Basil and Gregory in Athens. Homilies of Gregory of Nazianzus. Panteleimon Monastery, Mt. Athos (cod.6, f.115r).

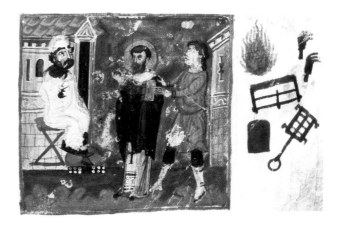

75. Modestus threatens St. Basil. Homilies of Gregory of Nazianzus, Panteleimon Monastery, Mt. Athos (cod.6, f.140r).

Gregory of Nazianzus. [10] This text received full pictorial treatment in the ninth-century copy of Gregory's sermons in Paris (fig. 72), and more cursory and formulaic illustration in all other manuscripts of the Homilies. In addition, the *Sacra Parallela* by John of Damascus incorporated excerpts from Gregory's funeral oration and these were illustrated in the ninth-century copy of this text in Paris. The scenes illustrated in this group are:

1. Basil and his relatives hide from Maxentius in a cave in the Pontus mountains (PG 36:500C, 502A [PG abbreviates *Patrologiae cursus completus, Series graeca*, ed. J.-P. Migne, 161 vols., Paris, 1857–66]). In the Paris Gregory, deer arrive to provide food and milk to the starving fugitives (PG 36:502B, 502D–504A) (fig. 72); in the Milan Gregory, also of the ninth century, birds appear to the figures in the cave (PG 36:501C). [11] One copy of the so-called liturgical Homilies includes the deer, alone. [12]

2. Gregory and Basil study in Athens (PG 36:513–525B). Distinct versions of this scene appear in the Paris Gregory (fig. 72) and a copy of the Homilies on Mount Athos (fig. 73). [13]

3. Basil writes (PG 36:553A–B). The scene occurs only in the Paris Gregory (fig. 72).

4. Basil's persecution by Modestus, a prefect of the emperor Valens (PG 36:557C–561C). Two copies of the so-called liturgical Homilies illustrate this episode (figs. 74, 75). Both show Basil being brought to the prefect and, as a separate scene, the prefect threatening Basil. One copy then shows the prefect reporting to Valens, the other pictures a group of riders hunting Basil and, separately, Basil's later healing of the converted prefect (PG 36:565B–C) (fig. 76). [14]

5. Basil at the sickbed of Galatias, son of the emperor Valens (PG 36:564B–565B). This episode appears in two manuscripts of the Homilies, that in Paris (fig. 72) and one at Mount Athos; [15] the two images are not related.

6. Basil's exile (PG 36:588A). Again, this episode recurs in only two manuscripts, the same two that illustrate Basil at Galatias' sickbed (fig. 72). [16]

7. Several episodes recount Basil's protection of the widow (PG 36:568A–569C).
 –In the Paris Gregory, Basil protects the widow,

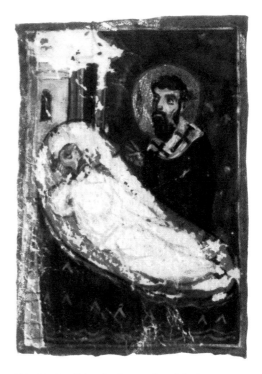

76. St. Basil heals the prefect Modestus.
Homilies of Gregory of Nazianzus.
Panteleimon Monastery, Mt. Athos (cod.6, f.138v).

defends his protection before a judge—whose attendant tears at Basil's cloak—and is then rescued by the citizens of Caesarea, who rush to Basil's aid (fig. 72).
–In the Sacra Parallela, the assessor pleads with the widow and then, in a separate image, Basil defends her before the judge (fig. 77). [17]
–The Turin copy of the liturgical Homilies pictures Basil with the widow (fig. 78); two other manuscripts show Basil before the judge and the citizens of Caesarea coming to his rescue (fig. 79) and Basil teaching (fig. 80). [18]

8. Basil's death and funeral (PG 36:601A–604A). Versions of this scene appear in the Paris Gregory (fig. 72) and in most copies of the so-called liturgical Homilies of Gregory of Nazianzus (figs. 81–87). [19]

Nearly every illustrated copy of Gregory's funeral oration contains at least one scene from Basil's life, and all draw their illustrations directly from Gregory's sermon. Only three, however, show extensive sequences: Paris.gr.510 (fig. 72); Mount Athos,

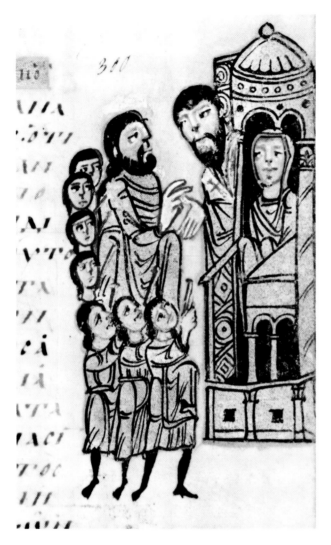

77. St. Basil defends widow. *Sacra Parallela.*
Bibliothèque Nationale, Paris (gr.923, f.300r).

78. St. Basil and the widow. Homilies of Gregory of
Nazianzus, Biblioteca Nationale Universitaria, Torino
(cod.C.I.6, f.89v).

Panteleimon 6 (figs. 73–76, 79); and Paris. Coislin, 239 (fig. 80). The Coislin and Panteleimon manuscripts share five scenes and, though they are far from identical, these are iconographically related to each other. As each contains scenes—and sometimes, as with the isolated deer of the Panteleimon sequence, fragments of scenes—omitted from the other, I suspect that both manuscripts ultimately descend from a common, and more fully illustrated, source. That source has not left other traces: the three ninth-century manuscripts illustrating this sermon—the Paris (fig. 72) and Milan Homilies and the *Sacra Parallela* (fig. 77)—are related neither to the later liturgical editions nor to each other. Aside from the Coislin and Panteleimon manuscripts and their hypothetical source, we have, in short, no evidence that a coherent and canonical cycle of Basil's life accompanied Gregory's funeral oration.

The second vita is that ascribed to pseudo-Amphilochios. [20] As with Gregory's funeral oration, the earliest surviving images that may be connected with the pseudo-Amphilochios vita date to the ninth century. Indeed, the same manuscript that preserves the most complete sequence of scenes drawn from Gregory's oration also contains two images that appear to have been inspired by the pseudo-Amphilochios text (fig. 88). [21] Most pictorializations of this account, however, appear in mural decoration. The wall paintings at the so-called Temple of Fortuna Virilis in Rome provide the second ninth-century visualization of this text (fig. 89), [22] while the New Church at Tokali (fig. 90) and Chapel 3 at Balkan Dere in Cappadocia supply tenth-century versions. [23] The vita scenes illustrated by this group are:

1. Basil baptizing, presumably either the Jewish man who watched him say mass (PG 29:cccii) or the Jewish doctor Joseph (PG 29:cccxiv-cccv), appears in Chapel 3 at Balkan Dere.
2. Basil prays for delivery from Julian the Apostate and has a vision of the emperor's death at the hands of Merkurios (PG 29:ccciv–cccv). Both scenes appear, in two registers of the same page, in a miniature depicting the life of Julian in the Paris Gregory (fig. 88).
3. The contest between Basil and the emperor

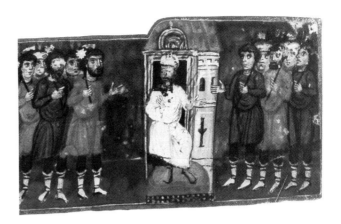

79. Citizens of Caesarea protest St. Basil's treatment. Homilies of Gregory of Nazianzus. Panteleimon Monastery, Mt. Athos (cod.6, f.140v).

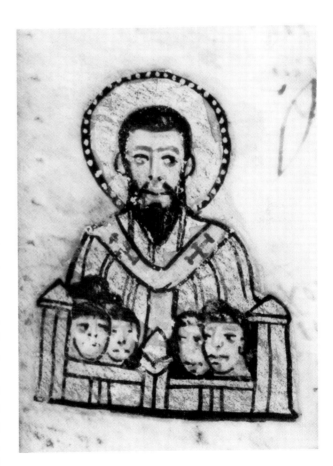

80. Basil teaching. Homilies of Gregory of Nazianzus. Bibliothèque Nationale, Paris (gr. 239, f.104v).

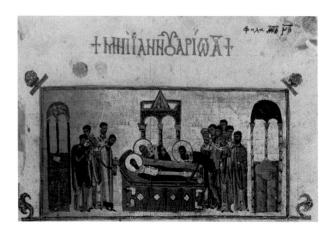

81. Funeral of St. Basil. Homilies of Gregory of Nazianzus, Patriarchal Library, Jerusalem (Taphou 14, f.114r).

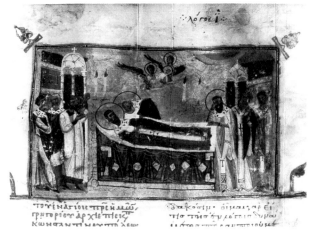

83. Funeral of St. Basil. Homilies of Gregory of Nazianzus, Laurenziana Library, Florence (plut.7,32, f.70r).

82. Funeral of St. Basil. Homilies of Gregory of Nazianzus, Biblioteca Apostolica Vaticana, Città del Vaticana (gr.1947. f.52v).

84. Funeral of St. Basil. Homilies of Gregory of Nazianzus, Bodleian Library, University of Oxford (Canon.gr.103, f.90v).

85. Funeral of St. Basil. Homilies of Gregory of
Nazianzus, Panteleimon Monastery,
Mt. Athos (cod.6, f.100r).

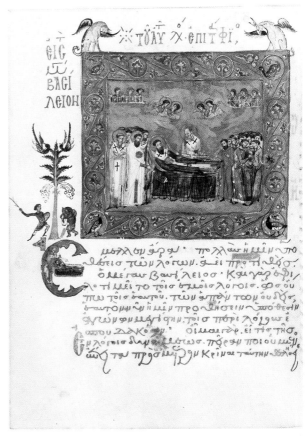

87. Funeral of St. Basil. Homilies of Gregory
of Nazianzus, Bibliothèque Nationale, Paris
(gr. 550, f.94v).

86. Funeral of St. Basil. Homilies of Gregory of
Nazianzus, Monastery of St. Catherine, Mt. Sinai
(gr.339, f.109r).

Valens for the church at Nicaea (PG 29:cccxi–cccxii). The New Church at Tokali presents this episode in five scenes, most in fragmentary condition: Basil and Valens, the prayer of the Arians, the departure of the Arians, the prayer and victory of the Orthodox, and finally a badly damaged scene that Jerphanion suggested once showed Basil leading the Orthodox in prayer.

4. Basil and Ephrem (PG 29:cccx–cccxi). The New Church at Tokali originally devoted two scenes to the meeting of the saints, but both are now destroyed.

5. The miracle of Basil's brother Peter (PG 29:cccxii–cccxiii). Though badly damaged, part of this scene remains at the Temple of Fortuna Virilis. [24]

6. The sinful woman begs Basil to pardon her sins and the miracle at Basil's funeral (PG 29:cccxiii–cccxiv). A wall painting at the Temple of Fortuna Virilis showing a woman prostrate at Basil's feet depicts the first part of this episode (fig. 89). The New Church at Tokali retains most of the conclusion (fig. 90): while the sinful woman who had futilely gone to Ephrem to erase the last sin on her list is no longer preserved at the base of Basil's bier, the man holding her miraculously blank scroll and the surviving inscriptions insure the identification. A badly abraded image in Chapel 3 at Balkan Dere may also show this scene, though all that can now be discerned is Basil lying in state. [25]

7. The entombment of Basil (PG 29:cccxvi). A simple version of this scene appears in Chapel 3 at Balkan Dere.

In addition, at least one of the mid-eleventh-century images painted on the sanctuary wall at Hagia Sophia in Ohrid may also rely on pseudo-Amphilochios. The first fresco shows a figure sleeping while Christ, followed by his disciples, bends over him (fig. 91). This image has been interpreted variously as the dream of John Chrysostom or of Basil, recounted in the pseudo-Amphilochios, in which the apostles appeared and taught him the words of the anaphora. The second fresco unequivocally depicts Basil saying mass, holding a scroll on which are written the opening words of the anaphora (fig. 92). [26] The face of the dreaming saint is so badly damaged that it is

virtually impossible to identify him firmly as either John or Basil. If the former was meant, Ohrid nonetheless supplies a liturgical image of Basil, but one that may or may not rely on the pseudo-Amphilochios; if we are meant to read the dreaming figure as Basil, the Ohrid frescoes assuredly provide another visualization of the anonymous vita.

Whether or not the Ohrid frescoes legitimately belong with the pseudo-Amphilochios scenes of Basil's life, we can no more extract a coherent tradition of imagery associated with this text than we could with Gregory's funeral oration. There is only one instance where it is even possible that two monuments may duplicate the same scene. While the text itself was evidently widely known, the monuments themselves provide neither positive nor negative evidence that appropriate images were also familiar.

One last, and small, group of images remains. This group consists of a few scenes of Basil preaching or officiating at mass that rely on no particular text. Most of these appear in Byzantine liturgical rolls, usually at the head of Basil's liturgy, or in the *Sacra Parallela*, beside quotations from Basil's sermons (fig. 80). [27] We might also place in this group the random images of Basil conversing with Gregory of Nazianzus that appear in various copies of Gregory's sermons. [28]

The vita scenes on the Menil icon share few details with the Basil scenes that accompanied Gregory's funeral oration, but they do suggest that the icon's designer knew the pseudo-Amphilochios vita. The only scenes that we can identify without hesitation, however, reflect passages of that vita that find no other illustrations.

The upper left corner of the icon is badly damaged, but enough remains to indicate that it pictures a baptism (fig. 59). A nude male figure with brown hair and beard stands before a triangular grey-blue indication of water that comes to a point just below his knees; a buff-colored shape just above the figure's left shoulder is too badly abraded to identify securely. The hand conferring baptism is visible at the far left, but the baptising figure has been destroyed. A green hillside covered with plants rises on the right, and before this stand two figures: the first is a white-haired priest in a red phelonion who appears to be swinging a censer toward the

88. Julian in Battle, St. Basil praying, death of Julian. Homilies
of Gregory of Nazianzus, Bibliothèque Nationale, Paris (gr.510, f.409v).

89. Funeral of St. Basil. Temple of Fortuna Virilis, Rome.

nude male; the second is a youthful attendant—presumably a deacon—wearing an ochre tunic trimmed in red.

According to the pseudo-Amphilochios vita, Basil performed at least two baptisms, one of which was portrayed in Chapel 3 at Balkan Dere. The icon scene, however, looks completely different from the Cappadocian fresco. Indeed, it cannot be either of Basil's baptisms unless considerable liberties were taken with it, for neither of them occurred outdoors: his first recorded performance of the rite took place in a church, the second on his deathbed. While the officiating priest is no longer preserved, certainly the censer-swinging figure does not look like Basil: he has white rather than brown hair, and wears a red rather than a dark greenish-brown phelonion. The only preserved figure who looks at all like Basil is the man being baptized, who retains the hairstyle and facial type familiar from the central portrait. Rather than Basil's baptism of the Jewish man who converted after hearing him say mass, or of the Hebrew doctor Joseph, the painter has presented us with the baptism of Basil himself. This episode has no pictorial antecedents, but it merited a detailed description in the Life of Basil attributed

to pseudo-Amphilochios (PG 29:ccc). The vita informs us that Basil and his friend Eubulus went to Jerusalem to ask Bishop Maximus to baptize them in the river Jordan. When they arrived at the banks of the river, Basil asked God for a sign and stepped into the water to pray. Immediately after the priest baptized him, a flash of lightning rent the sky, and a dove swooped down over the Jordan. While there is no sign of lightning in our scene, the abraded buff shape over Basil's shoulder might be the remnants of a dove; more certainly, the implicit connection between Christ's and Basil's baptisms in the Jordan made in the pseudo-Amphilochios vita is expressed pictorially on the Menil icon, where Basil's baptism follows an iconographical pattern established by images of Christ's baptism. [29] The use of this formula for baptism of figures other than Christ was not common, [30] and its rarity suggests that the Menil painter knew or was told of the Jordan connection made in the pseudo-Amphilochios vita. The unusual emphasis on baptism, a scene that occurs on no other historiated icons and only exceptionally in hagiographical cycles of any medium, [31] also argues for the impact of the detailed and extensive description of the event in the pseudo-Amphilochios vita. As no other monument containing a picture cycle based on this text preserves the scene, however, there is no way to determine whether the Menil painter independently adapted an image of Christ's baptism or followed the lead of an earlier composer.

The middle scene of the top tier presents Basil's consecration as bishop in the presence of two deacons (fig. 60). [32] Basil, clad as in the central portrait, stands in the center of the composition. He inclines his head and raises his covered hands toward the consecrating bishop, who stands behind a red altar set within the bema of a church, defined by a marble wall and the open doors of the templon or iconostasis screen. He holds a golden gospel book in his left hand, and reaches toward Basil with his right; unfortunately, this segment of the scene, which is directly over the head of the large portrait of the saint, is lost, and so it is impossible to decipher the bishop's gesture. The central image is framed by architecture. On the left, an ochre and green arcade encloses two deacons, one of whom repeats the attendant figure at Basil's baptism; the

other, dressed identically, is distinguished by his shorter hair. While these men are presumably the two deacons who escorted Basil to the altar, the surface paint detailing their hands has flaked, so it is impossible to determine whether or not they carried the appropriate candle, censer, and pyxis. On the right, a red church with a darkened opening extends behind the consecrating bishop. A green stepped construction rises at the side of the church; as the priest is shown within the altar precinct, this curious motif may represent the ambo or the synthronon. Ševčenko, who observed a similar large stepped construction beside a scene of the consecration of Nicholas on an eleventh-century icon at Mount Sinai, plausibly suggested that it was included to underscore the fact that the ritual took place within the bema of the church. [33]

Scenes of consecration and ordination were not common in Byzantium: aside from a handful of isolated examples, all conceived independently and for precise topical reasons, Nicholas was the only Byzantine cleric whose consecration was habitually portrayed. [34] Because of this, Ševčenko has suggested that scenes of Nicholas' consecration were the source of the few other consecration vignettes that exist, and certainly the Menil consecration of Basil follows the pattern established for Nicholas. [35] Just as certainly, the episode does not appear in any other Basil cycle known to me. [36] The preservation or loss of Byzantine Basil sequences relies, obviously, on chance, but it is worth noting that all other cycles closely follow texts, none of which spends much time on Basil's ordination as priest or consecration as bishop. [37] Only the Menil icon—which is the only *icon* to present Basil's life—lays such stress on the consecration. The importance of the episode is clear not only from the unusual presence of the scene, but also from its central position on the frame, directly above (and abutting) Basil's halo. That this emphasis on Basil's elevation to the bishopric occurs on an icon is, I suspect, no accident: several historiated icons of Nicholas include two scenes of ordination and consecration, and some also place his consecration as bishop in a prominent position. [38] I shall return to this point later; for now, it is sufficient to note that the Menil painter could easily have adapted the image from a conventional scene of the consecration of Nicholas and, on the

90. Funeral of St. Basil, New Church, Tokali Kilise.

basis of the admittedly random preservation of Basil sequences in Byzantium, one is tempted to argue that this is exactly what happened.

The top right fragment retains only the lower half of a seated figure (fig. 61). This figure should almost certainly be identified as yet a third portrait of Basil, for it wears the dark greenish-brown phelonion that distinguishes him in all other scenes. The fragment probably originally represented Basil writing his famous liturgy or his monastic rules. As we have seen, this image appears in the Paris Gregory (fig. 72), and what we can still decipher in the Menil composition is quite similar to the miniature version.

Basil penning his liturgy would not be inappropriate to an icon that we may assume was donated to a church; Basil composing the monastic rules would be particularly apt in a monastic establishment. Neither Gregory's funeral oration nor the vita of pseudo-Amphilochios, however, emphasizes Basil's (prolific) writing, nor is a writing scene standard in the hagiographical cycles of other saints. Both the basilian liturgy and the basilian rules were nonetheless the basis of Basil's fame in the Byzantine world and, by joining a writing scene with scenes of Basil's

baptism and consecration at the top of the icon, the Menil painter paid tribute to this. As is true of the vita icons for other saints, [39] an accurate chronological narrative of Basil's life seems to have been less important to the designer of the Menil icon than encapsulating moments of symbolic significance to the Byzantine audience and, perhaps, arranging them in thematic units. The point is not, in other words, historical biography; rather, the painter was simply trying to portray Basil's importance to the community receiving the icon. [40] It is, I think, significant that none of Basil's miracles or interventions—by far the most popular scenes of his life in other cycles—appear in the top register of the Menil icon. Instead, this important location was reserved for Basil's entry into the Christian community, his consecration as a leader of the church, and his lasting contributions to Orthodox Christianity.

Of the remaining six scenes, only one, the sole image remaining in the bottom register (fig. 62), can be identified with any assurance. Though fragmentary, we can still make out a white-haired figure, dressed in a brown mantle over an ochre tunic, inclined toward a red altar. Remnants of a green arcade or roof float over the figure's head, and the marble wall and pillar of the templon or iconostasis screen protect the altar. All that remains of the figure behind the altar—presumably, with its greenish-brown phelonion, Basil—is an outstretched arm gesturing toward the supplicating man. Though Walter tentatively suggested that this image might show Basil giving thanks for the death of Julian the Apostate, [41] a scene otherwise documented in the Paris Gregory (fig. 88), the inscription "Ephrem" indicates otherwise: what we see is the meeting of Basil and Ephrem the Syrian. This meeting, described in the account of Basil's life attributed to pseudo-Amphilochios, initiated a long friendship, but was beset with difficulties. Ephrem, praying in the desert, asked God to lead him to Basil; a column of fire appeared in the sky, and God replied "Ephrem, Ephrem, where you see this column of fire, there is the great Basil." Ephrem journeyed to Caesarea with an interpreter because his Greek was inadequate, and arrived in Basil's church at Epiphany. No column of fire appeared, so Ephrem tucked himself away in the corner of the church. Basil, meanwhile, asked his archdeacon

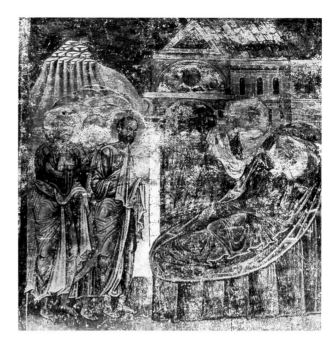

91 . St. Basil's dream. Hagia Sophia, Ohrid.

to go to the west door of the church and bring the man there to the sacristy. The disappointed Ephrem refused to go. Then, as Basil expounded the holy books, tongues of fire shot from his mouth; Ephrem was persuaded to come to the sekreton to see this miracle and realized that God's words had been fulfilled. Basil greeted Ephrem as the "father of the sons of the desert" and offered him communion; shortly thereafter, Ephrem was consecrated as priest, and immediately and miraculously became fluent in Greek (PG 29:cccx-cccxi). The Menil scene presumably shows the initial meeting, a scene that we know from inscriptions once adorned the walls of the New Church of Tokali. Though the painting no longer survives—and thus cannot help us reconstruct the Menil image—both attest, again, to the wide diffusion of the pseudo-Amphilochios vita and its impact on hagiographic cycles of Basil's life. The Tokali sequence, described above, also suggests that the remaining scenes of the lowest register of the Menil icon may have shown the conclusion of the saga of Basil and Ephrem, the story of the sinful woman and the miracle at Basil's funeral. Certainly Basil's funeral would be an appropriate episode to include on the icon—it was one of the most frequently represented moments of

92. St. Basil celebrating Mass. Hagia Sophia, Ohrid.

his life (figs. 72, 81–87, 89, 90), and death or funeral scenes form a standard part of most hagiographical cycles [42]—and it could fit nowhere else on the panel. The combination of these two scenes would also emphasize the liturgical theme of the Menil icon, for, from the early eleventh century, the Orthodox service used Basil's liturgy only at certain specified times, and two of these were Epiphany (when Basil met Ephrem) and 1 January (Basil's feast day, the date of his death). [43]

Immediately below the image of Basil writing, descending down the right side of the frame, we see part of a figure wearing a polystaurion, a mantle covered with crosses reserved for bishops (fig. 64). This man, whom we may identify as Basil by his facial type and ochre omophorion with round-headed cross decoration, stands in front of a badly damaged building and inclines his upper body slightly toward the right. It seems most likely that the scene represents Basil performing his liturgy, leaning forward over the altar. Such an identification accords well with the placement of the scene beneath the portrait of Basil writing, and reiterates the liturgical theme of the Menil icon.

It is impossible to identify securely the remaining four scenes. Interestingly enough, however, the painter invariably placed Basil on the inner edge of the composition, toward the central portrait; he is therefore always visible even when most of the scene itself has disappeared. In fact, the scene below the one we have tentatively identified as Basil performing his liturgy, nearly all of which has perished, retains only the inscription "Basil" (fig. 66).

A little more survives on the left frame, and once again Basil plays the leading role. Just below his baptism, he is shown moving toward the center of the icon (fig. 63). Though the architecture above his head and the red building—identifiable as a church by the green stepped structure attached to it—to his right indicate that this is an interior scene, it is difficult to identify. Parallels with the rightmost image of the second register in the Paris Gregory (fig. 72) may suggest that this scene represents Basil's exile during the reign of Valens; if so, however, it is exceptionally represented in an ecclesiastical setting.

Below this, Basil raises his arms in prayer or supplication (fig. 65). We no longer know for whom (if anyone) he prays, and most of the intervening paint has flaked off the gold ground. We can, however, tell that he is not behind an altar, but in some sort of secular architectural setting. Basil performed a number of miracles and it seems likely that at least one of these was once included on the Menil icon. Most of Basil's miracles took place in church, but the miracle of Basil's brother Peter occupied several days and transpired in three distinct locations, two of which were secular. A long and complicated account of this miracle appears in the pseudo-Amphilochios vita (PG 29:cccxiii): briefly, a group of "disturbers of souls" accused Peter, bishop of Sebastina, of cohabiting with his (unnamed) wife, and Basil arrived to prove that, though the couple lived together, they did so as brother and sister. After a discussion with Peter's wife at the "house of the bishop" (our first possible secular location), Basil takes Peter and five other men to the church to sleep the night. He awakens the five in the dark, and they all observe angels flying around Peter's bed. The next morning, Basil gathers everyone together and asks for an iron cauldron and places it over the fire. He asks Peter and his wife for their outer garments, which he then tosses into the cauldron. The garments are unharmed; the five men

tell the crowd about the angels over Peter's bed; the couple is exonerated; and Basil glorifies God and goes home. It is possible that we see the detritus of either the first or last episode of that miracle (also represented, though differently, in the Temple of Fortuna Virilis) here.

The lowest scene of the left frame shows Basil standing behind an altar speaking to a youthful male (fig. 67). Walter suggested that this might represent Basil reciting the prayer of the Proskomide;[44] it could equally well picture another liturgical scene, either a specific moment of the rite as portrayed at Ohrid (fig. 92) or a generic scene of Basil saying mass. Other possibilities include the first moment of the Ephrem sequence, which continues below on the lower register; Basil's prayers against Julian the Apostate; or one of Basil's conversions. In short, there are a number of episodes in Basil's life that this scene *could* allude to, but in my opinion there is insufficient evidence to argue forcefully for any one of them.

While it would be foolish to argue that there were never any other examples of historiated Basil icons, it seems unlikely that the Menil Basil is the lone survivor of a very large group, the rest of which has since perished. I would suggest instead that there were not many icons like this one, and I base this thesis on two observations. First, saintly portraits surrounded by hagiographical cycles were not common in Byzantium. Nearly all Byzantine examples date around the time of the Menil example (ca. 1200) and were evidently occasioned by a particular set of circumstances. Second, Basil cycles in any medium are rare. Aside from the Menil icon, only one other pictorial vita of Basil still exists in full. Three more cycles remain in fragmentary state; and a small handful of monuments illustrate isolated narrative scenes from Basil's life. Most of these images are in manuscripts containing Gregory of Nazianzus' funeral oration to Basil (or, as in the *Sacra Parallela,* excerpts from this sermon); a small number of liturgical rolls include images of Basil performing the liturgy. Mural cycles or isolated scenes—which have a public function more analogous to the role of an icon—exist in only four churches: two in Cappadocia, where Basil was of course revered as one of their own; one in Rome, done under a pope who had a particular

affection for Basil; and the liturgical scene(s) of Basil celebrating mass in the sanctuary at Hagia Sophia, Ohrid. The Menil icon does not, then, perpetuate a very common form; it does not belong within a large iconographical group, and it stands alone among Basil cycles in its icon format.

The Menil icon also stands alone in its particular interpretation of Basil's life, for the frame images do not follow known traditions of Basil iconography. While the tentative identification I have offered of one scene on the Menil icon relies on visual parallels with the Paris Gregory, I would not argue that the icon follows this manuscript tradition. Just as remnants of any picture of the Expulsion would allow us to identify another image as a depiction of the Expulsion without requiring us to say that the two versions were closely related to each other, the similarities that exist between icon and miniature are sufficient to identify scenes, but not to identify a direct prototype for the icon. Indeed, most scenes on the icon do not figure in Gregory's account of Basil's life. Similarly, while at least two scenes on the icon demonstrate that its designer knew the pseudo-Amphilochios vita, there are no obvious connections between the Menil compositions and other pictorializations of this text. And, again, many scenes on the icon do not derive from the pseudo-Amphilochios text.

Instead, these scenes, I would argue, were selected and "invented" for an icon, and quite possibly this icon. Liturgical episodes, conspicuously missing from other narrative cycles of Basil's life, dominate the Menil icon. Starting with Basil's baptism, we next see his consecration as bishop, probably his composition of the liturgy, and, apparently, his performance of it, before ending with his delivery of mass interrupted by Ephrem and, perhaps, his funeral. These scenes would be perfectly appropriate to any narrative of Basil's life, but only as part of a larger whole. Here, however, they replace episodes accorded far greater importance in both visual and textual accounts of Basil's life— the account of his parents' exile, his education in Athens, his baptism of the Jew Joseph, and so on. The stress on Basil's liturgical rites of passage (so to speak), and on events in Basil's life commemorated by the use of his liturgy in the Orthodox service, is certainly not found in other narrative editions

of Basil's life, even those on church walls or in manuscripts such as the liturgical homilies of Gregory of Nazianzus destined for liturgical use. From this we may conclude, I think, that the icon was designed for its ultimate resting place in a church, and that a certain amount of care was taken to emphasize the parts of Basil's life that linked him with church ceremonial. In order to achieve this, the Menil painter, I would argue, "invented" a lot of scenes.

Invention is perhaps too strong a word to use in this context, for, though the Menil painter does not appear to have relied on some illustrated vita of Basil, the icon is closely related to other icons, particularly those detailing the life of Nicholas. Like the Menil icon, the Nicholas cycles do not closely follow any one text; unlike the Menil icon, there are a sufficient number of Nicholas icons (Ševčenko catalogued nine) that we may observe broad patterns. As Ševčenko noted, one significant feature of these icons is their consistency, and this consistency argues for a strong workshop tradition.[45] A painter steeped in this same tradition, with training similar to that received by the painters responsible for the Nicholas icons, must have compiled the Menil Basil.[46]

The substance of this article was originally presented at the Fourteenth Annual Byzantine Studies Conference, in a session organized by Thalia Gouma-Peterson, whom I thank for thus prompting my interest in the Basil icon. I should also like to thank the staff of The Menil Collection, who facilitated my examination of the icon while it was still in storage; Nancy Ševčenko, for her comments on an earlier version of this article; and Chris Wickham, for his comments and help with the Latin texts.

1. So Walter (1978a), 248–249; on vita icons in general, see also Ševčenko (1983), 162–165 and the cautionary remarks on 170–171.

2. Buchthal (1963), 83, 86–89; Weitzmann (1976), 48–49. The type continued throughout the Byzantine period, and ultimately appeared in the *Painter's Manual* by Dionysios of Fourna: for a fourteenth-century example, see Underwood 3 (1966), fig. 479.

3. Walter (1982), 9–13.

4. See the Mount Sinai icons portraying Nicholas and John Chrysostom (B.33, seventh-eighth century), Theognios (B.38, eighth-tenth century), and Nicholas (B.52 and B.53, both of the tenth century) (Weitzmann [1976], 58–59, 65–66, 83–87, pls. XXIV, XXXIII, XCII, CIX); and portraits of Basil on the late ninth- or early tenth-century Palazzo Venezia ivory casket (Cutler and Oikonomides [1988], 77–85; Maguire [1988], 89–93), the eleventh-century Harbaville triptych (Buchthal [1963], fig. 9; Kalavrezou-Maxeiner [1977], 320–321), and the eleventh-century Paris. gr. 533, f.91r (Galavaris [1969], fig. 248).

5. E.g., the Sinai icon B.58, all portraits of Basil in the ninth-century *Sacra Parallela*, all but two portraits in the so-called liturgical Homilies of Gregory of Nazianzus: Weitzmann (1976), 95, pl. XXVI; Weitzmann (1979), figs. 565–567, 569–590, 646–647; Galavaris (1969), figs. 153, 157, 158, 159, 222, 224, 227, 260, 309, 328, 388, 399 (the omophorion in this image may be asymmetrical; it is largely obscured by a book), 415, 461 all show straight-armed crosses; figs. 114, 268, 282, 363 embellish the omophoria of both Basil and Gregory with angular crosses with triangular arms.

6. Demus (1949), fig. 7A; Mount Athos, Panteleimon 6, f.115r: Galavaris (1969), fig. 152. The remaining portraits of Basil in this manuscript display rectangular crosses on the omophoria.

7. Walter (1982), 14–17.

8. Walter (1982), 19–22.

9. While it is tempting to speculate that Basil holds his famous liturgy, the codex format suggests a Gospelbook rather than a liturgical roll. On the lectionary, see now J. Cotsonis, "On Some Illustrations in the Lectionary, Athos, Dionysiou 587," *Byzantion* 59 (1989), 5–19.

10. PG 36:493–605; trans. *Nicene and Post-Nicene Fathers*, ser.2,7 (reprint Grand Rapids, 1978), 395–422.

11. Milan, Ambrosiana E.49/50 inf., p. 220: Grabar (1943), pl. XXIV, 1. As indicated above, the arrival of the deer and birds represent two discrete moments in Gregory's narrative.

12. Mount Athos, Panteleimon 6, f.105r: Galavaris (1969), 130, fig. 151.

13. Panteleimon 6, f.115r: Galavaris (1969), 130, fig. 152.

14. Mount Athos, Panteleimon 6, ff.132r (riders) 134v, 135r, 138v (healing); Paris. Coisl. 239, ff.100v (2 scenes), 101v (Valens and prefect): Galavaris (1969), 127–128, figs. 153, 156, 157, 159, 222, 224, 225.

15. Panteleimon 6, f.138r: Galavaris (1969), 128, fig. 158.

16. The two scenes in the Panteleimon Gregory share a frame; for references, see previous note.

17. These scenes are not related to those in the Paris Gregory. Paris. gr. 923, ff.299v, 300r: Weitzmann (1979), 230, 235, figs. 646–647.

18. Turin C.I.6, f.89v; Mount Athos, Panteleimon 6, ff.140r, 140v; Paris. Coisl. 239, ff.104v, 105r: Galavaris (1969), 128–129, figs. 160, 161, 227, 223. The Turin image is described but not illustrated by Galavaris.

19. Galavaris (1969), 46–51, figs. 11, 114, 130, 149, 221, 260, 268, 282, 309, 328, 349, 363, 388, 415, 417, 461.

20. PG 29:ccxciv–ccxvi. This text was first connected with images of Basil by Jerphanion (1931), 535–558; for a recent discussion, see Walter (1978a), 245–250.

21. Paris. gr. 510, f.409v. Full discussion of this page appears in my forthcoming monograph on the Paris Gregory.

22. Lafontaine (1959), 35–40, pls. XI–XII; Trimarchi (1978), 668–670, pls. IX–X.

23. Jerphanion (1931), 535–558; Jerphanion II, 1 (1936), 52–53; Epstein (1986), 26, 36–37, 77–78, figs. 108–109.

24. For the reidentification of this scene, earlier described as Basil's funeral, see Trimarchi (1978), 668–669.

25. See Walter (1978a), 247, 260.

26. PG 29:ccci–cccii; reproductions in Hamann-MacLean and Hallensleben (1963), pls. 24–25. Grabar (1965), 261–264 argues that both scenes show Basil; Walter (1982), 100, 112, 193–195 follows earlier readings and argues that only the second of these scenes shows Basil.

27. For the liturgical rolls: Grabar (1954), 163–199, esp. 167–172; Mouriki and Ševčenko (1988), 289–291. For the *Sacra Parallela* (Paris. gr. 923, ff.11v, 204r, and see also 272r where Basil is flanked by the subjects of his sermon): Weitzmann (1979), 212–213, figs. 565, 567, 570.

28. E.g., Milan, Ambrosiana E.49/50 inf., p.128: Grabar (1943), pl. XI, 1.

29. See Walter (1980), 8–25; idem (1982), 125–130.

30. For examples in the marginal psalters and on one of the Grado ivories, see ibid.

31. See Ševčenko (1983) and Walter (1978a); most examples appear in the idiosyncratic Paris. gr. 510.

32. For a convenient and succinct description of the consecration ceremonies, see Ševčenko (1983), 80–82;

for a broad overview, Walter (1978b), 108–125; idem (1982), 130–136. It is worth noting that the vita texts emphasize neither Basil's ordination to the priesthood nor his consecration as bishop: see note 37 below.

33. Ševčenko (1983), 81.

34. Ševčenko (1983), 76–85; for the other examples, ibid., 82 and note 25.

35. Ibid., 82. Ševčenko rightly excludes the Paris Gregory from this dependence.

36. *Pace* Walter (1982) 130, who incorrectly identified a scene in the Milan Gregory as the consecration of Basil.

37. Gregory gives no details of Basil's consecration, but rather focuses on his own father's participation in the ceremony. The pseudo-Amphilochios vita is more informative. First, it tells us, Basil was ordained deacon by Bishop Meletios of Antioch; he then journeyed to Caesarea where Bishop Leontios had a vision that indicated Basil would succeed him and, on Leontios' death, he did (PG 29:ccc–ccci).

38. E.g., the fourteenth-century icon at Skopje: Ševčenko (1983), 50–52, pl. 37.1/3. Double, and sometimes triple, consecrations appear in Nicholas sequences: ibid., 76–82.

39. Ševčenko (1983) includes diagrams of over forty Nicholas cycles, few of which proceed in chronological order.

40. Such an approach was quite common in Byzantine hagiographical and ekphrastic texts: see, for example, Rouan (1981), 415–436; Brubaker (1989), 19–26.

41. Walter (1978a), 249–250.

42. On the death of Nicholas, for example, see Ševčenko (1983), 134–142; in general, see Walter (1976), 113–127.

43. See Mouriki and Ševčenko (1988), 298–290.

44. Walter (1978a), 249.

45. Ševčenko (1983), 172–173.

46. To end on a speculative note: the earliest icon of Nicholas' life—an eleventh-century fragment at Mount Sinai (Ševčenko's no. 1)—displays so many similarities with the Menil Basil that, despite their stylistic differences, it is tempting either to see them as products of the same workshop tradition or to suggest that the Menil painter knew something very like the earlier Sinai icon. Both include the curious stepped structure to indicate a church interior, use similar architectural formulas (flat roofs marked with hatching, gold lozenge patterns on exterior walls and, less idiosyncratically, red altars), and the consecration scenes resemble each other as well: Ševčenko (1983), 29, 32–33 (diagram), 81–85, pls. 1.1–6.

Bibliography of Sources Cited

L. Brubaker, "Perception and Conception: art, theory and culture in ninth-century Byzantium," *Word and Image* 5/1 (1989), 19–32.

H. Buchthal, "Some Notes on Byzantine Hagiographical Portraiture," *Gazette des Beaux-Arts* 62 (1963), 81–90.

A. Cutler and N. Oikonomides, "An Imperial Byzantine Casket and Its Fate at a Humanist's Hands," *Art Bulletin* 70 (1988), 77–87.

O. Demus, *The Mosaics of Norman Sicily* (London, 1949).

A. W. Epstein, *Tokali Kilise, Tenth-century Metropolitan Art in Byzantine Cappadocia,* Dumbarton Oaks Studies XXII (Washington DC, 1986).

G. Galavaris, *The Illustrations of the Liturgical Homilies of Gregory Nazianzenus,* Studies in Manuscript Illumination 6 (Princeton, 1969).

A. Grabar, *Les miniatures du Grégoire de Nazianze de l'Ambrosienne (Ambrosianus 49–50),* Orient et Byzance IX (Paris, 1943).

———, "Un rouleau liturgique constantinopolitain et ses peintures," *Dumbarton Oaks Papers* 8 (1954), 163–199.

———, "Les peintures murales dans le choeur de Sainte-Sophie d'Ochrid," *Cahiers archéologiques* 15 (1965), 257–265.

R. Hamann-MacLean and H. Hallensleben, *Die Monumentalmalerei in Serbien und Makedonien vom 11. bis zum frühen 14. Jahrhundert,* Osteuropastudien der Hochschulen des Landes Hessen II: Marburger Abhandlungen zur Geschichte und Kultur Osteuropas 3–5 (Giessen, 1963).

G. de Jerphanion, *Une nouvelle province de l'art byzantin. Les églises rupestres de Cappadoce,* 2 vols. in 4 parts (Paris, 1925–1942).

———, "Histoires de Saint Basile dans les peintures cappadociennes et dans les peintures romaines du moyen âge," *Byzantion* 6 (1931), 535–558. A slightly more detailed version of this article appeared in *La voix des monuments* (Rome and Paris, 1938), 153–173.

I. Kalavrezou-Maxeiner, "Eudokia Makrembolitissa and the Romanos Ivory," *Dumbarton Oaks Papers* 31 (1977), 305–325.

J. Lafontaine, *Peintures médiévales dans le temple dit de la Fortune Virile à Rome* (Brussels and Rome, 1959).

H. Maguire, "The Art of Comparing in Byzantium," *Art Bulletin* 70 (1988), 88–103.

D. Mouriki and N. P. Ševčenko, in A. D. Kominos, ed., *Patmos, Treasures of the Monastery* (Athens, 1988).

M.-F. Rouan, "Une lecture 'iconoclaste' de la Vie d'Etienne le jeune," *Travaux et mémoires* 8 (1981), 415–436.

N. P. Ševčenko, *The Life of Saint Nicholas in Byzantine Art,* Centro Studi Bizantini Bari, Monografie I (Turin, 1983).

M. Trimarchi, "Per una revisione iconografica del ciclo di affreschi nel Tempio della 'Fortuna Virile'," *Studi medievali* ser. 3, 19 (1978), 653–679.

P. Underwood, *The Kariye Djami,* 3 vols., Bollingen Series LXX (New York, 1966).

C. Walter, "Death in Byzantine Iconography," *Eastern Churches Review* 8 (1976), 113–127.

———, "Biographical Scenes of the Three Hierarchs," *Revue des études byzantines* 36 (1978a), 233–260.

———, "Church Appointments in Byzantine Iconography," *Eastern Churches Review* 10 (1978b), 108–125.

———, "Baptism in Byzantine Iconography," *Sobornost* 2/2 (1980), 8–25.

———, *Art and Ritual of the Byzantine Church,* Birmingham Byzantine Series I (London, 1982).

K. Weitzmann, *The Monastery of Saint Catherine at Mount Sinai, The Icons I: From the Sixth to the Tenth Century* (Princeton, 1976).

———, *The Miniatures of the Sacra Parallela, Parisinus Grae cus 923,* Studies in Manuscript Illumination 8 (Princeton, 1979).

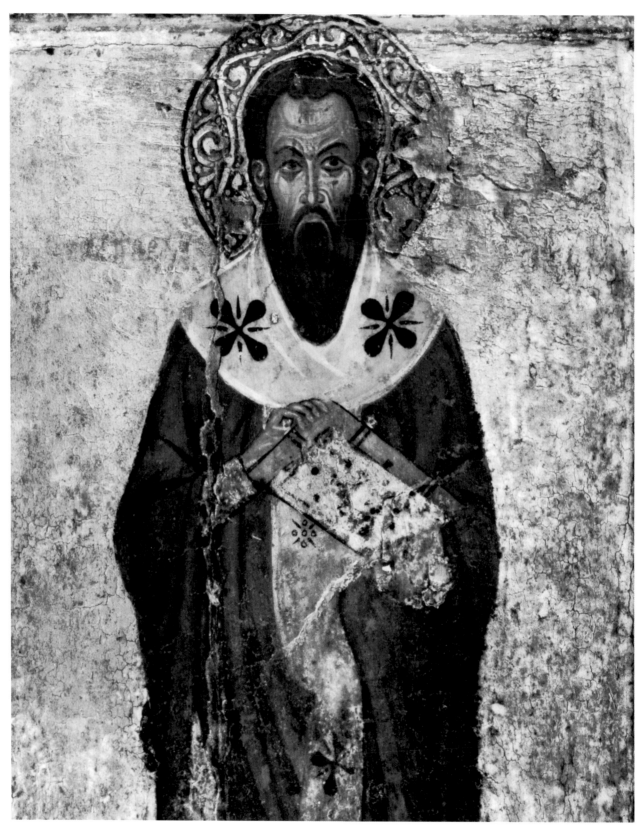

93. St. Basil icon (detail of head and omophorion).
The Menil Collection, Houston.

The Vita Icon of Saint Basil:

Notes on a Byzantine Object

ANNEMARIE WEYL CARR

The collection of icons in the Menil museum is distinguished by its Byzantine examples. [1] Though Byzantium created the icon as a form of art, it is rarely given the central role that it deserves in studies of this medium. Byzantine paintings survive only in very small numbers. Especially rare are icons from the formative, Middle Byzantine period of the ninth through the thirteenth centuries; very few of them survive in anything reliably resembling their original context of use, and their technical data are as yet little published. Many still await the reproduction in color that is so crucial to their effective study. Thus the history of the panel painting in Byzantium has yet to be written, in terms of both its technical attributes and its relation as a medium to the functions and messages that the "icon" as a genre came to assume. [2] The present article examines one Middle Byzantine icon (pl. 3, fig. 93), a panel from the period around 1200 showing the fourth-century bishop and Church Father, Saint Basil of Caesarea (ca. 329–379), surrounded by scenes from his episcopal life. [3]

The icon is painted on a single panel of pine wood 3 cm thick. Today it measures 68 by 36 cm; its height is original, but its width has been reduced. The saint himself occupies a rectangular depression some 5 mm deep in the panel's center, while the scenes from his life occupy the borders framing this depression. The panel has warped hardly at all. It has, however, suffered from other depredations. A blackened concavity in the lower right side of its front face records a burn, most likely ignited from a candle placed before the image. The painted face of

the icon's lower border has been removed along with several millimeters of the wood's thickness, perhaps in an ineffectual effort to even the surface to the level of the burned area. Both vertical borders of the panel have been ravaged throughout their length by worm-holes. The left side of the panel was at some point trimmed, presumably in an effort to shave off the ragged, worm-eaten margin; the right side is virtually lacy with damage. [4] It is clear that the two sides have been substantially diminished by the worm damage, and that the panel was originally wider than it is now. Its original measurements were carefully conceived: the central rectangle occupied by Basil measures 45 by 23 cm, constituting in essence two squares of about 22 by 22 cm; the top and bottom borders in turn measure 11 cm each, adding another 22 cm to the height of the panel. If one imagines the borders at either side being 11 cm wide, as well, the outer measurements of the panel would assume a proportion of 2:3, a relationship that is encountered in icons elsewhere. [5] Under these circumstances, the left border would have been some 5 cm wider than at present, and the right one 4 cm.

The front of the panel was entirely covered with cloth before being coated with gesso; the back of the panel was coated with gesso as well, though over the bare wood. [6] Two battens, each 3 cm wide, ran across the back at a distance of 3 cm from top and bottom of the panel; the wood is bare where they were. They probably belonged to, or were used to affix the icon to, its setting. The 3-cm width is repeated then in a series of painted stripes,

now barely visible, that ran horizontally across the back, white stripes separated by alternating stripes of brick-red and green. The stripes suggest no more than a simplistic finishing off of the back, and do not imply that the icon was to be admired equally from both sides. Only one nail hole remains in the path of each of the battens, placed directly in the center. Assuming that two further nails anchored the two ends of each batten, Laurence Morrocco, the conservator, postulated that the original panel had been wider than at present; his estimate, though produced independently, yielded the same dimensions suggested above. Several more recent nail holes, one still containing a bit of a metal nail, pierce the icon near its present edges, but their placement is random and they remain ambiguous in function and date.

The front of the panel has been gilded and painted in tempera. The gold was laid directly on the gesso, giving it a pale, cool tone that is enhanced in the central rectangle by its extensive loss. The gold was laid on in leaves; especially in the scenes along the left side of the icon, one can see how Basil's hands and the edges of his head have flaked off the metal, leaving the leaves' quadrangular shapes clearly visible. The halo of the central figure of Basil was also originally gilded. The halo is exceptional in being worked in relief, in pastiglia, or fine gesso. [7] The pastiglia was dribbled or squeezed onto the surface in scrolling patterns with smooth, bloblike ends. The halo's outer contour was outlined in black. In addition, a dark oil or varnish that was applied at some time to the entire gilded surface has settled especially densely in the hollows of the pastiglia, casting it into sharp relief and lending it particular luminosity even though most of the gold has now rubbed off of its smooth surfaces. The fact that the halo overlaps the frame need not be a sign of negligence: one finds the same in no less a work than the icon of Christ by Theodore Apseudes. [8] And in fact, the figure of Basil is carefully laid out in four 11-cm increments—from the top of the halo to the tip of the beard; from the tip of the beard to the fold of the omophorion, from the fold of the omophorion to the hem of the phelonion, and from there to the feet. His narrow shoulders, too, measure 11 cm across. As such, he echoes the dimensions of the panel as a whole.

The colors in the panel are few and used recurrently. Brick, olive, brown, ochre and a bright vermilion dominate; violet and blue-green appear, as well. In their warm tonality, spiced with the hot red of the vermilion, they produce a warm, resonant effect against the gold. Applied at consciously modulated intervals, they yield a decorative, rhythmic play of pattern. All major colors are united in Basil, who draws the panel together into a coherent whole. One sees this in his costume; more impressively, one sees this in Basil's long, powerfully modelled and imposing face. Red, olive, brown and ochre play across his features in deft contrasts, enhancing one another mutually and drawing the full color range of the panel to a focus. Here as in his measurements, Basil orchestrates the whole.

Coloristically, Basil is somber and strong. His costume is the one traditional for Byzantine bishops through the twelfth century, while its dark color is traditional for Basil himself. He wears a brick-red sticharion, simply streaked with a darker variant of the local color to suggest folds. A golden epitrachelion falls over the front of the sticharion, the sleeves are gathered in golden cuffs or epimanikia, and a triangle of gold—the epigonation—is visible above Basil's right knee. His heavy phelonion is brown. The local color here is a not wholly opaque brown applied over the gesso ground; the folds are sketched with strokes of slightly darker, more opaque brown that are sometimes reinforced with lines of black, and the highlights are brushed on in a thin, very smooth layer of opaque olive green whose edges dissolve against the brown. Over the phelonion is the Saint's episcopal insignia, the omophorion. Theoretically white, it is painted ochre here, its yellow hue contributing significantly to the warm tonality that unifies the panel. Only its highlighted edges are brushed with thin white, the pale curves drawing attention to Basil's head (fig. 93). The book is gold with vermilion edges. The saint's heavy beard is opaque brown. His fingers are ochre, tipped with a rosy red that is composed of fine dabs of both brick and vermilion; one can see the outline of the fingernail at the end of each.

Basil's face, finally, is the most intricately composed passage in the painting, building in thin lay-

ers of saturated ochre and brick over the olive-green proplasmos. The brows are brown; strokes of creamy ochre create the highlights; red lines establish the hollows above the eyes; and tiny dabs of brick and vermilion lend an almost cosmetically lush, rosy glow to nose and lips. Though intricately composed, the face has a smooth surface in which pure color dominates depth of any kind: the medium does not accumulate in any perceptible thickness, and brushstrokes are not used to produce any plastic modelling.

Only to a limited extent is color used to create depth in the panel. One sees this in Basil's features, where the robust play of vermilion and brick along the ridge of his nose brings out its projection forcefully, and his dark eyes recede beneath the richly modelled brows. But above all, color provides the rhythmic framework within which the panel's powerful surface pattern is composed. Here once again, Basil's relation to the panel as a whole is carefully conceived. An initial impression of the figure as composed in depth, his brick-colored sticharion advancing before the low green wall at his feet, is challenged by the silhouette-like sharpness with which his brown phelonion is projected against the gold. The surface is asserted, too, by Basil's head, which—far from receding—builds from the surface forward. The robustly modelled head and heavy, dark body, for all their density, are flattened as if by the sheer intensity of their luminous setting into a wraithlike silhouette on the surface. Its contour uneventful, its shape steep and vertical, this haunting silhouette echoes the severe verticality of the central rectangle. The silhouette of the saint, then, is laced to the frame as element after element of shape and color tie it to the play of the smaller, more active patterns in the surrounding scenes. The sweep of Basil's omophorion in the upper scene on the left frame echoes the sweep of the omophorion across his shoulders in the central panel; the diagonal of his phelonion in the scenes below echoes the inward diagonal of the phelonion's hem in the central figure; above all, the play of vermilion creates a vivid, syncopated rhythm around the main figure. How consciously the artist developed these rhythms can be seen in his division of scenes in the two side frames: evenly cadenced on the left, they are unevenly divided with an elongated

upper scene on the right to echo the angle of the book and Basil's rightward gaze. This rhythmic play of colors and shapes on the surface, binding the still figure at the center to the lively activity of the frame and the activity of the frame to the looming saint in the center, forms a cardinal component in the icon's effectiveness, quite overwhelming issues of space and recession. The significance of color and surface is reinforced by the quality of the paint itself—smooth and glossy even at its most complex—in the face of Basil. It is consistently laid on as color, with none of the job of modelling plastic surfaces that is found in the fine, dry strokes of Italian tempera on panel.

It is the character of the modelling, especially in Basil's face, that suggests a date for the painting. A rough index to chronology is provided already by the very format of the image, with its central figure surrounded by scenes from his life. This kind of panel, known as a "vita icon" for its inclusion of scenes from the saint's life, made its appearance in Byzantine art only toward the end of the twelfth century; our earliest surviving examples are two large, late twelfth-century icons of Saint Nicholas and Saint George on Mount Sinai.[9] A cluster of vita icons follows these in the ensuing century, including panels not only of the great wonder-workers Nicholas and George, but of the desert saint Marina and Sinai's patron saint, Catherine. Though the vita icon continued to be produced in the fourteenth and fifteenth centuries, its vogue seems to have abated then; only slightly over a dozen such icons survive from the whole of Byzantium. Their chronological distribution in itself points to the later twelfth or thirteenth centuries as the most likely time for the production of our icon of Saint Basil. This chronology is sharpened and confirmed by the character of the modelling in the face.

Notable in the face of Basil are the intensity of the colors used in the modelling—in particular the strong red, olive, and creamy ochre—and the vigor of the patterns produced with them. The patterns themselves are best known in twelfth-century art; the icon of Saint Nicholas from Mount Sinai itself gives us a good picture of them:[10] the asymmetrical furrows emanating from the wings of the nose, the little diagonals running to the cheeks from its ridge, the heavy pouches under the eye, the ruddy lines

on the cheeks running into the beard, the actively rumpled brow. The linear composition of facial modelling like this was a stylistic device of the twelfth century and especially of the second half of the twelfth century, where it is seen well in wall paintings. [11] The pattern of the highlights in Basil's face is asymmetrical, producing a distinct and not entirely appealing sneer. This very asymmetry makes the expression riveting, however. Tense and impossible of easy resolution, the face challenges ever renewed examination. In this, we sense the uniqueness of what seems at first to be a highly standardized work. [12]

In the face of the Saint Nicholas at Sinai (fig. 94), such lines are essentially modelled in terms of value. Along the nose and in the hollows above the eyes, the lines are colored, but elsewhere—as most visibly in the cheeks—value and color function separately. In the face of Basil, the patterns are much the same, but they are creations as much of color as of line. This amalgamation of color and line has been studied above all in the icons of Cyprus, where it can be dated quite clearly. Anticipated in the daring colorism of Theodore Apseudes's great icon of Christ from Lagoudera of 1192, [13] one sees it fully developed in the slightly later icon of the Archangel from the monastery of Saint Chrysostom, now missing but well reproduced in color by Papageorghiou. [14] The intensity of red and green in these icons recalls the Saint Basil at once. A comparable forcefulness is seen in the icon of the Way to Calvary, also from Cyprus. [15] That a comparable richness of modelling was being practiced elsewhere, however, is indicated by the sequence of icons from Mount Sinai showing the Virgin of the Bush being venerated by a standing saint. As exemplified by the icon with Isaiah reproduced by Weitzmann, [16] these works exhibit in their faces a colorism in which luminosity and spontaneity of brushstroke enliven traditional twelfth-century linear patterns.

In the course of the thirteenth century, the Cypriot painters sharpened the linearity of their faces, losing much of the spontaneity of these early thirteenth-century examples. [17] Icons now on Mount Sinai from the thirteenth century, in turn, retain the richness of ductus, but subsume it in a technique that emphasizes volumetric continuity over line

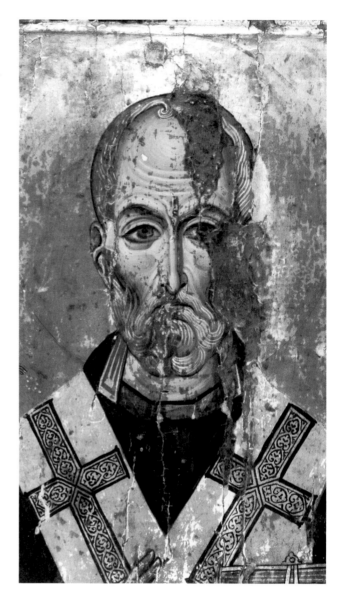

94. St. Nicholas vita icon (detail of head). Monastery of St. Catherine, Mt. Sinai.

itself. [18] In the icon of Basil, the modelling enlivens the surfaces of the face, bringing every segment of it into aggressive play. But it does not marshal the masses of the head, as does that of the thirteenth-century icons on Sinai, and so the icon of Basil seems to find a more apposite place earlier, in the years around 1200.

This attribution may be reinforced by the kinship that unites the figures in the small scenes of the border with those in such "decorative style" manuscripts as Chicago, University Library, cod. 965. [19] Notable here are three factors. One is

the preference for simple forms, colored in warm tones with very little surface modulation. Another is the radical inconsistency of the painted surface. Some surfaces in the "decorative style" books are finely modelled, with lines of both darker local color and white, like those in the sticharion of the figure who bends toward Basil in the bottom scene in the left border of the icon. The sticharion of this figure forms a sharp contrast to the unmodulated brown of his phelonion; precisely the same kind of awkward contrast is seen in the manuscripts. Both surfaces, in turn, contrast with the gummy transparency of the red worn by the figure just above the head of Basil in the upper border. This kind of contrast, too, figures in the manuscripts. [20] Third, the round, rudimentarily modelled but expressive faces like the two who watch the Baptism scene in the upper border of the icon find ready parallels in the manuscripts. [21] Though not securely dated, the Chicago manuscript surely falls into the second half of the twelfth century, and so reinforces the attribution suggested for our icon.

Among vita icons, our image of Basil is notable in scale—it is among the smallest of the surviving vita icons from the late twelfth and thirteenth centuries. [22] It is also notable in its subject. Portable icons devoted to Saint Basil alone are rare in the extreme. Though represented repeatedly in the company of the great Church Fathers, of whom he was himself the greatest, Basil was rarely presented by himself. The name of the central figure in our icon, in fact, is no longer legible, its red letters quite effaced from the film of gold on which they were traced. The letters ... Βασι ... [Basi...] in the lower scene of the right frame suggest the name "Basilios," however, and there can be no question but that this is correct. Not only the physiognomy of the figure, with his high forehead, brown hair, and heavy, full brown beard, but the posture identify him as Basil. [23] Already in the eleventh century, we find Basil characteristically represented with his book held diagonally in both hands, and his omophorion gathered beneath it. The omophorion in these cases is not draped in the sharp "V" that is its most usual configuration, but is thrown softly around the neck in a curving form. This is Basil's form in the Menologion of Basil II (Vatican, gr. 1613) and in the slightly later mosaics of Kiev; [24] he assumes the same

posture at the center of a row of hierarchs on a steatite of the eleventh century; [25] he has very nearly the same pose—the book is upright but still held in both hands—in the Cappella Palatina in Palermo in the twelfth century; [26] he is seen again in this form in the late twelfth century at the church of the Hagioi Anargyroi in Kastoria; [27] and still in the fourteenth century, it is Basil who holds his book at an angle and drapes his omophorion in a soft curve, as attested in the silver frame of the steatite St. Demetrius in Leningrad and in the sonorous icon of the three hierarchs in Athens. [28] Usually—though not always—it is Basil, too, who wears the round-ended crosses on his omophorion. [29] The form of the omophorion on our icon, a semi-circular collar with a vertical strip falling from its border—is more usual in tenth- and eleventh-century representations of Basil than in later ones, [30] but it is repeated in several metal and steatite icons of the thirteenth century, [31] and it seems more likely to be a Byzantine form—a Byzantine form used with striking effectiveness in our icon—than to be a hybrid influenced by the "T"-shaped pallia of Crusader icons of bishops, especially Saint Nicholas. [32]

Though clearly showing Basil, then, our icon is exceptional in showing him alone, and even more exceptional in showing him in a vita icon. As noted, vita icons were not especially numerous in Byzantium. The class of saints chosen for this distinction is not readily defined, though it clearly includes both the patron saints of noted shrines—like Catherine at Sinai and Marina at Pedoulas—and above all great wonder-workers like Nicholas and George. Basil, for whom no tradition of relics existed in Byzantium so far as we know, [33] had a reputation as a wonder-worker, but one focused only in his native province of Cappadocia. Here, pilgrims still travelled in the Middle Byzantine centuries to the site of the church and hospital he built; [34] it is in Cappadocian churches that we find monumental cycles of Basil's life; [35] it was the Cappadocian noblewoman and nun, Eirene of Chrysobalanton, who conjured Basil in working her miracle of healing a possessed nun; [36] and it is in Cappadocian churches that one finds Basil imaged alone in separately framed votive murals. [37] This suggests Cappadocia as the likely place of origin for something as exceptional as a vita icon of Basil.

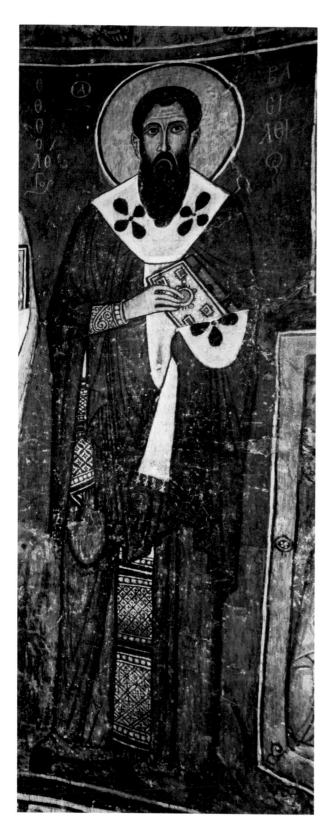

95. St. Basil (detail of apse painting). Panagia, Phorbiotissa, Asinou, Cyprus.

Our icon, however, is notable in emphasizing Basil's liturgical activities, and not his life as a wonder-worker. [38] Moreover, the artistic characteristics of our icon seem to find comparanda not in Cappadocia, from which we know almost nothing in the decades on either side of 1200, but in Cyprus. Several aspects of the icon suggest a Cypriot origin. One is the pastiglia halo. The history of pastiglia in Byzantium is as yet poorly understood; long believed to have been an import from Italy, it is now considered to be a Byzantine technique, and possibly a Constantinopolitan one: the mosaic icon of the Virgin and Child from the twelfth-century templon screen of the Pammakaristos Church in Constantinople originally had haloes of gilded stucco, now unfortunately replaced. [39] However, the only extensive group of icons using pastiglia that we know is the Cypriot group from the thirteenth century discussed most fully by Doula Mouriki. [40] The clumsy pattern of Saint Basil's halo is too rudimentary to invite careful comparison, but is nonetheless akin to that of the Virgin's halo in the early thirteenth-century Cypriot icon of the Koimesis from Pelendri, [41] and suggests a common, Cypriot origin.

A second aspect of the Saint Basil that invites a Cypriot attribution is the treatment of its gold ground. Laid directly on the gesso without a ground color, the gold in the icon is cool and pale. A similar preference for cool metallic grounds is found in Cyprus. A number of its icons actually have silver grounds, the silver laid directly on the white of the gesso, as in the early twelfth-century icon of St. John the Baptist from Asinou. [42] But other icons, like the Virgin by Theodore Apseudes, use a silvery gold, that seems to be without a colored ground. [43]

A third aspect of the icon that points to Cyprus is iconographic. Though Basil is shown on it in a form readily identifiable from monuments widely distributed through Byzantine art in both space and time, he finds remarkably immediate parallels in the churches of Cyprus. The figure of Saint Basil in the apse of the Church of the Virgin at Asinou from 1106 (fig. 95) already parallels in virtually every detail the figure on our icon: the posture with the diagonally held book, the treatment of the omophorion as a rounded collar, and its round-ended crosses are strikingly closely akin to those of our image. The same intimate kinship is

found in the imposing Saint Basil (fig. 96) of about two generations later in the Apostles Church at Perachorio in eastern Cyprus. [44] No other renditions of Basil are so closely similar to that of the icon as these.

A fourth aspect of the Saint Basil that points to Cyprus is the vigor of its facial coloring, a quality noted by Mouriki as characteristically Cypriot. [45] Further enhancing the icon's association with Cyprus may be its kinship with Chicago, University Library 965, recently attributed to Cyprus. [46] Notable finally is the fact that the icon was, apparently, in Egypt earlier in this century. [47]

At present, we know far more about Cypriot than about any other local traditions of icon painting in the twelfth and thirteenth centuries, and it is perhaps wise to defer final attribution of the Saint Basil until a more balanced field of comparison is possible. Nonetheless, we can cite one useful piece of evidence that individual icons of Basil were being made in places other than his cult site in Cappadocia. That a tradition did exist of imaging Basil by himself as a bishop and liturgist is suggested by a miniature on a liturgical scroll. The scroll, Athos, Dionysiou 105, is attributed to much the same date as that postulated for our icon. [48] The miniature prefaces the liturgy of Saint Basil, and shows a canopied icon stand on which is displayed an icon of Basil by himself (fig. 97, 98). The icon assumes the place occupied in other liturgical scrolls by an image of the living Basil, standing behind an altar, canopied by its ciborium, and celebrating his liturgy. [49] The icon in the miniature is diminutive. But it is notable that it is identical to ours: in posture, physical type, and coloring. Only the surrounding scenes are lacking. The two images can well be understood as reflections of a common tradition, a tradition showing Basil in his characteristic posture as bishop and liturgist, but depicted alone. The Dionysiou rotulus's place of origin is unknown, but its style is Constantinopolitan and thus implies a basis in the most widely diffused of Byzantine traditions— that of the capital. Thus icons of Basil (if not vita icons like ours) may well have existed in a variety of places.

The miniature may also cast light on the function of our icon. The image offers the most graphic

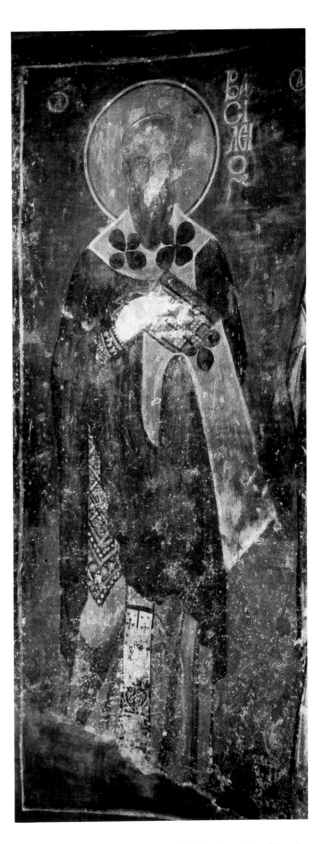

96. St. Basil (detail of apse painting). Apostles Church, Perachorio, Cyprus.

depiction that survives from the Middle Byzantine period of an icon in an icon stand, presented as an image for special veneration. Such images were known as proskynetaria. The location of their stands and their relation to the choreography of official worship are not well understood, but their existence is clearly indicated by monastic typika from the eleventh century onward. It must have been in such stands that the great name icons of Constantinopolitan churches like that of the Pantokrator Monastery were displayed;[50] by the same token, it must have been in a similar way—as the icons of patron holy powers—that many of the vita icons were displayed in the churches or chapels for which they were made. One might imagine our icon in such a context, its schematically painted back sufficing for its exposure when being moved to or from the stand but not inviting attention. Among vita icons, our image of Basil is notably small. But proskynetaria cannot have been very large, to judge from the intimate scale of the icon stands that survive in Byzantine churches and museums. In the case of the icon of Basil, the figure's strong, simple shapes stand up well over distance, making the object immediately impressive the moment it is seen. At the same time, as an object of modest size, it invites not distant but intimate contemplation. When encountered in this way, the image is again notably impressive, the vibrantly worked head and stark, imposing silhouette of the saint exerting a concerted power over its viewers. The icon is in this sense both public and personal. As such, it answers perfectly the requirements of the proskynetarion, marshalling both public recognition and private contemplation. And as such, it gives a good impression of the dual power of the Byzantine icon, public and immediately recognizable in form, yet personally compelling in address.

97. St. Basil in icon stand from a liturgical scroll. Dionysiou 105, Mt. Athos.

98. Detail of St. Basil in icon stand (fig. 97). Dionysiou 105, Mt. Athos.

1. I am deeply indebted to Carol Mancusi-Ungaro, conservator at The Menil Collection, for having spent a day examining the icon of Saint Basil with me. I owe my understanding of it as an object to her guidance.

2. Byzantinists owe an enormous debt to Kurt Weitzmann, whose sequence of magnificent coffee-table books on the icon constitutes our single truly significant corpus of reproductions in color of Middle Byzantine icons: Kurt Weitzmann, Gaiané Alibegasvili, Aneli Volskaja, Manolis Chatzidakis, Gordana Babić, Mihail Alpatov, Teodora Voinescu, *The Icon* (New York: Alfred A. Knopf, 1982); Kurt Weitzmann, *The Icon. Holy Images—Sixth to Fourteenth Century* (New York: Braziller, 1978); Kurt Weitzmann, *The Monastery of Saint Catherine at Mount Sinai. The Icons, I: From the Sixth to the Tenth Century* (Princeton: Princeton University Press, 1976); Kurt Weitzmann, Manolis Chatzidakis, Krsto Miatev, *Frühe Ikonen. Sinai, Griechenland, Bulgarien, Jugoslawien* (Vienna: A. Schroll and Co., 1965). Also valuable are Alisa Bank, *Byzantine Art in the Collections of Soviet Museums* (Leningrad: Aurora, 1977) and Athanasios Papageorghiou, *Icons of Cyprus* (Geneva and Paris: Nagel, 1969).

3. The icon was a part of the Bradley Collection before its acquisition by The Menil Collection. It has been exhibited in London at the Temple Gallery in 1974 (R. Temple, *Masterpieces of Byzantine and Russian Icon Painting, 12th–16th Century*, exhibition catalogue, Temple Gallery, London, 30 April–29 June 1974, no. 1, p. 12), in Brussels in 1982 (Jacqueline Lafontaine-Dosogne, ed., *Splendeur de Byzance*, exhibition catalogue, Musées royaux d'Art et d'Histoire, Brussels, October 2–December 2, 1982, no. Ic 2, p. 36), and in Washington, D. C. at Dumbarton Oaks in 1983. The panel is also discussed and reproduced in Christopher Walter, "Biographic Scenes of the Three Hierarchs," *Revue des études byzantines* 36 (1978): 248–50 and pl. IV. It will be presented in Bertrand Davezac's forthcoming catalogue of icons in The Menil Collection.

4. Before The Menil Collection acquired the panel, it had been saturated with polyvinyl acetate because of this damage. In addition, the nail holes along the two sides of the panel had been filled in, and losses to the gold ground had been inpainted in a pale ochre.

5. Although vita icons assume many patterns of relationship between height and width, border and central panel, one finds much the same proportional scheme encountered here in the thirteenth-century vita icon of Saint Catherine that is preserved at Mount Sinai: Kurt Weitzmann, "Crusader Icons and Maniera Greca," in *Byzanz und der Westen*, ed. Irmgard Hutter, Oesterreichische Akademie der Wissenschaften, Phil.-Hist. Klasse, Sitzungberichte, 432. Band (Vienna: Verlag der Oesterreichischen Akademie der Wissenschaften, 1984), pl. 13.

6. As Mancusi-Ungaro points out, this undoubtedly helps to account for the lack of warping in the panel.

7. Pastiglia is described both by Denys of Fourna and by Cennino Cennini: see Paul Hetherington, *The 'Painter's Manual' of Dionysius of Fourna* (London: The Sagittarius Press, 1974), p. 6, and Cennino Cennini, *The Craftsman's Handbook*, trans. Daniel V. Thompson, Jr. (New York: Dover, 1954), pp. 73 n1, 76. They describe rather different methods of applying it, though both entail painting patterns in fine gesso onto a gesso surface. Yet a third technique of applying it is indicated by Mojmir Frinta, "Raised Gilded Adornment of the Cypriot Icons and the Occurrence of the Technique in the West," *Gesta* 20, 2 (1981): 335: "The raised portions, such as scrollwork and foliage, often were made by squeezing out the paste from a pierced bag, very much the way a pastry cook applies frosting or cream decoration." The halo of St. Basil can readily be imagined as a product of this last technique. Different yet again must have been the technique used in the icons of the Cypriot group with the rosette and fleur-de-lys patterns, as these seem to have been made with molds. On this group, see Doula Mouriki, "Thirteenth-Century Icon Painting in Cyprus," *The Griffon* NS 1–2 (1985–86): 9–112.

8. Papageorghiou, *Icons of Cyprus* (as in note 2 above), title page.

9. On the vita icon, see Nancy Patterson Ševčenko in this volume.

10. Reproduced in color in Kurt Weitzmann, *The Icon. Holy Images* (as in note 2 above), pl. 33.

11. See in particular the faces from Nerezi of 1164, from Staraya Ladoga of 1167, and Nereditsa of 1199, and of Saint Nicholas Kasnitzes and the Hagioi Anargyroi in Kastoria. For Nerezi, see Vojislav Djurić, *Byzantinische Fresken in Jugoslavien* (Munich: Hirmer Verlag, 1976), pl. VIII, and Victor Lazarev, *Storia della pittura bizantina* (Turin, Einaudi, 1967), pls. 305–7; for Staraya Ladoga and Nereditsa, see idem, *Old Russian Murals and Mosaics* (London: Phaidon, 1966), pls. 85, 91, figs. 47–48 and pls. 94–100; for Saint Nicholas Kasnitzi and the Hagioi Anargyroi, see Stylianos M. Pelekanides and Manolis Chatzidakis, *Kastoria* (Athens: Melissa, 1985), plates on pp. 36, 53, 58, 59, 63.

12. While the pursuit of individual painters or workshops has proved difficult in Byzantine art, it is clear that each rendition of an icon was a personal process. The powerful play of the wings of the nose here reminds me repeatedly of the great seventh-century icon of hierarchs at Mount Sinai, and makes me wonder at times whether the painter had seen that work: Weitzmann, *The Monastery of Saint Catherine at Mount Sinai* (as in note 2 above), no. B24. On the plane of Morellian detail, the formation of the ears as two interlocking question marks might prove traceable.

13. See note 8 above.

14. Papageorghiou, *Icons of Cyprus* (as in note 2 above), pp. 14–15.

15. Athanasios Papageorghiou, *Byzantine Icons of Cyprus*, exhibition catalogue, Benaki Museum, Athens, 1 September–30 November 1976, no. 9.

16. Weitzmann, *The Icon. Holy Images* (as in note 2 above), pl. 30.

17. On thirteenth-century icon painting in Cyprus, see Mouriki, "Thirteenth-Century Icon Painting in Cyprus" (as in note 7 above), passim.

18. Weitzmann, *The Icon. Holy Images*, pl. 36 and the valuable details of heads in Weitzmann et. al., *The Icon* (as in note 2 above), pp. 212–13, 218, 230. On the origins of this style, see in particular Robin Cormack and Stavros Mihalarias, "A Crusader Painting of St George: 'maniera greca' or 'lingua franca'?," *Burlington Magazine* 126 (1984): 132–41.

19. The miniatures of this New Testament are fully reproduced in color in both J. Edgar Goodspeed, Donald W. Riddle and Harold Rideout Willoughby, *The Rockefeller-McCormick New Testament*, 3 vols. (Chicago: University of Chicago Press, 1932), vol. 3, and Annemarie Weyl Carr, *Byzantine Illumination, 1150–1250: The Study of a Provincial Tradition* (Chicago: University of Chicago Press, 1987), fiches 3A1–4A10.

20. Goodspeed, Riddle and Willoughby, *The Rockefeller-McCormick New Testament*, 3: compare the garments of the apostles with those of Christ in a miniature like that on 15v, or the meticulously modelled blue robe on 36v with others near it, and see the gummy pink in a miniature like that on 89r; Carr, *Byzantine Illumination*, fiches 3B3, 3C7, 3G1.

21. Goodspeed, Riddle and Willoughby, *The Rockefeller-McCormick New Testament*, 3: 54v, the faces of the women at the tomb; Carr, *Byzantine Illumination*, fiche 3D10.

22. The Sinai vita icon of Saint Nicholas cited above is 82 cm high; that of Saint George from much the same period on Mount Sinai is 127 cm high; and the thirteenth-century vita icon of Catherine at Sinai is 75 cm high (see George A. and Maria Soteriou, Εἰκόνες τῆς Μονῆς Σινά [*Eikones tis Monis Sina*], 2 vols. [Athens: Academy of Athens, 1956], 2: 147). The thirteenth-century sculpted icon of Saint George in the Byzantine Museum in Athens is 109 cm high; and that of Saint Nicholas in the Archaeological Collection at Kastoria is 107 cm high. The icon of Saint Marina at Pedoulas is 97 cm high; and the twin icons of Saint Nicholas and the Virgin in the Archiepiscopal Museum in Nicosia are fully two meters high.

23. On Basil's iconographic type, see Hugo Buchthal, "Some Notes on Byzantine Hagiographical Portraiture," *Gazette des beaux-arts* NS 62 (1963): 81-90. Buchthal argues that the great Fathers—including Basil—received their definitive characterization in the eleventh century. But Basil already has his heavy beard and dark hair in seventh-century representations: see the icon at Sinai (Weitzmann, *The Monastery of Saint Catherine* [as in note 2 above], no. B24) and the image in the north aisle of Santa Maria Antiqua (Christopher Walter, *Le Monde des icones* [Paris and Geneva: Nagel, 1982], pl. 2). Traditional for Basil from the time of his earliest surviving images, the brown hair and heavy beard give him a guise reminiscent of Saint Paul, no doubt deliberately. The kinship of their facial types can be appreciated on images like the twelfth-century icon of the Crucifixion on Mount Sinai (Weitzmann, *The Icon. Holy Images*, pl. 26), where busts of both adorn the frame, or perhaps even more clearly in the thirteenth-century copy of this icon (Weitzmann et al., *The Icon*, p. 211), where only Saint Theodore intervenes between Paul and Basil.

24. See Buchthal, "Some Notes" (as in note 23 above), fig. 7; Lazarev, *Old Russian Murals and Mosaics* (as in note 11 above), pls. 25–26.

25. Otto Demus, *The Mosaics of Norman Sicily* (London: Routledge and Kegan Paul, Ltd., 1949), pl. 23B.

26. Ioli Kalavrezou-Maxeiner, *Byzantine Icons in Steatite*, 2 vols., Byzantina Vindobonensia 15 (Vienna: Verlag der Oesterreichischen Akademie der Wissenschaften, 1985), no. 4, pl. 5.

27. Pelekanides and Chatzidakis, *Kastoria* (as in note 11 above), p. 27, fig. 4.

28. On the silver frame, see Kalavrezou-Maxeiner, *Byzantine Icons in Steatite*, no. 124, pl. 59, and Weitzmann et al., *The Icon*, p. 80. On the icon of the three hierarchs, see Myrtali Acheimastou-Potamianou, *Holy Image, Holy Space. Icons and Frescoes from Greece*, exhibition catalogue sponsored by the Greek Ministry of Culture and the Byzantine Museum, Athens (Athens, 1988), no. 17.

29. Thus Basil has the round-ended crosses on the tenth-century ivory triptych in the Palazzo Venezia (Weitzmann et. al., *The Icon*, pp. 32–33); in eleventh-century manuscripts, on the other hand, like Athos, Dionysiou 61, it is Gregory of Nazianzus who has the round-ended crosses (Stylianos M. Pelekanides, P. C. Christou, Ch. Tsioumis, S. N. Kadas, *The Treasures of Mount Athos, I: Illuminated Manuscripts, 1: The Protaton and the Monasteries of Dionysiou, Koutloumousiou, Xeropotamou and Gregoriou* [Athens: Ekdotike Athenon, 1974], fig. 111), and in the mosaics at Kiev, Basil has Maltese crosses while Pope Clement and Gregory Thaumatourgos have the round-ended ones (Lazarev, *Old Russian Murals and Mosaics*, pls. 25–26 and figs. 6, 8). In the church of the Hagioi Anargyroi at Kastoria, the depiction of the Fathers in the apse gives the rounded crosses to John Chrysostom and not to Basil, while the figure of Basil in the narthex has them (Pelekanides and Chatzidakis, *Kastoria*, p. 30, fig. 7 for the apse and p. 27, fig. 4 for the narthex).

30. See, for instance, the omophoria on the Palazzo Venezia triptych and in the miniatures of Athos, Dionysiou 61, both cited in the preceding note, the omophorion

of Basil in the ivory triptych in the Musée du Louvre (Buchthal, "Some Notes," fig. 9), or the steatite image of Saint Nicholas (Kalavrezou-Maxeiner, *Byzantine Icons in Steatite*, no. 13, pl. 9).

31. See Kalavrezou-Maxeiner, *Byzantine Icons in Steatite*, no. 120, pl. 58, no. 124, pl. 59.

32. See for instance the images of Nicholas in Weitzmann et al., *The Icon*, pp. 209, 233.

33. *Catholic Encyclopedia* (New York: Robert Appleton, 1907), s.v. Basil the Great.

34. Speros Vryonis, *The Decline of Medieval Hellenism in Asia Minor and the Progress of Islamicization from the Eleventh through the Fifteenth Century* (Berkeley: University of California Press, 1971), pp. 19, 33–34, note 165; Lyn Rodley, *Cave Monasteries of Byzantine Cappadocia* (Cambridge: Cambridge University Press, 1986), p. 253.

35. Thus Walter, "Biographic Scenes" (as in note 3 above), discusses cycles of Basil's life in the Cappadocian cave churches of New Tokali and Balkan Dere 4.

36. Jan Olaf Rosenqvist, *The Life of St. Irene Abbess of Chrysobalanton*, Studia Byzantina Uppsaliensis 1 (Stockholm: Almqvist and Wiksell International, 1986), pp. 56–61.

37. See the large mural icon of Basil in the Daniel Chapel (Göreme Chapel 18): Guillaume de Jerphanion, *Une Nouvelle Province de l'art byzantin. Les Eglises rupestres de Cappadoce*, 5 vols. (Paris: P. Geuthner, 1925–42), 1, 1: pl. 39 (4), or in color, Walter, *Le Monde des icones* (as in note 23 above), pl. 46. Or see the donor portrait with Basil in Hallaç Manastir near Ortahisar: Rodley, *Cave Monasteries of Byzantine Cappadocia*, pp. 23–26 and fig. 4. In Belli Kilise in Soganli, Basil is shown in a separate architectural niche to the north side of the apse facing the naos: Marcell Restle, *Byzantine Wall Painting in Asia Minor*, 3 vols. (Greenwich, Conn.: New York Graphic Society, 1968), 3: fig. 444 and plan.

38. On the icon's iconography, see Leslie Brubaker in this volume.

39. See George Soteriou, " Ἡ εἰκὼν τῆς Παμμακαρίστου [I Eikon tis Pammakaristou]," in *Πρακτικὰ τῆς Ακαδημίας Ἀθηνῶν* [Praktika tis Akademias Athinon] 8 (1933): 361.

40. Mouriki, "Thirteenth-Century Icon Painting in Cyprus" (as in note 7 above), passim; Mojmir Frinta, "Raised Gilded Adornment" (as in note 7 above), 333–41; David Talbot Rice, "Cypriot Icons with Plaster Relief Backgrounds," *Jahrbuch der österreichischen byzantinischen Gesellschaft* 21 (1972): 269–78.

41. Papageorghiou, *Byzantine Icons of Cyprus* (as in note 15 above), no. 8. Sophia Kalopisi-Verti, " Διακοσμιμένοι φωτοστέφανοι σὲ Εἰκόνες καὶ Τοιχογραφίες τῆς Κύπρου καὶ τοῦ Ἑλλαδικοῦ Χώρου [Diakosmimenoi Photostephanoi se Eikones kai Toichographies tis Kyprou kai tou Helladikou Chorou]," in *Πρακτικὰ τοῦ δευτέρου διεονοῦς Κυπρολογικοῦ Συνεδρίου* [Praktika tou deuterou diethnous Kyprologikou Synedriou], 3 vols. (Nicosia: Zavallis Press, 1986), 2: 555–60, pl. 1, gives an excellent detail of the haloes of Christ and the Virgin. That of the Virgin is especially closely akin to the halo of St. Basil in our icon

42. Papageorghiou, *Icons of Cyprus* (as in note 2 above), p. 28. On the basis of its silver ground, the icon of almost identical shape showing the Archangel Gabriel in a private collection in the United States has also been attributed to Cyprus: see *Holy Image, Holy Space* (as in note 28 above), no. 11.

43. Papageorghiou, *Byzantine Icons of Cyprus*, no. 7. The companion icon, the Pantokrator cited in note 8 above, has a gilded ground in the central field but a silver ground on the frame.

44. Arthur H. S. Megaw and Ernest J. W. Hawkins, "The Church of the Holy Apostles at Perachorio, Cyprus, and Its Frescoes," *Dumbarton Oaks Papers* 16 (1962): fig. 27.

45. Mouriki, "Thirteenth-Century Icon Painting in Cyprus," pp. 13, 16.

46. Annemarie Weyl Carr, "A Group of Provincial Manuscripts from the Twelfth Century," *Dumbarton Oaks Papers* 36 (1982): 39–81.

47. Kurt Weitzmann told me in conversation that he remembers seeing it in Cairo.

48. Pelekanides et al., *The Treasures of Mount Athos* (as in note 29 above), pl. 158.

49. See for instance Patmos, Rotulus 1 of much the same date around 1200: Giulio Jacopi, "Le miniature dei codici di Patmo," *Clara Rhodos* 6–7 (1932–33): pl. XXIII.

50. Paul Gautier, "Le Typikon du Christ Sauveur Pantocrator," *Revue des études byzantines* 32 (1974): 32.

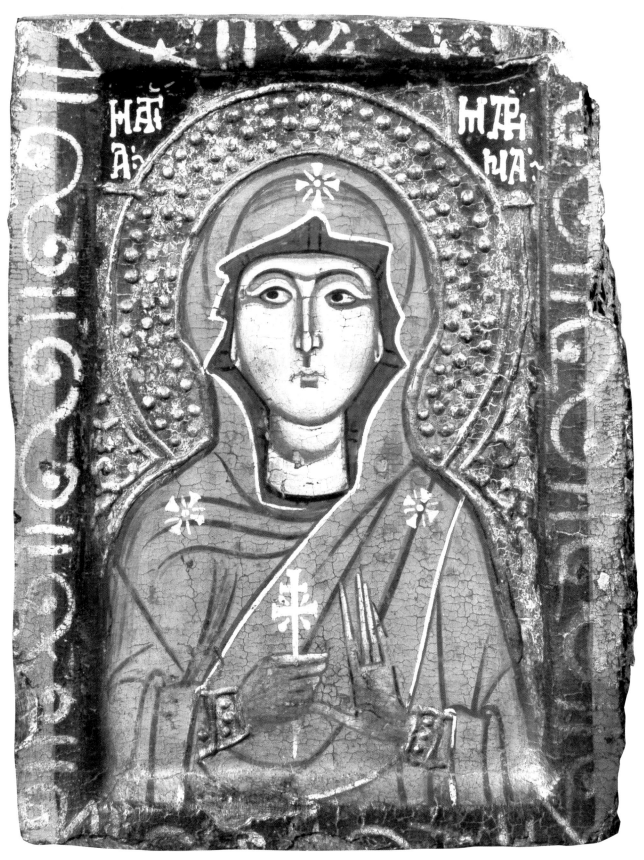

99. Icon of Saint Marina (front). Houston, The Menil Collection.

The Saint Marina Icon

Maniera Cypria, Lingua Franca, or Crusader Art?

JAROSLAV FOLDA

The icon of St. Marina in The Menil Collection (pl. 4, figs. 99, 100) is a handsome, small, bust-length image of the saint in excellent condition. It is a painting of fine quality, however straightforward and direct its formal characteristics may be. Despite its seeming simplicity, on careful analysis the icon exhibits art historical complexity which makes it both fascinating and mysterious. Although effectively unpublished until 1988, the icon is not unknown, having been exhibited in London in 1969, in Cardiff in 1973, and at Dumbarton Oaks in 1983. [1]

St. Marina herself was widely venerated in the Middle Ages. Glanville Downey's synopsis from another context can serve to introduce her here:

St. Marina was martyred at Antioch in Pisidia during the reign of the Emperor Diocletian (284–305). The Latin Church celebrates her martyrdom at July 17th and the Greek Orthodox, August 16th. St. Marina continued to be honored in the Near East on into the Middle Byzantine period, as is indicated by a number of grottoes near Tripoli decorated with frescoes. However, her relics appear to have been moved, at least in part, to Constantinople about the eighth century by an empress named Marina or Maria. They were in the monastery outside Constantinople in 1213, and because the monks in the monastery where they were kept were accused of adultery, Joannes de Borea was allowed to remove her relics to Venice. . . . In Venice the relics of the saint were put in a parish church [whose dedication] was thereupon changed to St. Marina. The relics were still in the church in the seventeenth century and [a Venetian chronicler] mentions the silvery reliquary of the hand as well as another bone mounted in a band of silver also inscribed in Greek. The daughter of a Pagan priest, this Marina later converted to Christianity. Having shunned the marriage proposal of Olybrius, a Roman prefect, the aristocratic Marina was charged with being a Christian, tortured and thrown into prison. There she steadfastly maintained her faith through various confrontations with the devil, victorious always in the sign of the cross. Her private and public trials only served to convert others so that eventually she was beheaded, a martyr to her faith. [2]

At this point we must observe that there were at least two different major saints named Marina in the Near East. Besides the Early Christian virgin martyr (d. 305) at Antioch in Pisidia, [3] there was also the fifth-century virgin St. Marina from Syria. [4] She was the daughter of a widower who, not wishing to abandon his child, took her with him into a monastery, Deir el Qannoubine in the Qadisha Valley of what is now Lebanon, where he disguised her in male garments. After his death she remained disguised, growing up and receiving the education of the religious in the monastery. One day a young woman from a local village, Turza, who had had illicit sexual relations with a stranger, accused the disguised monk Marina of fathering the child that she, the young woman, was obviously bearing. Rather than reveal her sex, Marina did not attempt to disprove the accusation. Instead she cared for the illegitimate baby and submitted as a consequence to the most severe penitence. Despite the rigors of her ordeal, she remained a model of patience and humility. Only when she died did the monks discover her secret and their scorn and contempt were then replaced with admiration and reverence; indeed, she became the object of their great veneration.

100. Icon of Saint Marina (back). Houston, The Menil Collection.

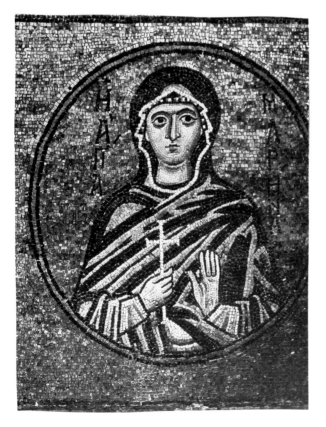

101. Mosaic medallion of St. Marina. Hosios Lukas in Phocis.

St. Marina, the martyr of Antioch in Pisidia, was known in the West as St. Margaret where she appears prominently in the *Golden Legend* (ca. 1270), and in images with the dragon at her feet in various famous late medieval artistic examples, e.g., the Portinari Altarpiece of Hugo van der Goes (1472), or Jean Bourdichon's Hours of Anne of Brittany (Paris, Bibl. Nat. ms. lat. 9474, ca. 1490). In the Greek East, she appears as a virgin martyr saint in aristocratic religious dress featuring a red veil. As such, she is comparable to several other female saints including Eugenia, Euphrosyne and Pelagia. St. Marina, the disguised Syrian monk, appears much less frequently in images. When she does, she sometimes also wears a red veil. [5]

In the Menil icon, St. Marina appears as a frontal bust-length figure glancing slightly to the onlooker's left and holding a double-barred cross in her proper right hand, gesturing towards it with her left hand. She is wearing a bright red veil, or maphorion, trimmed with a white hem and with three yellow star-shaped ornaments on her head and shoulders. Underneath the veil she has a blue coif on her head, and the cuffs of her undergament are emphasized with the use of raised gesso. Her halo is also articulated in raised gesso. She is identified by a Greek inscription painted in squarish white letters: "H 'Agia Mapina," "Saint Marina." There can be little doubt that the saint depicted here is St. Marina of Antioch in Pisidia, because the basic iconography follows the familiar representational elements found in Middle Byzantine art. [6]

For bust-length images of St. Marina of Antioch in Pisidia such as we find in our icon, there are precedents and parallels in various media. At Hosios Lukas we find in the narthex (north bay, west wall) a mosaic of this saint in a roundel from the 960s or the early eleventh century (fig. 101). [7] Here the standard Byzantine iconography is recognizable: for her religious garment she wears an undecorated veil or maphorion like the Virgin Mary except that it is red; properly, she holds a cross in her right hand as a sign of Christ and as a symbol of her martyrdom and victory over evil (the dragon); and to emphasize the cross she gestures towards it with her left hand, fingers extended, index finger and thumb separated. Approximately contemporary with this example is the image in the Bari Exultet Roll, but the medallion

is even smaller so that her hands do not appear. [8] In metalwork we have the roundel on the reliquary of the hand of St. Marina now in the Correr Museum in Venice. Marvin Ross dated this reliquary in the first decade of the thirteenth century, but the technique of the repoussé roundel and the iconography of the image of St. Marina may go back to the tenth or eleventh century. Indeed, he suggests that this roundel: "may derive from a then famous and now lost icon of the saint as often was the case in Constantinople." [9]

Other later frescoes and painted icons with the image of St. Marina exist, as we shall see, but no other bust-length icon on wood panel of this saint is known to me from before the twelfth century. There is, however, a series of special features about the Menil icon which clearly differentiate it from other contemporary Byzantine works of the twelfth and thirteenth centuries and direct our attention to a possible origin in Syria-Palestine or Cyprus, as opposed to Constantinople or the Greek mainland.

First of all the Menil icon is quite small, a characteristic that is typical of a large number of icons in the collection of St. Catherine's, Mt. Sinai, particularly among the Crusader group. Furthermore, the border (pl. 4) is strikingly painted in vermilion and dark green with yellow decorations in the form of reverse S-curves and paired linear dividers. This feature distinguishes the Menil icon from the more standard Byzantine practice of plain and understated monochromatic framing elements on painted (as opposed to mosaic or enamel) icons. [10] Such patterned borders are, moreover, frequently found among Sinai icons identified by Weitzmann as Crusader, e.g., the thirteenth-century St. Sergius (fig. 102), [11] the Christ in Majesty icon, [12] or on several other unpublished ones, such as a small twelfth-century St. Marina (fig. 109). [13] Also relevant is the popularity among the same group of Sinai Crusader icons as well as contemporary Cypriot icons of boldly decorated borders which were done in raised gesso patterns and gilded or painted silver, e.g., the thirteenth-century Virgin and Child with Standing Sinai Church Fathers (fig. 104) or the double-sided Crucifixion icon from the Church of St. Luke in Nicosia (ca. 1200–1210). [14] The most recently published Crusader icon is the British Museum St. George attributed to Lydda before 1268. [15]

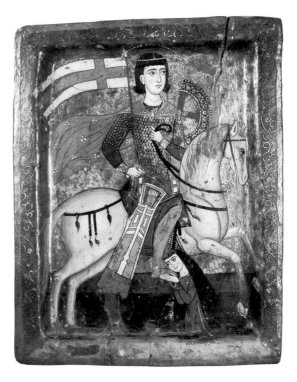

102. Icon of St. Sergius with Donor (Icon #80). St. Catherine's Monastery, Mt. Sinai.

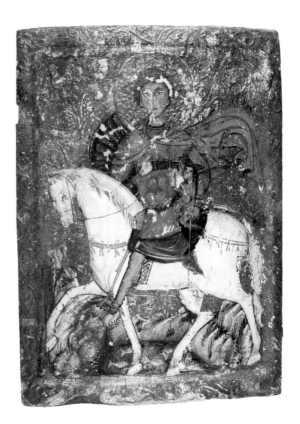

103. Icon of St. George (Icon #357). St. Catherine's Monastery, Mt. Sinai. *(Cited in note 24.)*

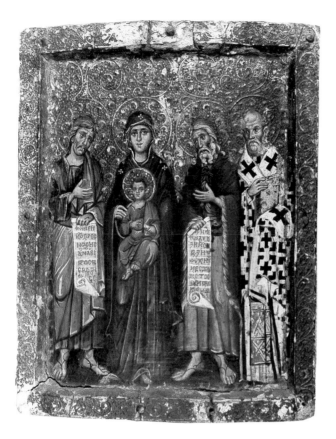

104. Icon of the Virgin and Child with Standing Sinai Church Fathers (Icon #54). St. Catherine's Monastery, Mt. Sinai.

In style we can compare the Menil icon with the St. Marina from Pedoulas on Cyprus, ca. 1275 (fig. 112), a prime example of what D. Mouriki has recently characterized as the *maniera cypria*.[16] Looking at the Menil image we see that the maphorion is painted in a flat, but thick opaque red that features a matte surface with no visible brush strokes. Despite the summary indications of the folds in darker linear elements of variable thickness, the artist presents us with a highly-patterned two-dimensional image with emphasis on the outlines of the frontal figure. The more three-dimensional components of the icon are found in the face (and to a lesser extent, the hands) within the frame of the coif and maphorion, and secondly, in the gesso relief pattern of the halo and linear outline element of the head and body. All of this creates the idea of the saint looking out from deep inside the recessed surface, that is, through the large bulbous

maphorion and the surrounding gesso decoration, but the result is nonetheless highly decorative and surface-oriented.

The Cypriot example, although also decorative, is by contrast more three-dimensional in its Byzantine painting style of drapery, face and head, but the gesso decoration is less boldly protruding if more complex in its repertory of designs. Not only is the face more rounded and three-dimensional, but also the draperies are more voluminous and softer, all of which is rendered through the artist's use of modulated painting. This emphasis on shading by layers, rather than by discrete linear elements, is also reflected in the de-emphasis of the purely decorative surface, with strongly delineated formal components in favor of softer drapery folds that instead blend together with the garment to form a relatively more organic whole.

In regard to technique, the face of St. Marina in the Menil icon is oval in shape and its roundness in the third dimension is suggested by a technique of painting which is basically Byzantine. Over a greenish ground which shades the eyes and brows, the nose and the forehead, the sides of the face, chin and neck, the artist has painted layers of skin tones with browns, reds and whites to create the idea of plump cheeks, dramatic eyes and a firmly articulated nose. But although the technique of layering over a greenish ground is Byzantine in conception, the result here looks rather overdefined in schematic terms. In fact, it appears to be an interesting imitation of Byzantine practice, but not something likely to have been done by a Greek painter, in contrast to the artist of the Pedoulas icon. Furthermore, the tiny chips in the paint on the neck clearly reveal that the usual linen foundation for Greek icon painting on wood panels was not utilized here.

The ornament in raised gesso is used for similar reasons on the Menil and Pedoulas icons: it is clear that these artists have conceived of this decoration as a gessoed imitation of a decorated metal covering.[17] It is handled differently on the Menil icon, however: besides the halo and cuffs,[18] not only is the figure outlined with a raised gesso linear element, but also beyond the halo there are decorated zones which extend to the inside edge of the painted border.

There can be little doubt that this gessoed relief decoration with prominently studded halo was meant to imitate a metal covering of some kind for the Menil icon, because careful inspection of the surface of the gesso reveals a gray substance that appears to be a metallic (tin) leaf.[19] No contemporary icon of St. Marina with its metal covering is known, but to illustrate what the artist may have been imitating, consider the example of the Virgin Paraclesis icon of Spoleto, a twelfth-century painted Comnenian icon with *oklad* or *riza*.[20] Although the metal covering may be later, consider the distinction between the finely patterned halo and surrounding "background" and the bold forms of the border, a distinction also sought in the Menil icon with much more economical means. But the fact that the metallic substance employed on the

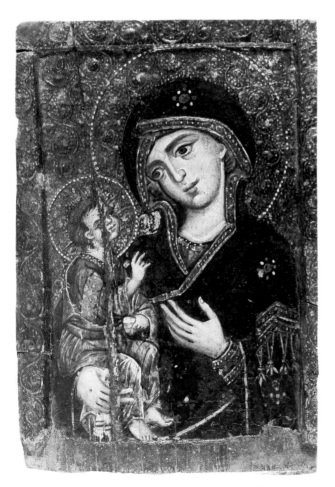

105. Icon of the Virgin Hodegetria (Icon #55). St. Catherine's Monastery, Mt. Sinai.

Menil icon was apparently tin means that the artist was probably imitating silver. This also suggests he was imitating a Cypriot icon where the use of silver or silver and gold backgrounds was widespread in the thirteenth century.[21]

The problem of the gessoed relief patterns on icons has been much discussed lately, but whatever its origins—Constantinople, Cyprus, or the West—the important extant early examples are found predominantly in Cyprus and the Holy Land.[22] However, so far as I know, only one St. Marina icon as yet published from either area has gesso relief, the icon from Pedoulas (fig. 50) discussed above. But neither this icon nor any of the numerous gessoed examples with other figures is like the Menil icon in two respects:

First, there are no other studded haloes quite like this in form: I refer to the large round studs, like pellets in numismatic terminology, and thick linear elements. The Sinai triptych with the Virgin and Child enthroned and scenes from the life of the Virgin on the wings (Acre, ca. 1250) has some similar ornament, but it is not the same in shape or function and it is only part of a larger repertory.[23]

Second, there are rarely examples where the decoration extends beyond the halo, but then fails to carry over onto the surrounding border. That is, whereas many Sinai Crusader icons have raised gesso patterns for the haloes, background decoration, and the borders, as we saw in the Sinai icon of the Virgin and Child with Standing Church Fathers (fig. 104) or the British Museum St. George[24] or in the well-known thirteenth-century Virgin Hodegetria (fig. 105), no other example has a bold, flat painted border combined with a raised gesso halo and background. (There are, of course, Sinai crusader icons with raised gesso haloes and borders but flat painted backgrounds [fig. 106]).[25] This feature, among others, gives the Menil icon a distinctive character and is another aspect that suggests it may not belong with the large group of icons associated by Weitzmann with Crusader artists at Sinai or those icons more recently attributed to Cyprus by Doula Mouriki.[26]

There are other special features of the Menil St. Marina icon as well. If we seek the source of the curious painted reverse S-curve designs on the border, we are also led away from Sinai or

Cyprus. The relevant parallel here seems not to be found in painting, however, but rather in Crusader metalwork from Jerusalem. The most important extant example available is a reliquary of the True Cross produced in Jerusalem during the 1130s and now in the church of the Holy Sepulchre in Barletta (fig. 107).[27] The beaded and filigree gold patterns on the front side of this reliquary present consistent sets of paired S-curve and reverse S-curve designs. It seems likely that our painter was drawing on designs from a Crusader metalwork example in order to give authenticity to his attempt to articulate the border of this icon in the repertory of form appropriate to such a function and in harmony with his intention to imitate a metal covering for the icon.[28]

The presence of this reverse S-curve design also directs our attention to another special feature of this icon: the cross which St. Marina holds.[29] This cross is unusual because it is a double-barred cross, not the standard single cross held by hundreds of Byzantine standing or bust-length saints in eleventh-, twelfth-, and thirteenth-century icon painting on panels, in frescoes or in mosaics.[30] While the double-barred cross is rare, it is not unknown as the attribute of saints; indeed, we find that patriarchs, bishops, and deacons, i.e., churchmen, are the main recipients on Byzantine and even Crusader icons for which this type of cross may carry an ecclesiastical, that is, patriarchal or episcopal, significance.[31] No other example of St. Marina carrying a double-barred cross is known to me, however. Its presence on this icon in association with the reverse S-curve design taken from Crusader goldsmith's work clearly suggests that here it is meant to refer to the True Cross.[32] The double-barred cross was, in fact, primarily associated with this reference in the twelfth and thirteenth centuries through reliquaries of the True Cross in both Crusader and Byzantine goldsmith's work.[33] Moreover, the cult of the True Cross was a central concern of the Crusaders, and the specific shape of the double-barred cross was the precise vehicle through which this devotional focus was represented in images.[34] Why St. Marina should carry the image of the True Cross here is less obvious, and we shall comment on this problem below.

There are other distinctive characteristics about

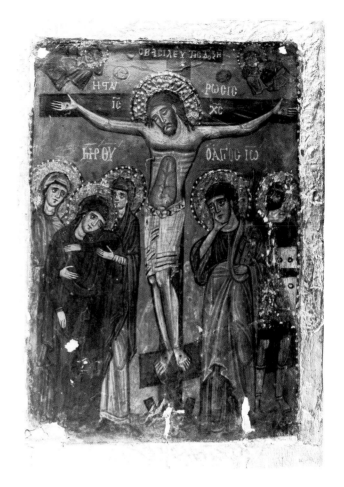

106. Icon of the Crucifixion (Icon #285). St. Catherine's Monastery, Mt. Sinai.

this St. Marina that are worth noting for what they may indicate about its place of origin and its date; some are iconographic, others have to do with technique or function, but none is more important than that of style. In doing the head of Marina, for example, the artist seems to have painted the entire maphorion, i.e., inside and outside the white hem around the face, in vermilion. Then, to execute the requisite indication of a coif for Marina in the eastern manner, the artist proceeded to paint over the red inside the white hem with a deep blue outlined in black and decorated with paired black lines. Uncharacteristic of Byzantine practice, however, the coif fills the entire interior opening between the maphorion and the head, extending all the way below the ear level to the base of the neck. Compare the Menil icon with the Sinai mosaic icon of the Hodegetria (ca. 1200) in this regard.[35] In

this connection it is worth pointing out, first, that St. Marina is not always depicted in Byzantine or Crusader art clearly wearing a coif like the Virgin Mary as in the Menil icon, [36] and, second, other Crusader artists adequately represent the coif of the Virgin Mary without dematerializing it into a decorative form. [37] The result here is that by dealing with this coif as if it were a two-dimensional surface rather than a three-dimensional object on the head of St. Marina, the artist loses the significance of the original and stylistically transforms the Byzantine iconographic model into what can be recognized as a non-Byzantine imitation.

The veil of St. Marina also suggests that this artist has produced a not purely Byzantine imitation. We notice that the hem of the maphorion around the facial opening is positioned as if Marina's head were turned to our left, but the folds of the veil and the star-shaped ornament [38] on the forehead, in concert with the head itself, are unmistakably frontal; indeed, they are axially symmetrical. In contrast to this, the star-shaped decorations on the shoulders of the maphorion are placed at a slight angle, roughly 60 degrees to the right, again in a position that would suggest that Marina was turning to her right, while in fact she is completely frontal, not turning at all. Comparison with the icon of the Virgin Hodegetria at Grottaferrata and other thirteenth-century Sinai Byzantine and Crusader icons of the same image [39] will help clarify by contrast how this artist again has treated St. Marina as a decorative design composed of discrete components, with no sense of an organic figure covered by a decorated maphorion as a three-dimensional object in space. By transforming the image of Marina into a two-dimensional decorative surface design, he lost the unity and coherence of the maphorion in three-dimensional terms.

Stylistically, of course, we have already noted the flat-patterned character of the forms. To our other observations we may add the unusually long, pointed fingers, the exaggerated size of the left thumb and the fact that it touches the other hand. This unaccountable joining of the two hands seems to be partly explained by the artist's wish to move the cross close to the central axis of the icon, something not typical of other eastern representations of St. Marina, such as the

107. Silver-gilt Reliquary of the True Cross. Church of the Holy Sepulchre, Barletta.

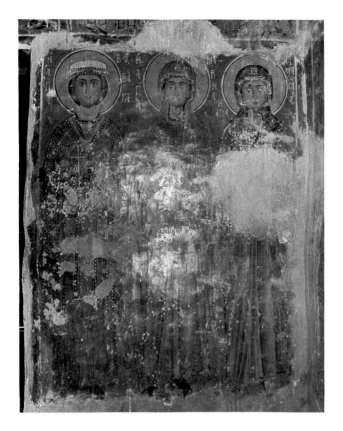

108. Fresco of St. Marina. Church of the Panagia, Moutoullas, Cyprus.

Moutoullas and Pedoulas images (figs. 108, 112) or the Sinai icons of St. Marina with or without St. Catherine (figs. 109, 110).

Finally, in the face of St. Marina on the Menil icon, we can point out the very unusual handling of the greenish ground to produce effects which, though based on Byzantine technique, are hardly Byzantine in stylistic result. I refer to the shading of the eyes and the eyebrows. The brows are linked by a smooth flow of green ground that reverses the curve of the dark brown brows. Although it approximates the effect of the Byzantine female facial type as seen in certain Virgin images or representations of St. Marina as well (figs. 112, 114),[40] this is a significant simplification of what a Greek artist would typically do. Furthermore, in shading the eyes, the artist employs a red accent line between eye and brow, something which Doula Mouriki has noticed in a large group of icons which she argues should be associated with Cyprus.[41] This feature appears, for example, in the Pedoulas St. Marina, in an icon of Christ from Moutoullas also of ca. 1275 (fig. 113), and in the Virgin Hodegetria of ca. 1200 now in the Byzantine Museum in Athens (fig. 114).[42] The result in the Menil icon is, however, very different from the Byzantine examples on Cyprus: the red line in conjunction with the shading of the eyebrow and the brow itself produces an oddly discrete form; rather an effect of flat pattern than three-dimensional modeling. The artist may be imitating the Byzantine style of the Cypriot examples we mentioned above (figs. 112–114), but does not belong to that school directly.

Then there is the shading immediately around the eyes. The odd feature here is the way in which the green-shaded forms, joined with the outlines of the eyes, produces a pronounced spectacled, indeed mask-like effect which almost completely obliterates the short crescent accents in brown below the eyes. This result is totally un-Byzantine and very different from its closest Cypriot antecedent, the Virgin Hodegetria in Athens (fig. 114). It is also clearly distinct from its known Crusader analogue, a linear spectacled articulation of the large round eyes found especially in the mid-thirteenth-century Acre workshop associated with the Arsenal Bible and certain closely related icons.[43] The artistic handling of the Menil icon, seen again from this aspect, is a patterned definition of two-dimensional form rather than significant enhancement of the idea of the complex three-dimensional surfaces surrounding the eyes and leading back toward the sides of the head.

Finally there are the eyes of St. Marina themselves, which also contrast with the greater articulation and the painterly effects of contemporary Cypriot icons (figs. 112–114). The eyes of the Menil St. Marina are painted as solid black irises without contrasting pupils set on a flat white eyeball. This simplifies the handling characteristic of the Cypriot icons where "a peculiar feature is the articulation of the whites of the eyes with 'brushstrokes' which repeat the curve of the irises"; and a black pupil is set on a contrasting brown iris.[44]

In sum, the overall approach of this artist seems to suggest someone working with knowledge of Byzantine technique and a certain access to the repertory of thirteenth-century painting, especially from Byzantine Cyprus and also the Crusader

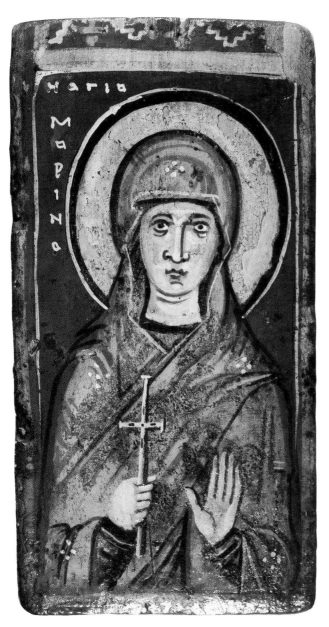

109. Icon of St. Marina (Icon #454).
St. Catherine's Monastery, Mt. Sinai.

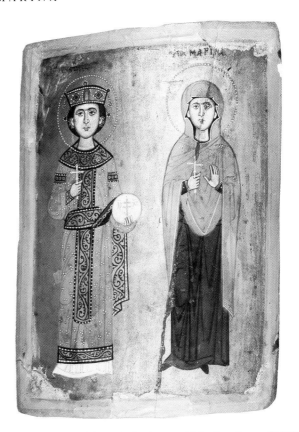

110. Icon of Sts. Catherine and Marina (Icon #1418).
St. Catherine's Monastery, Mt. Sinai.

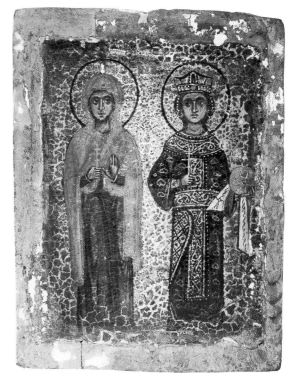

111. Sts. Marina and Catherine (Icon #168).
St. Catherine's Monastery, Mt. Sinai.

States, aspects of which he has reinterpreted and produced in his own distinctive style. He is akin, *mutatis mutandis,* to the artist we know in the twelfth-century psalter of Queen Melisende—the "saint's portrait master"—in the way he draws on the Byzantine tradition but transforms it into a more conservative result that has some direct affinities to romanesque qualities of form. [45] However, given the more progressive features of this style as it appears on the Menil icon, i.e., the nascent rotundity of the elongated features of the figure and the graceful, curved linear elements of the drapery, I cannot believe that this icon was done much before the second half of the thirteenth century. Moreover, given the distinctive levantine "look" of this St. Marina, quite distinct from the slender and elegant Pedoulas image of the saint for example, as well as the features that suggest the artist is copying both a well-established tradition and aspects of a then current mode, we seem to be in the presence of a work that reflects an accomplished if little-known painter working in a region which fostered distinguished icon painting.

Where does this analysis leave us in proposing an attribution for our charming and resolute St. Marina? It is clear from the discussion above that Cyprus and the Crusader States provide an important context for the origin of this icon. At this point, therefore, let us shift our approach, from an inquiry focused on visual analysis and comparisons of iconography, form, and technique, to the following question: where in the Levant do we find relevant images of St. Marina (or other holy figures) associated with sites of special veneration for the saint that stylistically may be more directly and coherently related to our icon?

On Cyprus, there can be no doubt that St. Marina is a popular saint, and Delehaye has found nineteen different locations where her name appears on the island. [46] But although St. Marina was venerated at various places on Cyprus, and there are even tiny villages which bear her name, at least one settled by Maronite refugees in the wake of the Moslem conquest of Saladin, there is no special center for her cult on Cyprus which equals that found on mainland Syria-Palestine. [47] The little church of St. Marina at Pyrga on Cyprus seems to be fourteenth century and thus too late for direct relevance here. [48]

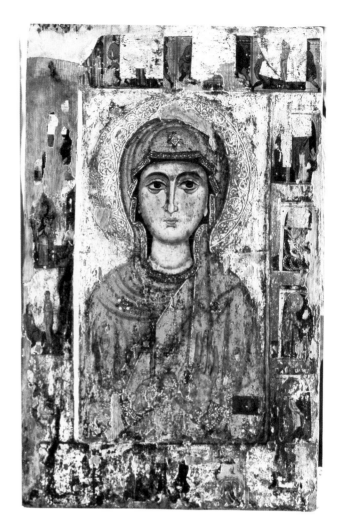

112. Icon of St. Marina. Pedoulas, Cyprus.

Among those images from Cyprus that are relevant comparisons, the icons of Pedoulas and Moutoullas (figs. 112, 113) done about 1275–1280 are characterized by their "romanesqueizing" linearity by Doula Mouriki. [49] Moreover, comparison of the Menil icon with the Pedoulas St. Marina or the Moutoullas Christ has indicated important differences despite some similarities. Even the compact and linear style of the standing St. Marina figure (fig. 108) in the frescoes of the Church of the Panagia at Moutoullas (1280) seems distinct in terms of highlighting, different proportions and simplification. And whereas the origins of the mask-like facial features of the Marina icon may be found in the earlier Virgin Hodegetria now in Athens of ca. 1200 (fig. 114), the conceptual and formal distance between the two images makes it clear that the Me-

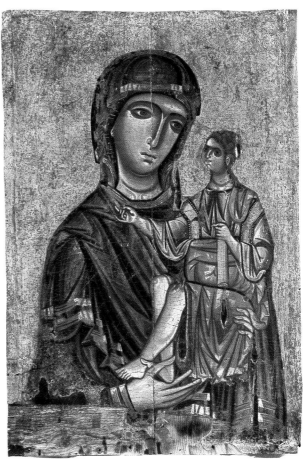

113. Icon of Christ. Moutoullas, Cyprus.

114. Icon of the Virgin Hodegetria. Byzantine Museum, Athens.

nil St. Marina artist produced an entirely different result.

The situation is different at the monastery of St. Catherine at Mount Sinai. Not only do we have a number of thirteenth-century icons with St. Marina (figs. 110, 111) among the Crusader group attributed there,[50] but the sixth-century Church of St. Catherine contained a chapel specially dedicated to St. Marina.[51] This chapel, located today in the southwestern corner of the church, no doubt reflected her importance on mainland Syria-Palestine and the Sinai peninsula from an early time. On the other hand, despite some general parallels already noted above, there seems not to be any thirteenth-century Sinai icons among the large Crusader groups or among any of the contemporary Byzantine examples with specific formal characteristics attributed there that relate closely to the Menil image of St. Marina. We

have seen, for example, how the gesso decoration of this icon reflects interests similar to those of the Sinai Crusader icons without being exactly like any of them. Moreover, none of the Sinai Crusader icons exhibits the same decorative linear style we find in the Menil St. Marina, and telling details, for example, the typically rounded, small and sometimes almost pudgy hands of the figures in the Sinai icons, seem distinctively different from the remarkably slender, attenuated examples in the Menil image. In fact, the Menil icon artist consistently seems in many aspects to reflect greater affiliation stylistically to the Cyprus icons than to those of Sinai in the thirteenth century. Thus, even though the Crusader icons of St. Catherine's, and other Crusader painting to which they are related in Acre, are logically our first point of inquiry in the Latin Kingdom, the lack of striking and persuasive stylistic relationships compels us to continue our

search elsewhere in the Crusader Levant.

Bethlehem is another possibility. The column paintings in the nave and aisles of the Church of the Nativity, dating from 1130 on into the thirteenth century, include two full-length images of St. Marina (fig. 115 and illustrated in Kühnel),[52] both with inscriptions in Greek and Latin, both probably dating from the 1160s. One is on the south nave column closest to the crossing, St. Marina of Syria wearing a gray garment (Kühnel, fig. 74); the other, in the south aisle opposite the image of St. Leo and next to the nave column with the image of John the Baptist, is St. Marina of Antioch in Pisidia wearing a red maphorion and holding her cross of martyrdom (fig. 115).[53] It is clear that Marina is an important saint here because both major St. Marinas are represented, and besides the two St. Marinas, there is only one other female saint, not counting the images of the Virgin, along with twenty-two male saints in this ensemble.[54]

If we compare the Menil St. Marina with the Bethlehem column painting of St. Marina of Antioch (fig. 115), the better preserved of the two images at Bethlehem, it is clear that the two images share only some general formal characteristics, in figure style and proportions and the linear handling of the draperies. On the other hand, no specific connections can be seen: consistent highlighting of the broadly painted folds of the maphorion on the Bethlehem St. Marina have no parallel on the Menil icon, and the treatment of the veil hem, the cross, the presence of the star-shaped ornaments, and the shape of the inscription are all different on the latter. Even though the images of St. Marina in Bethlehem demonstrate a strong devotional interest in the cult of both saints there, no artistic evidence exists to associate the Menil icon with artists who worked in the Church of the Nativity. Thus Bethlehem, like Sinai, is witness to the importance of devotion to St. Marina in the Crusader States, but neither is a likely source or venue for the artist of the Menil icon.

There is, however, one other specific area in the Crusader Levant where the cult of St. Marina was even stronger. I refer to the area of Tripoli, the Qadisha Valley south of Tripoli, and the Maronite churches in Bahdeidat, Ma'ad, and Edde between Gibelet (Byblos, Jbail) and Batroun, south of Tripoli

115. Column Painting of St. Marina of Antioch in Pisidia. Church of the Nativity, Bethlehem.

in what is now Lebanon and was then the heart of the County of Tripoli in the Crusader States. It is here within a small triangle—with sides stretching from Tripoli 30 km southeast to the Cedars, from Tripoli 40 km southwest to Gibelet, and 40 km northeast from Gibelet to the Cedars—more than anywhere else that the cult of St. Marina flourished during the Crusader period in the context of vigorous schools of painting during the period from the late twelfth century to the 1260s. Moreover, it is notable in regard to the fate of the Crusader States in the thirteenth century that the County of Tripoli was second only to the Latin Kingdom of Jerusalem in its longevity, holding out against the Mamluks until April of 1289. The relative lack of painting from this area as yet published should not mislead us about the existence of relevant examples in this area. [55] The corpus of frescoes being prepared by Professor Erica Dodd and the material from the three important Maronite churches recently published by Y. Sader will assist us here. [56]

It is particularly the grotto south of Tripoli just off the coastal road, known as Mar Marina near the town of Qalamoun, which is the important extant site for locating the focus of the cult. Although the fresco paintings and their inscriptions in the grotto are now heavily damaged, many parts beyond recognition, they clearly indicate that St. Marina was venerated here, indeed both St. Marinas. The unique significance of this grotto is that the frescoes of the lower, i.e., earlier, probably twelfth-century layer represent St. Marina of Antioch in Pisidia with Greek inscriptions, and those of the upper, later, thirteenth-century layer represent St. Marina of Syria with Latin inscriptions. [57] The image of St. Marina of Antioch in Pisidia features a fragmentary Marina wielding a hammer against the devil, unusual iconography otherwise rarely found. [58] For St. Marina of Syria, however, there were apparently eight small panels narrating the life of the saint of which only fragments of four remain. [59]

No other images of St. Marina from the territory south of Tripoli in the area enclosed by the triangle described above are known to me or have as yet been published, but associated with this region, proximate to the cult center of both St. Marinas, is a "romanesqueizing" figure style, or, at least, head

and facial style, a flat-patterned drapery style, and strikingly elongated fingers similar to those in the Menil icon. .

In the Maronite churches south of Tripoli in particular, there exists evidence of a basic style of painting from ca. 1240–1260 which relates generally to a number of the characteristics found in the Menil St. Marina icon. In the apse frescoes of the church at Bahdeidat there are standing male saints (apostles) in an arcade along the dado zone (fig. 116) which are done in a flat linear style with heavy outlines that shows some general parallels in facial types to the Menil St. Marina. [60] The spectacled eyes, the red accent lines above the upper lids, the heavy brows, the design of the nose and the configuration of the mouth combined with the round face and the very slight sense of three-dimensionality are in a related, if not the same, style as that of the Menil St. Marina. [61] Similarly, on the lower right face of the apse arch, the seated Virgin of the Annunciation (fig. 117) is also comparable in these terms, if harder to see because of her damaged state. Besides the characteristics of her face, here represented in three-quarter view, the style of her linear draperies is also a relevant comparison to that of the Menil St. Marina icon, which is to some extent related. [62]

Slightly north and west of Bahdeidat is another small Maronite church at Ma'ad with frescoes in the apse and a small room to the south of the apse (the diaconicon?). [63] In this room is a fresco of the Dormition on the south wall (fig. 118). Here we find an even more simplified version of the linear style of facial design, with somewhat comparable eyes, brows, nose, and mouth to those of St. Marina. [64] Again, this is a general comparison, because the specific formal characteristics of the St. Marina icon are not exactly paralleled here. But the importance of these two fresco ensembles resides in the fact of the basic simplified and somewhat archaizing linear style dated to the mid-thirteenth century that forms a convincing point of departure for the more refined artist of the Menil St. Marina, in contrast to the sophisticated Byzantine styles of contemporary Cyprus and Sinai.

It is to the east, in the heart of the Qadisha Valley itself, that we find additional parallels, including some of the specific details of the St. Marina icon. In particular there is, halfway between the Cedar

116. Standing Apostle under an arch (detail). Maronite Church of St. Theodore, Bahdeidat, Lebanon.

117. Virgin Mary of the Annunciation (detail). Maronite Church of St. Theodore, Bahdeidat, Lebanon.

and the Valley floor below the town of Diman, two kilometers from Hadschit, the grotto of Saidet ed Darr, "Our Lady of Abundant Milk." It is one of the relatively numerous milk grottoes in Lebanon surviving with extant frescoes. The wall paintings at this grotto are damaged and fragmentary, but remnants of several figures, including Salomone, mother of the Maccabees, survive (fig. 119). [65] Although her face is unfortunately almost entirely obliterated, her draperies show the same fluent linear articulation, decorative arrangement and two-dimensionality that is characteristic of the Menil St. Marina · icon. Furthermore, the strikingly elongated and slender pointed fingers of St. Marina's open hand find a close, if not exact, parallel in those of Salomone's comparably positioned hand along with that of another standing figure nearby (fig. 120). Indeed, these frescoes from Saidet ed Darr dating from the late twelfth or thirteenth century demonstrate that while the style is not exactly the same, it is directly and closely comparable in contrast to more three-dimensional tendencies in the draperies and the stocky fingered hands we consistently find on other Sinai or Cypriot images, icons or frescoes, and even the starkly two-dimensional examples at Bahdeidat and Ma'ad we have seen in the southern territory of the County of Tripoli cited just above. [66]

Finally, it is important to note that the inscriptions extant on the standing figures in room A of Tallon's plan, of which a few letters only can still be seen in fig. 119, seem to be contemporary with the paintings and are all in Greek. [67] These inscriptions are too damaged and fragmentary to be of any specific value here except to attest to the contemporary use of Greek inscriptions along with those in Syriac (estrangelo) and Latin. Elsewhere in this region, however, there are Greek inscriptions that reflect a similar blocky shape in the letter style, if not the same individual forms. To the west of Saidet ed Darr, just north of Ma'ad near Batroun, is the church of Edde. This church is particularly interesting because it has fresco painting in two styles: one a sophisticated Byzantine style closely related to Sopocani, presumably dating after 1261; [68] the other, seen in a tiny fragment of a Virgin and Child group (fig. 121), is more conservative, akin to the "romanesqueizing" style we have seen in Bahdei-

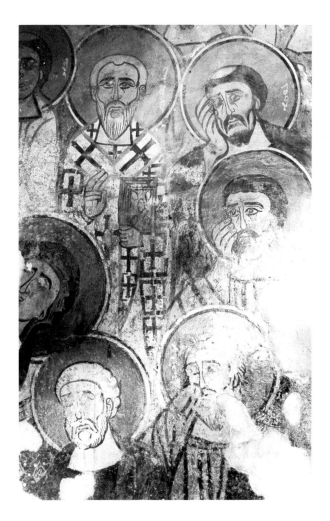

118. Apostles at the Dormition of the Virgin (detail). Maronite Church of St. Charbel, Ma'ad, Lebanon.

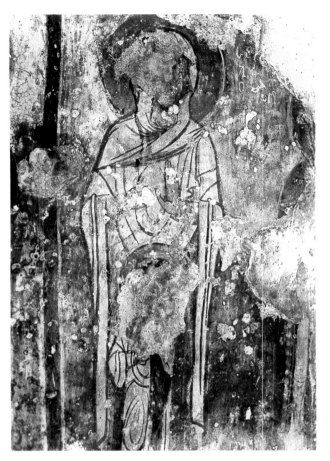

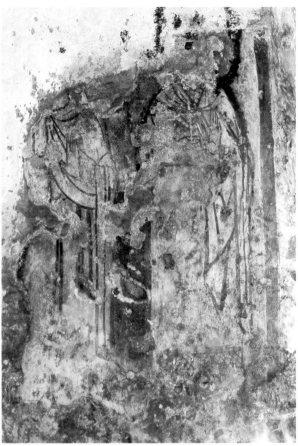

119. Standing figure of Salomone (detail). Saidet ed Darr, Qadisha Valley, Lebanon.

120. Standing figure of Saints (detail). Saidet ed Darr, Qadisha Valley, Lebanon.

dat and Ma'ad dating to ca. 1240–1260. Next to the head of the Virgin are the familiar sigla of part of her identifying inscriptions and those of Jesus, in blocky display letters. While none of the special formal features of the Menil St. Marina inscription is seen here, with this evidence we do have another example of the use of Greek in an example attested to date in the mid-thirteenth century, in contrast to Saidet ed Darr which is very loosely dated to the late twelfth or thirteenth century.

This brings us back to the grotto of Mar Marina, where the first layer of paintings includes inscriptions in Greek as mentioned above. The letters are especially clearly visible around the large figures of St. Marina and St. Demetrius.[69] Even though these letters are twelfth-century, they

provide distant parallels for some of the letter forms found on the Menil St. Marina icon. Observe, for example, the simplified lower case "alpha" or the "mu" with the dropped central configuration in comparably blocky forms. While these several examples obviously do not offer precise parallels to the Menil St. Marina inscription, they nonetheless demonstrate that Greek would be at home here in painting from the Crusader country of Tripoli in the mid-thirteenth century in a prominent display style, and that the letter forms of the inscription on the Menil St. Marina icon had antecedents which at least seem to provide a context for its existence ca. 1250.[70]

As we see from the discussion above, the Menil St. Marina icon clearly exhibits a complex mélange

of characteristics that relate it to developments in various locations at various times in the eastern Mediterranean during the Crusader period. The fact of this mélange and the nature of the characteristics seem to indicate clearly that this is an icon done under particular circumstances for a special patron. Far from being a work of the *lingua franca*, however, this icon, while related to the Byzantine tradition without doubt, is nonetheless stylistically rooted to painting in a flourishing area south of Tripoli, where not only can some of its most important formal features be identified, but where also the cult of St. Marina was known to be a central feature of the religious life of the area.[71] Moreover, certain stylistic affiliations with Cyprus have been referred to as well. This, in my opinion, is the result of a Syrian artistic presence in Cyprus, caused, as D. Mouriki has observed, by an "influx of Syrians into Cyprus following the establishment of Frankish

rule [in 1191]."[72] But given what we find in the Menil icon as discussed above, it is probably not the work of a Syrian artist painting under the Byzantine influence of his newly settled Cypriot milieu in the thirteenth century, but rather much more likely the work of a Syrian artist painting in the current mode ca. 1250 with a knowledge of developments in Cyprus, and painting in his homeland south of Tripoli in the service of the cult of St. Marina. This interpretation offers us an explanation for the unusual and distinctly eastern look of St. Marina referred to above, along with those features of style and technique that were current in Cyprus in the mid- and late thirteenth century.

Who could the patron possibly have been? Nothing indicating individual sponsorship or ownership has yet been identified in relation to this small devotional icon. However, some of the characteristics discussed above strongly suggest that the patron was

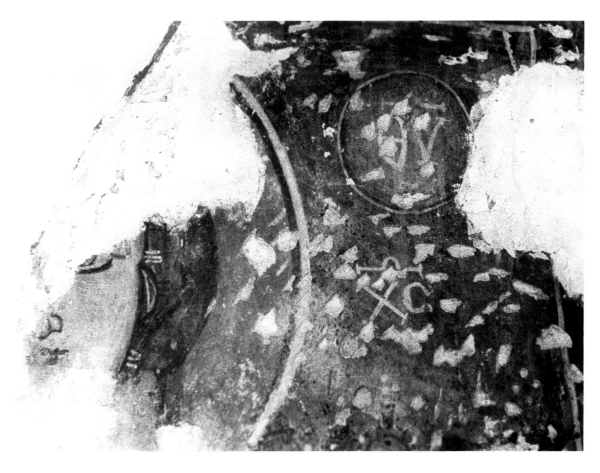

121. Virgin Mary and Jesus, fragment (detail). Church of St. Saba, Edde, Lebanon.

Crusader. The choice of St. Marina for this icon reflects her known popularity in the Crusader States. [73] The use of Greek inscriptions on icons of St. Marina is common on "Crusader" panels from Syria (e.g., fig. 110), and can be seen perhaps as the result of a patron's understandable desire to have an "authentic" image. [74] Finally, some of the choices made on this icon distinctly suggest the taste of a Crusader ranging from the strong colorism of the image and its unusual painted frame, the repertory of the decorative designs drawn very probably from Crusader metalwork, and the unusual iconography of Marina holding the image of the True Cross as her symbol of martyrdom and victory. [75]

There is no obvious individual to whom we may point as the likely patron in the period ca. 1240–1260, but it not unimportant to note that the County of Tripoli in these years was a promising location for religious art. Not only were negotiations continuing between the popes and the Maronite patriarchs concerning unification of the Maronite church with Rome, but also the Latin bishop of Tripoli enjoyed harmonious relations with the Uniate Maronites in his diocese. Indeed, of all the indigenous Christian sects with whom the Crusaders came in contact, the Crusaders from their first encounters in the twelfth century valued and respected the Maronites because of their independent spirit and their willingness to bear arms against the Moslems. This in part no doubt led to the unusual arrangement by which the Maronites were given autonomy even as a Uniate church whose only Latin superior was the pope. [76]

Politically, the situation was much more complicated, caused initially by the bitter internal Crusader struggle known as the Lombard War following Frederick II's departure from the Holy Land in 1229. During this time Bohemond V, son of Bohemond IV of Tripoli, became count of Tripoli and prince of Antioch from 1233 to 1252. Things improved in the Latin Kingdom with the advent of King Louis IX in 1250 and during his residence in Acre until 1254. Unfortunately, this was not the case in the north. Bohemond's son and successor, Bohemond VI, upon taking control in 1252, held the same titles as his father until 1268, when with the loss of Antioch he became only the titular prince. But Antioch and the territory of the principality had largely become separated and remote from the

fortunes of the Crusader States to the south after 1233 because of Moslem incursions to Lattakiah on the coast, and later the increasing threat of Mongol invasions from the east. Meanwhile, Tripoli, the Qadisha Valley, and the coastal cities immediately to the south were relatively secure, not only because of their compactness, natural defenses, and stout fortification, but also because both Bohemond V and Bohemond VI chose to reside in the more agreeable environment of Tripoli than the increasingly dangerous and isolated city of Antioch during this entire time. [77] Thus, although we cannot specify any individual Crusader who may have been interested in an icon of St. Marina during these years, certainly Tripoli and the region south and east of the city were not only comparatively safe, but they also provided one of the few extant holy sites still available for pilgrims to visit after the definitive loss of Jerusalem in 1244: the grottoes and monastery sacred to the memory of St. Marina. [78]

Finally, in terms of the current debate, what light does the Menil icon shed on the issue of the existence and reality of the art of the Crusaders in the Holy Land? We have proposed to explain the mélange of Crusader, Byzantine Cypriot, and Syrian characteristics identifiable in this icon as the product of a Syrian artist working for a Crusader patron in the region of Tripoli proximate to the cult center of St. Marina ca. 1250. Although the style of the icon may partially participate in the phenomenon of the art of the *lingua franca* in terms of its assimilation of aspects of the Byzantine tradition current in the eastern Mediterranean region during the thirteenth century, its distinctive characteristics allow us to attribute it to a local artist working on the Syrian mainland near Tripoli. [79] Thus, it is not "anonymous" in the sense of the origin of its artist being invisibly submerged in the larger artistic developments to which it is related. It is, moreover, not a direct example of the *maniera cypria* characterized by the union of a strong Byzantine tradition with the "romanesqueizing" linearity found in high-quality Cypriot icons of the thirteenth century (e.g., figs. 112–114), [80] but rather a reflection of this Byzantine Cypriot style as practiced by a mainland Syrian artist. Finally, although the mélange of features in the icon is arguably clear enough, the icon cannot be attributed

to a Western artist. The decisive Crusader aspects of this icon appear to be its hybrid and distinctively Eastern Mediterranean visual characteristics and its patronage. What this suggests is that we have much to learn about the contribution which local Christian artists working in Crusader territory on mainland Syria-Palestine between 1199 and 1291 made to the corpus of Crusader art.[81] Certainly it is significant that at about the same time the Menil icon of St. Marina was being painted, Louis IX was revitalizing the Latin Kingdom and the artistic production of Acre between 1250 and 1254. It is important also to observe that the fact that the Menil icon does not show any direct and close ties to the art specifically associated with the Latin Kingdom in Acre in the mid-thirteenth century suggests the possibility of a rich and varied Crusader art that apparently had recognizable, if independent, manifestations elsewhere on the mainland, in the County of Tripoli as well as Antioch.[82]

In conclusion, on the basis of the considerations presented above, I would like to entertain the possibility that the Menil icon of St. Marina was ordered by a Crusader patron with devotional interest in the cult of St. Marina from a Syrian artist connected to the Tripoli area whose work reflected Crusader, Byzantine Cypriot, and local Syrian developments in the mid-thirteenth century. In answer to the question posed in our title, the Menil St. Marina icon is a Crusader work which reflect aspects of the *maniera cypria* and participates in the context of painting of the *lingua franca* without losing its artistic identity in it. I propose, in other words, that we should recognize the Menil icon as an exemplar of Crusader icon painting from the County of Tripoli, an example unique in icon painting to this point. Furthermore, the Menil St. Marina is the only extant example of painting attributed to the Crusader States in the twelfth and thirteenth centuries as yet identified in the western hemisphere.

I should like to thank Bertrand Davezac, curator of The Menil Collection, and the Organizing Committee of the Fourteenth Annual Byzantine Studies Conference, especially T. Gouma-Peterson, A. Weyl Carr, and N. P. Ševčenko, for inviting me to study and report on this icon. This article is an expanded version of the preliminary paper which I delivered at the conference in Houston in November of 1988. I should also like to thank Dr. Davezac for the hospitality extended to me by him and The Menil Collection which made my research on this icon possible. The research and writing of this article was done while on a Guggenheim Fellowship in the wonderfully hospitable circumstances of the National Humanities Center in Research Triangle Park, North Carolina during 1988–1989. I wish to thank the John Simon Guggenheim Memorial Foundation for their generous support, and the library staff of the National Humanities Center for their able assistance during my stay.

I want to express my particular gratitude to Kurt Weitzmann for his willingness to discuss the problems of this icon with me, and for his generosity in opening his archive of photographs of icons from the collection of St. Catherine's Mt. Sinai to me for my research on the Menil St. Marina. I am further indebted to him for permission to reproduce here a number of photos of Sinai icons including a few previously unpublished. All Sinai icons published in this article are reproduced through the courtesy of the Princeton-Michigan-Alexandria Expedition to Mount Sinai.

All of the photos of fresco painting now in Lebanese territory reproduced here were provided to me by Erica Dodd at some considerable personal inconvenience to her. I am grateful for her unfailing cooperation even during a year when her household was scattered among various locations in Pakistan, British Columbia, and New York state. I am indebted to her for allowing me to use her photographs of material otherwise inaccessible at the present moment.

To others who were also indispensable in helping me acquire the photographs needed to illustrate this paper, especially Doula Mouriki, as well as A. Papageorgiou, Department of Antiquities in Nicosia, Dr. M. Acheimastou-Potamianou, Director of the Byzantine Museum in Athens, and Natalya Teteriatnikoff, head of the Department of Visual Resources at Dumbarton Oaks, I should like to express my thanks. To them and to all of my colleagues including Susan Boyd, Curator of the Byzantine Collection, Dumbarton Oaks, who have assisted me with this study in various ways, I am grateful. Whatever shortcomings this article may have, are my responsibility alone, but many stimulating points and excellent questions from those mentioned above and from my departmental colleagues Mary Sturgeon and Mary Pardo have greatly improved my presentation of this fascinating icon.

1. Davezac, pp. 10–12, with citations of earlier references in print. Davezac attributed it as, "Crusader icon, Cyprus(?), thirteenth century" (p. 10). In 1983, at Dumbarton Oaks, it was exhibited as thirteenth century by an artist from South Italy working in the Crusader East; in 1973 at Cardiff, it was identified as Byzantine, from the School of Jerusalem or Acre, thirteenth century; and in 1969, at the Temple Gallery in London, it was described as the work of an unknown master of the Crusader School, Acre or Sinai, thirteenth century.

The St. Marina icon is given acquisition number 85-57.04 DJ. The measurement of the icon are 8 1/2 in. (20.4 cm) high x 6 3/8 in. (15.8 cm) wide. Its maximum thickness along the outer border is 2.1 cm and the thickness of the panel in the central surface area of the image is 1.45 cm. A very steeply bevelled transition from the top surface of the border to the surface of the image measures 7 mm in width. On the back of the icon (fig. 100) one observes a series of drilled holes with diameters ranging from 1.5 mm to 3 mm, and there is a sticker with the number "78" on it. The new acquisition number has been painted on the lower part, without the "DJ".

The icon was conserved by L. Morrocco in London in 1985. A detailed four-page condition report with infrared and x-ray photographs prepared by the Courtauld Institute in 1972–73 exists in the curatorial file of The Menil Collection. The type of wood was unfortunately not identified, but the wood seems dense if very light in weight. The icon has been cut down on its top and bottom borders and is very worm-eaten on the right side.

2. Ross and Downey, pp. 41–44; this quote pp. 42–43.

3. AASS, Iul. V (P-R, 1867), pp. 24–45, feast day: 20 July; Butler's *Lives of the Saints,* vol. III, pp. 152–153; *LcI,* vol. 7, ed. W. Braunfels, Verlag Herder, 1974, cols. 494–500; *Bibliotheca Sanctorum,* vol. 8, ed. F. Caraffa et al., Rome, 1967, cols. 1150–1165. *Bibliotheca Hagiographica Graeca,* 3rd ed., ed. F. Halkin, Brussels, 1957, II, pp. 84–86, notes 1165–69d. We shall not endeavor to discuss the confusing questions surrounding which day in the Greek or Latin church year the various St. Marinas are commemorated. On this matter, please see the references in notes 3 and 4.

4. AASS, Iul. IV (A 1725), pp. 278–288, feast day: 17 July; Clugnet, pp. I ff.; Butler's *Lives of the Saints,* vol. I, pp. 313–314; *Bibliotheca Sanctorum,* vol. 8 (as in note 3), cols. 1165–1170; *Bibliotheca Hagiographica Graeca* (as in note 3) I, p. 187, notes 614–615d, II, p. 83, notes 1163–1163e. See also: E. Patlaegean, "L'histoire de la femme déguisée en moine et l'évolution de la sainteté feminine à Byzance," *Studi Medievali,* ser. 3, XVII, fasc. 2 (1976), pp. 537 ff., esp. 600–602, #8 for St. Marina from Syria.

5. For the artistic representations of St. Marina of Antioch in Pisidia (d. 305), see Ross and Downey, pp. 41–44; Lafontaine-Dosogne, p. 251–259; L. Reau, *Iconographie de l'art chrétien,* vol. III, pt. 2, Paris, 1958, pp. 877–882; J. Weitzmann-Fiedler, "Zur Illustration der Marina-Legende," *Münchner Jahrbuch der bildenden Kunst,* 3. folge, XVII (1966), pp. 17–48; *LcI,* vol. 7 (as in note 3), cols. 494–500; and Kühnel, pp. 110–111.

For the representations of St. Marina in Syria, see: Clugnet, pp. XXVIII ff.; L. Réau, *Iconographie de l'art chrétien,* vol. III, pt. 2, Paris, 1958, p. 891; *LcI,* vol. 7 (as in note 3), cols. 545–546; Kühnel, 1988, pp. 111–112; and Brossé, pp. 30–45. It should be noted that among other places, including the church of the Nativity, Bethlehem, and, in the West, the cathedral of Monreale, the grotto of Mar Marina discussed in this article included images of both St. Marinas. We shall discuss the intense interest in the cult of St. Marina in Sinai, in Bethlehem, and in the region around Tripoli below.

6. In Byzantine art St. Marina of Antioch appears as a full-length figure, in various Cappadocian churches of the middle Byzantine period: see the extensive list cited by Kühnel, p. 110, including Restle, vol. 2, III and X (Göreme), fig. 82 and vol. 3, LVI (Irhala) and LXII (Belisirama); Lafontaine-Dosogne, pp. 251–259.

There are also byzantinizing examples on Italian soil in San Marco, Venice: O. Demus, *The Mosaics of San Marco in Venice,* vol. I, Chicago and London, 1984, pp. 112, 262, 264, 375, nt. 203 (north transept, west arcade, middle arch, restored); and on the bronze door of the main entrance to San Marco: G. Matthiae, *Le porte bronzée bizantine in Italia,* Rome, 1971, pp. 13 ff. She also appears as a complete figure (restored) in the apse of Monreale: O. Demus, *The Mosaics of Norman Sicily,* New York, 1950, pp. 118, 164, nt. 332; and in the grotto of Carpignano in Salentino, but with no consistency in the iconography.

St. Marina of Syria appears in Byzantine art in the following examples: (lying in a coffin) in the Menologium of Basil II: *Il Menologio de Basilio II* (Cod. Vaticano Greco 1613), Turin, 1907, vol. I, p. 107, vol. II, pl. 394; Kühnel, pp. 111–112, cites two other Byzantine eleventh century examples: one from Göreme in Cappadocia (Kiliçlar Kilise: Restle, 1967, II, fig. 296), and another from the Moscow Menologium (D. K. Treneff, *Miniatures du menologue grec du XIe siècle, no. 183 de la Bibliothèque Synodale à Moscou,* Moscow, 1911, p. 56, pl. IV. On Italian soil she appears also in the cathedral at Monreale; a bust length image in a medallion on the east end of the wall in the northern aisle: O. Demus, *The Mosaics of Norman Sicily,* New York, 1950, pp. 120–121.

7. E. Diez and O. Demus, *Byzantine Mosaics in Greece: Hosios Lucas and Daphni,* Cambridge, MA, 1931, fig. 47. Carolyn Connor has raised the issue of redating Hosios Lukas and its decorations in her paper given at the Byzantine Studies Conference in Houston in November 1988; BSC 14, *Abstracts,* pp. 27–28. Her book on Hosios Lukas was recently published by the Princeton University Press, *Art and Miracles in Medieval Byzantium* (1991).

8. M. Avery, *The Exultet Rolls of South Italy,* Princeton, 1936, pl. XI.

9. Ross and Downey, p. 43.

10. Compare, for example, the frame of the St. Marina icon with those of the other Greek icons in The Menil Collection: Davezac, pp. 1–25; and consider the Greek examples published by K. Weitzmann, and G. Babić and M. Chatzidakis: "The Icons of Constantinople," and "The Icons of the Balkan Peninsula and the Greek Islands (1)," respectively, in Weitzmann, 1982, pp. 11–84 and 129–200. No studies of the painted or pastiglia frames *per se* of Byzantine icons are known to me, but whereas most Byzantine painted icons have plain borders (that could obviously have been covered in a metal frame, now lost), some can still be seen to have contemporary decorated frames, e.g., a mid-twelfth century icon of the Last Judgement from Constantinople (Weitzmann, 1978, pp. 84–85, pl. 23).

Parenthetically we may note that the top and bottom frame of the Menil St. Marina appears to have been cut down, leaving only half of the reverse S-shaped elements and the continuous dark green border. This has further reduced the size of this small icon, making its original function more difficult to assess. In view of the diminutive size, the thick wood and the nature of the painted border, very likely it was intended to be a small icon for private devotional use, one that also could have been placed on the proskynetarion of a church for the Saint's day. Much less likely is the possibility that the icon was cut out of a larger ensemble, but it is not obvious what the original configuration might have looked like.

11. The painted foliate decoration on this icon is actually done in a very slightly raised *pastiglia* technique. See Frinta, p. 336. For a color reproduction of the icon of St. Sergius, see Weitzmann, 1982, p. 232. This icon has recently been attributed to a Syrian artist working in Cyprus, by Mouriki, 1986, p. 71.

12. Weitzmann, 1966, pp. 52–53 and fig. 1. This icon has since been studied by two other scholars who have proposed stronger Egyptian connections and a dating in the thirteenth as opposed to the twelfth century: R. S. Nelson, "An Icon at Mt. Sinai and Christian Painting in Muslim Egypt During the Thirteenth and Fourteenth Centuries," *The Art Bulletin,* LXV (1983), pp. 201 ff.; and L.-A. Hunt, "Christian-Muslim Relations in Painting in Egypt of the Twelfth to mid-Thirteenth Centuries: Sources of Wallpainting at Deir es-Suriani and the Illustration of the New Testament MS Paris Copte-Arabe 1/Cairo, Bibl. 94," *Cahiers Archéologiques* 33 (1985), pp. 141, 144, fig. 35 and p. 155, note 205.

13. K. Weitzmann has very kindly shown me several examples in his archive of icon photographs from the Sinai expedition at Princeton University. The bust-length St. Marina illustrated here is no. 454, an icon which is in Weitzmann's "miscellaneous" group, for which the origin is as yet uncertain. It is a small bilateral icon in a sketchy style, probably of the twelfth century, which retains some painted geometric decoration along its top border only. Like the Menil St. Marina, this painted decoration has also been in effect cut in half.

14. For the Sinai icon, see Weitzmann, 1982, p. 217; for the Nicosia icon, see Mouriki, 1986, pp. 20 ff., and fig. 16, p. 89.

15. Cormack and Mihalarias, 1984, pp. 132–141.

16. Mouriki, 1986, pp. 36–37, figs. 37 and 43. Mouriki characterized the *maniera cypria* as substantially Byzantine, but with a pronounced linear stylization that distinguishes work done on Cyprus from that of Constantinople.

We could contrast the Menil St. Marina with the frescoes in the Church of the Panagia at Moutoullas, dated 1280, or the church of the Evanghelistria (among other churches) at Geraki on the Greek mainland (Peloponnesus) dated in the thirteenth century. On Moutoullas, see S. H. Young, *Byzantine Painting in Cyprus during the Early Lusignan Period,* diss. Penn State University, University Park, 1983, pp. 246–320, and the article by Mouriki, 1984, pp. 171–213 and pls. LXXXII–XC. For the church of the Evanghelistria at Geraki, see the publication by N. C. Moutsopoulos and G. Dimitrokallis, *Geraki: Les Eglises du Bourgade,* Monuments d'agglomerations byzantines, vol. 1, Thessaloniki, 1981, pp. 83–136.

17. This phenomenon has been discussed by Frinta, 1981, pp. 333–347. See also M. Frinta, "Relief Imitation of Metallic Sheathing of Byzantine Icons as an Indicator of East-West Influences," *The High Middle Ages* (Acta, vol. VIII), SUNY Binghamton, 1983, pp. 147–167, and M. Frinta, "Relief Decoration in the Gilded *Pastiglia* on the Cypriot Icons and Its Propagation in the West," *Acta of the Second International Congress of Cypriot Studies, 1982,* Nicosia, 1986, pp. 539–544. There are some additional comments on the subject by Cormack and Mihalarias, 1984, p. 138.

18. The cuffs on the Menil St. Marina are interesting in their prominence, which corresponds to the fact that such cuffs existed as discrete objects for some icons, especially those of the Virgin Mary, and are listed in various Byzantine inventories. N. P. Ševčenko referred to these cuffs in her paper at the Fourteenth Byzantine Studies Conference: see " 'Vita' Icons and the Origin of Their Form," BSC 14, *Abstracts,* pp. 32–33. In this paper she refers to an inventory dating from the year 1200 from the Monastery on Patmos as one important example. My thanks to Nancy Ševčenko for allowing me to consult the full typescript of her paper.

19. The condition report mentioned above, note 1, states that tests for silver were negative, but that there were (faint) positive reactions for tin.

20. S. G. Mercati, "Sulla santissima Icone del Duomo di Spoleto," *Spoletium,* 3 (1956), *passim.*; S. Der Nersessian, "Two Images of the Virgin in the Dumbarton Oaks Collection," *DOP,* 14 (1960), p. 84 and fig. 11; D. T. and T. Rice, *Icons and Their Dating,* London, 1974, p. 16 and fig. 4; Weitzmann, 1982, p. 17 and pl. on p. 52, lower left; and Weitzmann, 1984a, p. 144.

21. Mouriki, 1987, p. 413 and nt. 34.

22. See on this matter the various articles of Frinta, cited above in note 17, and also, M. Frinta, "The Decoration of the Gilded Surfaces in Panel Painting around 1300," *Europaische Kunst um 1300*, vol. 6, *Akten des XXV. Internationalen Kongresses für Kunstgeschichte: Wien, 1983*, ed. H. Fillitz and M. Pippal, Vienna, 1986, pp. 69–76, esp. p. 72; Mouriki, 1986, p. 20 and note 34.; Mouriki, 1987, p. 413, note 35. For the possibility of a Constantinopolitan origin, see H. Belting, C. Mango, and D. Mouriki, *The Mosaics and frescoes of St. Mary Pammakaristos (Fetiye Camii) at Istanbul*, Washington, D.C., 1978, pp. 9–10.

23. Weitzmann, 1963, pp. 186–189, figs. 9–12; Weitzmann, 1966, p. 59, figs. 16, 17. In this case the studs inside the lobes of the haloes or on the background are much tinier and shaped in a more pointed, thus less substantial form.

24. See note 15 above. Other examples can be cited; see, e.g., the Sinai icon of St. George (fig. 103) published by Cormack and Mihalarias in the article on the British Museum St. George, or the well-known thirteenth-century Virgin Hodegetria (fig. 105).

25. There are, of course, Sinai Crusader icons with raised gesso haloes and borders but flat painted backgrounds: see Weitzmann, 1966, p. 78 and fig. 61, and an unpublished Crucifixion, icon no. 285 (fig. 106), the latter having a raised gesso border and haloes with slender rounded or pointed studs, again very different in shape to the broad substantial type used in the Menil St. Marina.

26. For the Crusader icons on Sinai, see, e.g.: Weitzmann, 1963, 1966, 1982, 1984a; for the Cypriot icons, see: A. Papageorghiou, *The Icons of Cyprus*, Geneva, 1969, and Mouriki, 1986, pp. 9–112 and 1987, pp. 403–414.

27. The Barletta Cross Reliquary is published most recently and attributed to Jerusalem during the Crusader period by H. Meurer, "Kreuzreliquiare aus Jerusalem," *Jahrbuch der Staatlichen Kunstsammlung in Baden-Württemberg* 13 (1976), pp. 10 ff., and "Zu den Staurotheken der Kreuzfahrer," *ZfurK* 48 (1985), pp. 67 ff., with earlier bibliography. Meurer gives 1138 as a terminus ante quem for the Barletta cross and attributes its manufacture to Jerusalem along with several others.

Even though this extant exemplar is twelfth century in date, the importance of Crusader goldsmith's work in the twelfth and thirteenth centuries suggests that such a reliquary cross is a relevant comparison. I am discussing this issue at some length in my study of the art of the Crusaders in the Holy Land, currently in preparation.

28. Meurer, 1976, p. 14 and note 38, attributed the origins of the reverse S-curve design to Byzantine metalwork, e.g., as found on a medallion dated ca. 1100 now in the Kunstgewerbe Museum in Berlin. See Wessel, 1967, p. 126, note 44, illustrated on p. 93. For reasons of context, we believe the Crusader source is more likely for this motif, but the Byzantine origin of the Crusader use should not be overlooked because it offers in metalwork a precise parallel with the phenomenon in icon painting we are primarily concerned with here.

29. I am specifically concerned with the double-barred cross shape here. This form must be distinguished from a variety of other cross configurations that are similar but distinct. On these cross shapes and their significance, see E. Dinkler and E. Dinkler-von Schubert, "Kreuz," *LcI*, vol. 2, Freiburg, 1970, cols. 562 ff. and col. 569 on the double-barred cross. Notice that the Crusader icons of St. Marina (figs. 110, 111) mentioned below in note 36 hold crosses which are clearly distinct from this one.

The four rays that create a radiance emanating from the central crossarm of her cross are not significant in this context, though somewhat unusual. I interpret their presence as coordinating the cross with the radiant stars on St. Marina's maphorion. In the effort to represent St. Marina in the image of the Virgin, she is, in other words, wearing the stars of the Virgin and holding the image of the True Cross of Christ as references to her sanctity, her "Christlikeness" through the Virgin, if you will.

30. See as examples, the large Byzantine calendar icons published by K. Weitzmann from the Church of St. Catherine's at Mount Sinai: Weitzmann, 1984b, pp. 63–116, esp. pp. 107–112.

31. Ibid., e.g., St. John Chrysostomos, et al.; for a Crusader example, St. John Chrysostomos also appears in a bust-length image on the frame of a mid-thirteenth century Crucifixion icon from Sinai: see Weitzmann, 1982, p. 211; as a possible Crusader example, St. James the Greater carries a cross on a twelfth-century icon, but the cross is too flaked to be certain that it is a double-barred cross: see Weitzmann, 1966, pp. 54–56, fig. 8, and Weitzmann, 1982, p. 209.

32. It is interesting to note that the possible impact of Crusader metalwork, suggested by the association here of the reverse S-curve designs and the reliquary shape of the True Cross, is further strengthened by the unusual gessoed halo of St. Marina, whose studs may even echo the broad, substantial nailheads in the Reliquary of the True Cross from Barletta (fig. 107).

33. Besides the Crusader examples referred to by Meurer (see above, note 27), there are also the well-known Byzantine reliquaries of the True Cross, e.g., the magnificent tenth-century example from Limburg an der Lahn, or the late twelfth century example from Esztergom (Wessel, 1967, pp. 75 ff., no. 22, and pp. 158 ff., no. 49, respectively).

34. The studies of A. Frolow are the invaluable points of departure for consideration of the cult of the True Cross: *La Relique de la Vraie Croix*, Paris, 1961, p. 286ff., and *Les Reliquaires de la Vraie Croix*, Paris, 1965, passim. As mentioned in note 27, I am preparing a study of Crusader art which discusses the importance of the cult of the True

Cross in the Latin Kingdom of Jerusalem.

35. See Weitzmann, 1982, p. 64, lower left.

36. Compare the Menil St. Marina (fig. 99) with, among Byzantine examples, the Pedoulas (fig. 112) or Moutoullas (fig. 108) St. Marinas, whose coifs are not clearly distinct, with the Hosios Lukas St. Marina (fig. 101), whose coif is unmistakable. Few Crusader images of St. Marina among the icons from Sinai clearly indicate the coif: see St. Catherine and St. Marina (fig. 110) published by Weitzmann, 1966, pp. 72–73 and fig. 50, and a very damaged unpublished version of the same pair with their positions reversed, icon no. 168 (fig. 111). G. and M. Sotirou (Icônes du Mont Sinai, vol. 1, Athens, 1956, pl. 50; vol. 2, Athens, 1958, p. 68, no. 50) published yet another icon from Sinai with standing full-length figures of St. Marina and St. Catherine. They attributed it to the eleventh century, but it may well be at least a century later; it is similar to the two Crusader examples cited just above, in which the coif of St. Marina is not visible.

37. For Crusader examples of the Virgin Mary with her coif as a three-dimensional (i.e., highlighted) entity under the maphorion, see the thirteenth-century Sinai Virgin Hodegetria (fig. 105), or the Virgin and Child with standing saints (fig. 104).

38. The shape of these star-shaped ornaments varies greatly as even the brief article of G. Galavaris indicates: "The Stars of the Virgin, An Ekphrasis of an Ikon of the Mother of God" (a communication read at the XIIIth International Congress of Byzantine Studies in Oxford, September, 1966), Eastern Churches Review, vol. 1 (1966-1968), pp. 364–369. In the case of the Menil St. Marina, the star-shaped ornaments seem to resemble "Maltese" crosses with a distant parallel on the Grottaferrata icon of the Virgin Hodegetria (Weitzmann, 1966, fig. 52). What seems significant here is that like certain other aspects of this icon, the shape of the stars has no close parallel among the Sinai Crusader or the Cypriot Byzantine icons of the thirteenth century.

39. Weitzmann, 1966, figs. 52 (the Crusader [?] Virgin Hodegetria from Grottaferrata), 66 (a Byzantine Virgin Hodegetria from Sinai), and 67 (a Crusader Virgin Hodegetria from Sinai). Although Weitzmann attributed the Grottaferrata Hodegetria to the Crusader group of icons (p. 75, fig. 52), we should note that V. Pace has recently proposed a Cypriot origin for this icon: "Presenze e influenze cipriote nella pittura duecentesca italiana," Corsi di cultura sull'arte ravennate et bizantina, 32 (1985), pp. 265, 268, figs. 4 and 5. The issue has yet to be resolved.

40. Fig. 112, Weitzmann, 1966, fig. 66 (a thirteenth century Byzantine Virgin Hodegetria from Sinai); or fig. 114: Mouriki, 1987, p. 407, fig. 1 (a Virgin Hodegetria from Cyprus dated ca. 1200).

41. Mouriki, 1986, pp. 36–37, and 1987, p. 412, fig. 1.

42. Mouriki, 1986, pp. 34 ff. for the Moutoullas Christ and the Pedoulas St. Marina icons. The Athens Hodegetria is published by Mouriki, 1987, pp. 403 ff., and by Dr. Myrtali Acheimastou-Potamianou, Catalogue of the Exhibition in Honor of the Centennial of the Christian Archaeological Society, Byzantine Museum, Athens: October 6, 1984–June 30, 1985 (title and text in Modern Greek), Athens, 1984, pp. 16–17, entry #5, and color plate at the back of the catalogue. My thanks to Dr. Acheimastou-Potamianou for supplying me with a copy of this catalogue.

43. On the spectacled eyes in Crusader painting, see Weitzmann, 1963, pp. 189, 199; Weitzmann, 1966, pp. 56 ff.

44. Mouriki, 1986, pp. 36, 34, 13–14 and passim.

45. H. Buchthal, Miniature Painting in the Latin Kingdom of Jerusalem, 1957, pp. 9–11. The "saint's portrait master" probably worked in Jerusalem in the 1130s, most likely around 1135, on the Melisende Psalter.

46. H. Delehaye, "Saints de Chypre," Analecta Bollandiana, 26 (1907), pp. 161–301. By comparison the most popular saint, George, appears in 67 locations; comparably popular saints are St. Nicholas, 20 locations, and St. Barbara, 12 locations. Most other saints average four or five locations: see pp. 265–270. Mouriki has also noted this popularity: see Mouriki, 1984, p. 197; and Mouriki, 1986, p. 52, and notes 154–156.

47. Clugnet, pp. xi–xii.

48. A. and J. Stylianou, The Painted Churches of Cyprus: Treasures of Byzantine Art, London, 1985, p. 432.

49. Mouriki, 1986, pp. 33–37; the specific term "Romanesque" is cited on p. 34.

50. Recall that we have also seen a twelfth century St. Marina from Sinai as yet unpublished and unattributed (fig. 109). See above, nt. 13.

51. On the current location of the chapel of St. Marina in the Monastery church of St. Catherine, Mt. Sinai, see G. H. Forsyth and K. Weitzmann, et al., The Monastery of St. Catherine at Mount Sinai: The Church and Fortress of Justinian, Plates, Ann Arbor (1973), pp. 8–9, and pl. XCII, A (with an interesting painted ceiling). Note, however, that R. Pococke reported the chapel of St. Marina inside the church in a different location in the 18th century: A Description of the East and Some Other Countries, volume the first, Observations on Egypt, London, 1743, pp. 149–54, esp. p. 150 and pl. LVI opposite p. 150. Pococke reported the chapel of St. Marina to be the second on the south side, instead of the first as today.

Note also that in addition to the chapel dedicated to St. Marina located inside the monastery church, a separate outside chapel dedicated to St. Marina is mentioned by Pococke. A Description, p. 146, referred to also by Mouriki, 1986, p. 52, note 157. Pococke reported: "At

the very first ascent up to Mt. Sinai, from the vale of Elias, are two chapels adjoining to one another, dedicated to Elias and Elisha . . . and on the north side of them is a chapel now ruin'd [sic] dedicated to St. Marina." Pococke, p. 146. Pococke makes no attempt to identify which St. Marina was commemorated in either chapel, and the problem has not been addressed in the modern literature.

52. Kühnel, fig. 74.

53. Kühnel, pp. 105–112, pl. XXX (in color) and fig. 74. Kühnel is no doubt correct to identify these two Marinas as separate saints, but I identify St. Marina on the south side wearing the red maphorion as St. Marina of Antioch (Kühnel's St. Marina/Margaret I), and St. Marina at the east end column of the south nave as St. Marina of Syria (Kühnel's St. Marina/Margaret II). Kühnel does not conclusively identify which St Marina is which.

Fig. 115 reproducing the image of St. Marina of Antioch in Pisidia is included here without the image of St. Marina of Syria because the latter is so heavily damaged as to be almost invisible. For the latter, see, Kühnel, p. 74.

54. Ibid., fig. 3, with the location of the various saints on the columns of the church in Bethlehem. Note that on fig. 3 the identifications of Marina/Margaret I and II are reversed from the captions on pl. XXX and fig. 74.

55. We should recall that some Crusader painting from the County of Tripoli has been identified at Crac des Chevaliers: J. Folda, et al., "Crusader Frescoes at Crac des Chevaliers and Marqab Castle," *DOP*, 36 (1982), pp. 178–96, 209–10. Crac is located in the northeastern corner of the County of Tripoli, approximately 75 km from Tripoli itself. Although there is a surprising variety of styles at Crac, the frescoes extant all seem to date to ca. 1200 or earlier, and other than very general regional formal parallels, offer no helpful comparisons for understanding the origins and context of the Menil icon.

56. I am indebted to Professor Dodd for three things in particular: for guiding me to the extensive fresco material during my visits to Lebanon in the 1970's, for consulting her photographic archives for *comparanda* for the Menil St. Marina icon, and for providing me with photographs of the relevant material from her own black-and-white negatives of this material. I am also grateful for her willingness to discuss the issues raised by these paintings both then and now, and for her openness and collegial assistance in working with these frescoes in particular.

E. Dodd has already published the following article with useful bibliography on the painted churches in Lebanon: "Notes on the Wall Paintings of Mart Shmuni," *Archeologie du Levant, Recueil R. Saideh, Collection de la Maison de l'Orient Mediterraneen*, no. 12, série archéologique, no. 9, Lyons, 1982, p. 453, note 3. A recent publication of medieval frescoes in Maronite churches is Sader, 1987.

57. Brossé, pp. 1–16. Brossé points out two other grottoes in the vicinity of Mar Marina which are connected to the local cult of St. Marina: the one near the monastery of Qannoubine is the place where the saint died; the other is some kind of funerary grotto south of the serail at Amioun. Cf. Brossé, p. 16, note 1.

A more recent popular description of Mar Marina is found in B. Conde, *See Lebanon,* 2nd ed., Beirut, 1960, pp. 528–533.

58. See Brossé, p. 33, fig. 1; and for the iconography, Lafontaine-Dosogne, pp. 251–259.

59. Brossé, pp. 38–45 and plate X.

60. Sader, pp. 11–12, Tallon, p. 294.

61. Sader, 1987, pls. 11–22, esp. 14 and 22. In notable contrast to the St. Marina icon, however, are the stocky rounded fingers of the male saints. Nor do we find in these saints' faces or draperies the special features of the St. Marina icon artist, e.g., the handling of the mask-like eyes, or the shading of the brows and their flowing connection across the bridge of the nose. It should also be noted that the inscriptions on these frescoes are in Syriac "estrangelo" and stylistically are unrelated to the Greek on the St. Marina icon.

62. Sader, 1987, pl. 3.

63. Sader, 1987, pp. 23–33; Tallon, p. 294. In this church there are fewer inscriptions contemporary with and extant on the frescoes, but again those that survive are in Syriac "estrangelo."

64. Sader, 1987, pl. 37.

65. Tallon, pp. 286–287, and pl. I. Tallon's article is primarily devoted to Saidet ed Darr, but also lists some of the other extant fresco ensembles. See also for some remarks on related frescoes at Deir es Salib, Bahdeidat and Ma'ad: E. Dodd, as in note 56 above, pp. 451, 453, 454, 462.

66. The dating of all these frescoes is still under discussion. Sader, 1987, pp. 51–53, discusses this problem briefly, but without any *comparanda* to anchor his attributions. He embraces the idea that Bahdeidat was painted by Crusader artists at the time of the Third Crusade, 1189–1192, while Ma'ad and Edde were done between 1263 and 1292 [sic]. These dates are drawn from historical possibilities, but no art historical monuments or stylistic evidence are adduced to explain the proposals.

Erica Dodd, in her as yet unpublished work on these frescoes, compares them to contemporary Cappadocian, Cypriot and Yugoslavian wall paintings of the twelfth and thirteenth centuries. Her tentative dating attributes Saidet ed Darr to the late twelfth century or early thirteenth century, whereas Bahdeidat, Ma'ad and Edde are attributed ca. 1240–1260. The important terminus ante quem for the latter three fresco ensembles is the advent of the Sopocani style at Edde in the 1260s. I have adopted Dodd's dating for the purposes of my

discussion above, with the proviso that in my opinion the fresco fragments at Saidet ed Darr may turn out to be contemporary with the paintings at Bahdeidat, Ma'ad, and Edde.

67. Talon, p. 281, and pl. I.

68. Sader, 1987, pp. 35 ff., pls. 35–36, 40.

69. Brossé, p. 33 and pl. X.

70. The palaeographical issue here is difficult for two special reasons. First, the Greek palaeography of Cyprus and the Syrian mainland is closely related to provincial Byzantine work in the twelfth and thirteenth century, and secondly, the focus of palaeographical work on Greek script has understandably been on cursive script in dated or datable manuscripts from these two regions, not, in other words, on majuscule or display script of the sort germane to our inscription on the Menil icon and *comparanda* in extant frescoes. In any case, unfortunately, the cursive script in manuscripts of the thirteenth century does not offer any helpful parallels with our icon inscription. For the most recent studies, see A. Carr, *Byzantine Illumination, 1150–1250: The Study of a Provincial Tradition,* Chicago, 1987, chapter 5, "The Script," pp. 126 ff.; and P. Canart, "Les écritures livresques chypriotes du milieu du XIe siècle au milieu du XIIIe et le style palestino-chypriote 'epsilon,' " *Scrittura e Civiltà* 5 (1981), pp. 17–76, and 11 plates.

We should note here, however, that the strong affinities in palaeographical developments that connect Cyprus and the Syrian mainland are a feature that is paralleled in the painting style that we have discussed above. It is not without significance that we notice this linkage in the palaeography without being able at this point to refine our characterization to the point of saying whether the Menil icon inscription drew on recent Cypriot developments or those in Syria. We may reasonably suspect, however, that the widespread use of Syriac and especially "estrangelo" in frescoes in the region of Tripoli, that is, display scripts with block letter forms in contrast to the Greek, may have reinforced the squarish tendencies remarked on in the Greek letters of the Menil icon. Finally, we should also observe that a survey of the extant fresco inscriptions on Cyprus from churches and monastic establishments dated from ca. 1175 to 1280, as in, e.g., the Enkleistra of St. Neophytus, Lagoudera, the early phase of painting at the Monastery of St. John Lampadistis at Kalopanayiotis, and Moutoullas, yields no more closely related inscriptions than those we have seen from the Tripoli region. What is significant, of course, is that for the Menil St. Marina icon we have the possibility of comparable Greek inscriptions in a similar basic style in the Tripoli region. For the Byzantine frescoes on Cyprus, the useful recent guide is A. and J. Stylianou, as above in note 48, pp. 157 ff., 292 ff., 323 ff., and 351 ff.

71. Part of the success of Weitzmann's case for the Crusader icons at the Monastery of St. Catherine's, Mt. Sinai, is based on his ability to argue for a direct connection between certain icons and the content of the icons as related to the *loca sancta* at Sinai, such as the Burning Bush, etc. See Weitzmann, 1963, pp. 192 ff.; Weitzmann, 1966, pp. 66 ff., and K. Weitzmann, "An Encaustic Icon with the Prophet Elijah at Mount Sinai," *Mélanges offerts à Kazimierz Michalowski,* Warsaw, 1966, pp. 720–723.

Cormack and Mihalarias have taken a similar approach in suggesting the attribution of the British Museum St. George to Lydda, but their effort is hampered by the lack of visual evidence to provide a context for the icon. See Cormack and Mihalarias, 1984, pp. 132 ff.

72. Mouriki, 1986, p. 71.

73. Mouriki, 1984, p. 197, has recently commented on Marina's popularity in the Crusader States.

74. The ability to provide inscriptions in the language desired by the patron is a time-honored feature of doing business in the Levant. Whereas a newly arrived Westerner might wish to have a painting of this sort accompanied by a Latin inscription, a Crusader who had settled in the County of Tripoli, or farther south in the so-called Kingdom of Jerusalem ca. 1250, would have had the opportunity to learn more of local customs and observances and could have developed more acculturated and sophisticated sensibilities in his artistic taste. Greek would on this basis have been the likely choice, whereas it is improbable that such a patron would choose Syriac for an inscription which few foreigners could read.

75. Given the use of the relic of the True Cross as an ensign of the Crusader army after the taking of Jerusalem in 1099, the presence of its image in the hands of St. Marina raises questions about its purpose here. Conceivably the patron could have wished Marina to carry this special cross in honor of a recent victory. It is perhaps less likely, but not impossible, that the double-barred cross might also have ecclesiastical significance and reflect the wishes of an ecclesiastical patron, such as the bishop of Tripoli. Unfortunately, however, there is no evidence for either suggestion at this point.

76. See B. Hamilton, *The Latin Church in the Crusader States,* pp. 207–208, 333–334; and K. S. Salibi, "The Maronites of the Lebanon under Frankish and Mamluk Rule (1099–1516)," *Arabica,* IV, 1957, pp. 296 ff.

77. See: H. E. Mayer, *The Crusades,* 2nd ed., Oxford, 1988, p. 251 ff.

78. It seems possible that the St. Marina icon is a work of "pilgrimage art" from a *locus sanctus,* that is, an icon painted as a devotional souvenir and religious manifestation of a visit to the shrine of St. Marina at Mar Marina. At this point, however, we have little specific knowledge of the relationship of the cult of St. Marina of Antioch and that of St. Marina of Syria at Mar Marina in the thirteenth century. On Mar Marina, see note 57 above. On the tradition of art and the *loca sancta* in Palestine, see K. Weitzmann, "*Loca Sancta* and the Representational

Arts of Palestine," *DOP* 28 (1974), pp. 31–55.

79. H. Belting, "Zwischen Gotik und Byzanz: Gedanken zur Geschichte der Sachsischen Buchmalerei im 13. Jahrhundert," *ZfürK* 41 (1978), pp. 246 ff.

80. D. Mouriki has argued that certain icons attributed to Acre or St. Catherine's, Mt. Sinai by Weitzmann, should in fact be assigned to Cyprus in the thirteenth century. A conspicuous example is the St. Sergius icon (fig. 40) referred to above (note 11) as part of the group done by the "Master of the Knights Templars." I favored this possibility in 1976 (Folda, *Crusader Manuscript Illumination at Saint Jean d'Acre, 1275–1291,* Princeton, 1976, pp. 118–19) and now Mouriki has provided an analysis of the artistic context in Cyprus which makes such a proposal indeed persuasive: Mouriki, 1986, pp. 66–71, and passim. Mouriki's concluding statement, moreover, points to the need for a revised understanding and formulation of the nature of Crusader painting: "faced with the challenge of these observations, we may wonder if Crusader painting, according to the traditional definition, is a less substantial reality than has been assumed" (Mouriki, 1986, p. 77). Far from indicating a less substantial existence, Mouriki's analysis of the "maniera cypria" and the Menil icon of St. Marina indicate that Crusader painting was a complex phenomenon, that it is more substantial than we hitherto thought, and that Cyprus was a major contributor to the developments of which it was part.

81. We look forward to significant contributions to this large and important but little-studied aspect of the problem in the forthcoming publications of Kurt Weitzmann, Erica Dodd, and Lucy-Anne Hunt, among others.

82. Crusader painting in the County of Tripoli has already been identified in the extant fresco fragments from two chapels of Crac des Chevaliers as cited above (note 55). The work of several artists can be seen here, but other than the very general regional characteristics from ca. 1200, no strong ties with the artist of the Menil icon are apparent.

A Crusader manuscript has been attributed to Antioch in the period before Antioch fell to the Mamlukes in 1268. See: J. Folda, "A Crusader Manuscript from Antioch," *Atti della Pontificia Accademia Romana di Archeologia,* ser. III, *Rendiconti,* 42 (1969–1970), pp. 283-98.

Postscript:

Just as this article went to press, D. Mouriki published a major new article in which she refined her views on the relationship between Cyprus and St. Catherine's, Mt. Sinai, in terms of icon painting. See: "Icons from the 12th to the 15th Century," *Sinai: Treasures of the Monastery of Saint Catherine,* ed. K. Manafis, Athens, 1990, pp. 102–120, 384–387.

Also, the following article reached me: Lucy-Anne Hunt, "A woman's prayer to St. Sergios in Latin Syria: interpreting a thirteenth-century icon at Mount Sinai," *Byzantine and Modern Greek Studies,* 15 (1991), pp. 96–145. Readers of my article will be interested in her comments on both the cult of St. Marina and woman's spirituality (pp. 121–122), and monumental wall painting in the County of Tripoli (pp.107–110).

Bibliography of Sources Cited

Abbreviations:

AASS – Acta Sanctorum
BSC Abstracts 14 – Fourteenth Annual Byzantine Studies Conference, Abstracts of Papers, The Menil Collection and the University of St. Thomas, Houston, 1988.
DOP – Dumbarton Oaks Papers
LcI – Lexicon der christlichen Ikonographie
ZfürK – Zeitschrift für Kunstgeschichte

Books and Articles:

Brossé, Ch.-L., "Les Peintures de la Grotte de Marina près Tripoli," *Syria,* VII, 1926, pp. 30–43.

Clugnet, L., *Vie et Office de Sainte Marine,* Bibliothèque Hagiographique Orientale, Paris, 1905.

Cormack, R. and Mihalarias, S., "A Crusader Painting of St. George: 'maniera greca' or 'lingua franca'?," *The Burlington Magazine,* CXXVI, 1984, pp. 132–141.

Davezac, B., " Spirituality in the Christian East: Greek, Slavic, and Russian Icons from The Menil Collection," typescript of a catalogue of the icon collection in development, The Menil Collection, Houston, 1988, to be incorporated in the forthcoming publication.

Frinta, M. S., "Raised Gilded Adornment of the Cypriot Icons, and the Occurrence of the Technique in the West," *Gesta,* XX, 1981, pp. 333–347.

Kühnel, G., *Wall Painting in the Latin Kingdom of Jerusalem,* Frankfurter Forschungen zur Kunst, Bd. 14, Berlin, 1988.

Lafontaine-Dosogne, J., "Un Thème Iconographique peu connu: Marina assommant Belzebuth," *Byzantion,* XXXII, 1962, pp. 251–259.

Mouriki, D., 1984, "The Wall Paintings of the Church of the Panagia at Moutoullas, Cyprus," *Byzanz und der Westen: Studien zur Kunst des Europaischen Mittelalters,* Österreichische Akademie der Wissenschaften, Philosophisch-Historische Klasse, Sitzungsberichte, 432. Bd., Vienna, 1984, pp. 171–213.

_____. , 1986 "Thirteenth-Century Icon Painting in Cyprus," *The Griffon,* n.s. 1–2, 1985-1986, pp. 9–112; republished as a separate monograph, Athens, 1986.

_____. , 1987 "A Thirteenth-Century Icon with a Variant of the Hodegetria in the Byzantine Museum of Athens," *Dumbarton Oaks Papers,* XLI, 1987, pp. 403–414.

Restle, M., *Die Byzantinische Wandmalerei in Kleinasien,* Recklinghausen, 1967, 3 volumes.

Ross, M. C., and Downey, G., "A Reliquary of St. Marina," *Byzantinoslavica,* XXIII, 1962, pp. 41–44.

Sader, Y., *Peintures Murales dans les Eglises Maronites Médiévales,* Beirut, 1987

Tallon, M., "Peintures Byzantines au Liban: Inventaire," *Mélange de l'Université Saint Joseph,* XXXVIII, 1962,. pp. 279–294.

Weitzmann, K., 1963, "Thirteenth Century Crusader Icons on Mount Sinai," *The Art Bulletin,* XLV, pp. 179–203; also republished in _____. , *Studies in the Arts at Sinai,* Princeton, 1982, pp. 291–324.

_____. , 1966, "Icon Painting in the Crusader Kingdom," *Dumbarton Oaks Papers,* XX, pp. 49–83; also republished in Weitzmann, *Studies in the Arts at Sinai,* Princeton, 1982, pp. 325–386.

_____. , 1978, *The Icon: Holy Images—Sixth to Fourteenth Century,* New York.

_____. , 1982 (Weitzmann, K., et al.), *The Icon,* New York, 1982.

_____. , 1984a, "Crusader Icons and Maniera Greca," *Byzanz und der Westen: Studien zur Kunst des Europaischen Mittelalters,* Österreichische Akademie des Wissenschaften, Philosophisch-Historische Klasse, Sitzungsberichte, 432. Bd., Vienna, 1984, pp. 143–170.

_____. , 1984b, "Icon Programs of the twelfth and thirteenth Centuries at Sinai," *Deltion of the Christian Archaeological Society,* XII, pp. 63–116.

Wessel, K., *Byzantine Enamels,* New York, 1967.

Photo Credits

Antonova-Mneva, *Katalog drevnerusskoi zhivopisi* (1963): figs. 9–11, 12, 15, 21, 22

Bayerische Staatsgemaldesammlungen, Munich; Byzantine Visual Resources, copyright 1992, Dumbarton Oaks, Washington, D.C.: fig. 54

Biblioteca Apostolica Vaticana, Vatican City: figs. 70, 82

Bibliotheque Nationale, Paris: figs. 68, 71, 72, 77, 80, 87, 88

Biblioteca Nazionale Universitaria, Torino: fig. 78

Bodleian Library, University of Oxford: figs. 45, 84

Byzantine Museum, Athens: fig. 114

Byzantine Visual Resources, copyright 1992, Dumbarton Oaks, Washington, D.C.: figs. 33, 35, 36, 46, 47, 89–92, 95, 96, 101, 108

Church of the Dormition in Volotova-Field, Museum Zone, Leningrad: fig. 14

Church of the Holy Sepulchre, Barletta, photo by H. Meurer: fig. 107

Cubinasvili, *Gruzinskoe cekannoe iskusstvo* (1959): figs. 48, 49

Department of Antiquities, Nicosia: figs. 112, 113

Erica C. Dodd, Islamabad, Pakistan: figs. 116–121.

Grabar, *Revĕtments* (1975): fig. 51.

Greek Orthodox Patriarchate, Jerusalem: fig. 81

Hirmer Fotoarchiv, Munich; Byzantine Visual Resources, copyright 1992, Dumbarton Oaks, Washington, D.C.: figs. 36, 43

Holy Apostles Church, Pe'c, photo by D. Tasic: fig. 29

Israel Department of Antiquities and Museums, Jerusalem: fig. 115

H. Kjellin, *Ryska Iconeri Svensk och Norsk Ago* (1956): fig. 8

Kominis, *Patmos: Treasures of the Monastery* (1988): figs. 39, 50, 52

Kondakov, *The Russian Icon*, Prague (1929): fig. 18

Laurenziana Library, Florence: fig. 83

Likachev, *Novgorod Icons*, 12–17th c. (1980): figs. 13, 17, 20

Malcove Collection, University of Toronto: fig. 30

Manastir Studenica, Serbia: fig. 32

The Master and Fellows of Corpus Christi College, Cambridge: fig. 44

The Menil Collection: cover, pls. 1–4, photos by A. C. Cooper, London; figs. 1–6, 23–26, 28, 31, 37, 40, 59; 60–67, photos by Hickey-Robertson, Houston; 93, 99, 100

Published through the courtesy of the Michigan-Princeton-Alexandria Expedition to Mount Sinai: figs. 38, 58, 69, 86, 94, 102–106, 109–111

Museum of Byzantine Icons, Nicosia: fig. 55

Nationalmuseum, Stockholm: fig. 19

Eric Orner (illustrator), Boston Globe (1988): fig. 42

Patriarchal Institute of Patristic Studies, Thessaloniki, Greece: figs. 73–76, 79, 85

Pelekanides et al., *The Treasures of Mount Athos* (1974): figs. 97, 98

Pinacoteca, Ikono St. Nicolas: fig. 41

Putnam Collection, Timken Museum of Art, San Diego, California: fig. 7

San Bartolomeo degli Armeni, Genoa: fig. 56

Smirnova, *Zhivopis Velikovo Novgoroda* (1982): fig. 16

State Art Museum, Tbilisi, Georgia: fig. 57

Tomovic, *Morfologija cirilickih natpisa na balkanu* (1974): fig. 34

Umetnicka Galerija, Skopje: fig. 53

Editorial Director: Harris Rosenstein

Editorial Associate: John Kaiser

Editorial Assistant: Gayle de Gregori

Design: Don Quaintance,
Public Address Design, Houston

Production Assistant: Elizabeth Frizzell

TEX Software Consultant: Arvin C. Conrad

Typesetting:
Times Roman by TEXSource, Houston

Color Separations/Halftones:
Wallace Engraving, Austin

Printing:
W. E. Barnett and Associates, Houston

Binding:
Roswell Bookbinding, Phoenix